Photography Companion
for the Digital Artist

AGAINST THE CLOCK
mastering graphic technology

PEARSON
Prentice
Hall

Upper Saddle River, NJ 07458

Acquisitions Editor: Melissa Sabella
Executive Editor: Jodi McPherson
VP/Publisher: Natalie Anderson
Marketing Managers: Steven Rutberg and Emily Knight
Marketing Assistant: Nicole Beaudry and and Barrie Reinhold
Associate Director of Production and Manufacturing:
 Vincent Scelta
Manager, Production: Gail Steier de Acevedo
Production Project Manager: Natacha St. Hill Moore
Manufacturing Buyer: Natacha St. Hill Moore
Composition: Against The Clock, Inc.
Design Director: Maria Lange
Design: Coordinator: Blair Brown
Cover Design: LaFortezza Design Group, Inc.
Printer/Binder: Phoenix Color Corporation

Pearson Education LTD.
Pearson Education Australia PTY, Limited
Pearson Education Singapore, Pte. Ltd
Pearson Education North Asia Ltd
Pearson Education Canada, Ltd.
Pearson Educación de Mexico, S.A. de C.V.
Pearson Education — Japan
Pearson Education Malaysia, Pte. Ltd
Pearson Education, Upper Saddle River, New Jersey

10 9 8 7 6 5 4 3 2 1

ISBN 0-13-113310-1

CONTENTS

Section 4 Distributing Your Images

Chapter 10 Working with Digital Images 149

Chapter 11 Distribution . 163

Gallery of Photography

Glossary

Index

PREFACE

The *Against The Clock Companion Series* offers insight into fundamental artistic issues. It covers the details of broad design topics, such as:

- The basic rules of good design.
- The proper and effective use of color.
- The history and application of typography.
- The principles underlying proven and compelling Web site design.
- Proven ways to take better and more compelling photographs.

The *Against The Clock Companion Series* works together with application-specific training books and complements the hands-on, skills-based approach of Against The Clock and other titles. The Companion series:

- Contains **richly illustrated real-world examples** of commercial and institutional artwork, designs, packaging, and other creative assignments.
- Provides the reasoning behind the **creative strategies, production methodologies, and distribution models** — in the words of the artists who provided them.
- Addresses the most important disciplines critical to successful use of computer arts applications: **design, color, typography, Web page design, writing, and photography**.
- Presents the material in a **friendly and easy-to-understand manner**.

The books in the Companion Series are:

- *Design Companion for the Digital Artist* (ISBN: 0-13-091237-9)
- *Typography Companion for the Digital Artist* (ISBN: 0-13-040993-6)
- *Web Design Companion for the Digital Artist* (ISBN: 0-13-097355-6)
- *Color Companion for the Digital Artist* (ISBN: 0-13-097524-9)
- *Writing Companion for the Digital Artist* (ISBN: 0-13-112485-4)
- *Photography Companion for the Digital Artist* (ISBN: 0-13-113310-1)

We hope that you'll find the books as effective and useful as we found them exciting to develop. We welcome any comments you might have that will make the next editions of the books even better. Feel free to contact us at againsttheclock.com.

About Against The Clock

Against The Clock (ATC) was founded in 1990 and went on to become one of the nation's leading systems integration and training firms. The organization, founded by Ellenn Behoriam, specialized in developing custom training materials for clients such as L.L. Bean, *The New England Journal of Medicine*, the Smithsonian, the National Education Association, *Air & Space Magazine*, Publishers Clearing House, the National Wildlife Society, Home Shopping Network, and many others.

Building on their lengthy experience creating focused and structured training materials, ATC's management team began working with major publishers in the mid-nineties to produce high-quality application and workflow-specific training aids. In 1996, ATC introduced the highly popular "Creative Techniques" series, which focused on real-world examples of award-winning commercial design, imaging, and Web-page development. Working with Adobe Press, they also developed successful management books, including *Workflow Reengineering*, which won the IDIA award as most effective book of the year in 1997.

In 1998, the company entered into a long-term relationship with Prentice Hall/Pearson Education. This relationship allows ATC to focus on bringing high-quality content to the marketplace to address up-to-the-minute software releases. The Against The Clock library has grown to include over 35 titles — focusing on all aspects of computer arts. From illustration to Web-site design, from image to animation, and from page layout to effective production techniques, the series is highly regarded and is recognized as one of the most powerful teaching and training tools in the industry.

Against The Clock, Inc. is located in Tampa, Florida and can be found on the Web at www.againsttheclock.com.

About the Authors

Win Wolloff has dedicated more than 35 years to the art of photography. He holds both a Master of Photography and a Photographic Craftsman degree from Professional Photographers of America, the oldest and largest such organization in the country. His images, published both locally and nationally, have won first-place awards in local, regional, and national competitions, including Best of Show, Courts of Honor, and Kodak's Gallery Award for Excellence. Several of his images have been selected for the National Traveling Loan Collection of the Professional Photographers of America. The images throughout this book are largely his photography.

Since 1997, Wolloff has taught at the International Academy of Design in Tampa and written about photography and digital imaging, including two textbooks on Adobe PhotoShop. He is a speaker at photographic conventions and lectures throughout the US and Canada. He also shoots luxury homes and portraits of prominent local figures for *Tampa Bay Magazine*. He is one of the photographers who cover the Tampa Bay Devil Rays baseball team. He has two businesses: Captured Moments Photography, a portrait studio, and The Photo Shop, a retouching business. He and his wife and partner, Jo-Ann, reside in Florida.

Gary Poyssick, co-owner of Against The Clock, is a well-known and often controversial speaker, writer, and industry consultant who has been involved in professional graphics and communications for more than 15 years. He wrote the highly popular *Workflow Reengineering* (Adobe Press), *Teams and the Graphic Arts Service Provider* (Prentice Hall), *Creative Techniques: Adobe Illustrator*, and *Creative Techniques: Adobe Photoshop* (Hayden Books).

Gary has worked with hundreds of creative personnel over the years; as the co-author of this book, he worked closely with Win and a host of other contributors to provide unique insight from the standpoint of the amateur photographer involved in general design assignments. As a result, *The Photography Companion for the Digital Artist* was created for the designer and creative professional who needs to understand photography in simple terms, yet be able to improve the quality of the images they must gather or shoot themselves.

Acknowledgements

I would like to thank the writers, editors, illustrators, photographers, and production staff who have worked long and hard to complete the Against The Clock series.

Thank you to our team of teaching professionals whose comments and expertise contributed to the success of this book, including Robert Howell of California Polytechnic State University, Katherine Havel of Texas A & M University, Curtis Stahr of Des Moines Area Community College, and Warren Kendrick of Florida Technical College.

Our thanks to all of the photographic artists whose images and creativity enhance this book. While Win Wolloff supplied the majority of photographs, many other photographers have contributed as well. Most are attributed adjacent to the images. The remainder were supplied by Photospin.

Thanks to Terry Sisk Graybill, senior editor and final link in the chain of production, for her tremendous help in making sure we all said what we meant to say.

INTRODUCTION

With a title like *Photography Companion for the Digital Artist*, it would be easy to assume that this is essentially a "picture book." It's not. While we certainly make extensive use of photography to illustrate the techniques and methods presented in the copy, this is a book designed to be just what the title indicates — a companion for artists involved in the field of computer arts and professional graphic design.

Not long ago, the graphic arts field included a wide variety of highly specialized disciplines. One individual sketched what the finished project should look like, another set strips of text known as "galleys," someone else glued and taped together the artboard, another shot the photography, yet another created the illustrations, and still another took pictures of the boards.

Today, if you're like most graphic artists and designers that we come in contact with, many of the skills that were once the domain of these individual experts in their fields are now your responsibility. This includes selecting typefaces, putting together page layouts, picking (or creating) images and illustrations, and getting everything ready for print publishing or distribution on the Web.

If you're in this group, this book should serve you well. As is the case in any complex and technical field, photography isn't something you can learn overnight, or from reading a book. What we set out to do in *Photography Companion for the Digital Artist* is to provide you with a solid and understandable framework from which you can begin the process of taking effective, compelling photographs.

Starting with a study of conventional film-based cameras and their modern, digital equivalents, you'll move on to an understanding of the business of photography — when and how to shoot or obtain pictures that meet the quality requirements of your design assignments. You'll learn about taking pictures of people — both candids and those shot under more controlled conditions. Next, you'll explore the subject of shooting places, including equipment considerations and even what you need to pack to get ready for location photography. Lastly, you'll become familiar with product photography for a range of different applications.

In the final chapters, we'll cover topics like digital to analog conversion, and how to get your images ready for use in both print and electronic distribution media.

When you're done, we hope that the information, techniques, and examples provided in the book serve your needs as you move forward in the world of professional design. And we hope that you enjoy the book as much as we enjoyed writing it.

CAMERAS AND EQUIPMENT

Equipment is the focus of Section 1 — specifically cameras, lenses, and related items that serve to enhance or streamline the process of capturing those special images.

A major part of the attraction many photographers, both professional and amateur, feel regarding image-making is directly related to equipment. While some might argue that this is true in any field where technology is continuously changing and advancing, it's particularly evident when you're talking about photography and photographic equipment.

Before you begin this section, stop for a moment and realize that equipment — no matter how sophisticated, expensive, or attractive it might be — does not make the artist. The artist, designer, or photographer brings the creativity to the table. Equipment is, and always will be, merely a tool in the hands of the skilled craftsperson. It's tempting to think, "If only I had that new, fast, incredible lens…" or "I wouldn't be having these problems if I had that new lighting system." Avoid the temptation. Highly effective, award-winning, compelling, and emotion-evoking images aren't in the box the camera comes in — they're in your mind's eye.

Despite this, you do need to think about your equipment carefully. You'll need to buy some, if you haven't already, and then learn to use it. All types of cameras, as well as lenses, lighting, filters, props, and other equipment have a learning curve. They're all different, even from the same manufacturer. Experience and time spent learning them is the key to developing your skills.

In this section, you'll first explore conventional, film-based cameras, and then move on to the rapidly-expanding universe of digital cameras. You'll learn about the underlying technologies of both, and become familiar with their benefits and pitfalls.

Additional discussions include lighting — a critically important area that is heavily dependent on equipment. Finally, you'll learn how lenses work, and how to select the correct lens for the specific job out of the seemingly infinite variety available in today's marketplace.

3

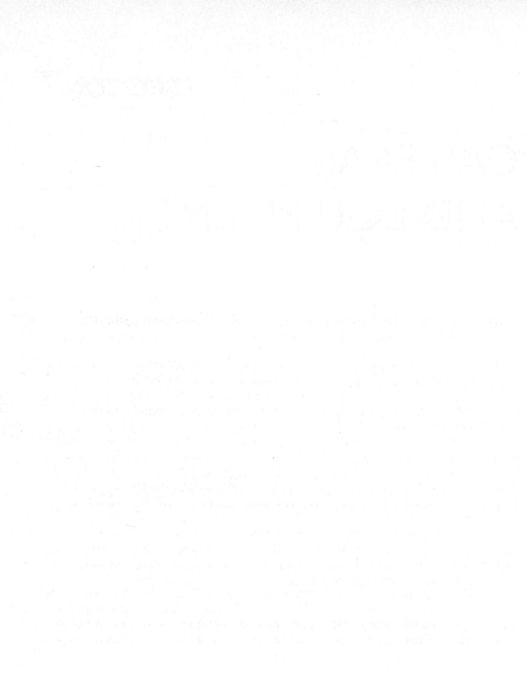

Film
Cameras

Have you ever taken a look at really old photographs? There's something almost mystical about them. From images of the Civil War to photographs of great grandmothers, old pictures convey a sense of a world long gone. Even pictures from our youth seem somehow magical; the people and places in those images have changed in ways the original photographer couldn't have imagined.

In today's increasingly digital, high-speed world, almost every image we see in print, in broadcast media, and on the Web appears perfect; the lighting is great, the focus crisp, and the colors accurate. This wasn't always the case, and probably isn't the case for every vacation or family portrait you've ever attempted to capture. Cameras, or more accurately photography, have a long and complex history. While we're not going to spend a lot of time on the origins of taking pictures, suffice it to say that the technology we take for granted today took a long time to reach its current state.

However you approach the subject, it's important to realize just how important an invention photography turned out to be. It has brought far-away places, events, and people to those who wouldn't ordinarily have been able to see them. Far more realistic than engravings, paintings, or illustrations, photographs provide a picture truly worth a thousand words.

In this chapter, we take a brief look at how cameras function. From there we move to a discussion of conventional film-based devices, and the types of film in common use today.

In this book, we focus primarily on what are known as "still cameras," as opposed to cameras designed to capture video. Note, however, that many of today's digital cameras have the ability to capture a series of images in much the same way as a video camera can; the only difference is that they're limited to short clips containing a limited number of individual still pictures.

How Cameras Work

All cameras — whether conventional or digital, disposables or expensive studio devices — work on the same principles. Still cameras have three components:

- **The mechanical component, or the actual camera body.** This part contains electronics, mechanical parts, or a combination of the two. Shutters, the button you press to take a picture, a mount to hold lenses (for cameras that offer the ability to change lenses), built-in flashlights (or a mount to hold an external flash device), and other features are often built into the body.

- **The optical component, or the lens.** Some cameras, particularly the more expensive ones, allow you to use different types of lenses for different types of pictures and conditions. Other cameras, such as disposables, so-called "point and shoots," and many digital cameras come equipped with a single multifunction lens, which can't be changed. We talk more about lenses and how they work in Chapter 3: Auxiliary Equipment. Basically, lenses bend incoming light and cause it to converge (come together) when it comes out of the back of the glass. The chemical (or capture) component (see following) then records the light coming through the optical component.

- **The chemical or capture component.** This term harkens back to the days before digital cameras could capture an image without the use of chemical, or physical, film. This is the part of the camera that records what you see when you look through the viewfinder and press the shutter button. In the case of conventional cameras, the image is stored on specially prepared, light-sensitive material known as "film"; in a digital camera, electronic components read the incoming light and color information, and store the data inside the camera's memory. Later, when you download the image to your computer or create a print, you can erase and use the component over and over again. (One major disadvantage of film is that it's disposable — it can only be used once and cannot be reused. Digital cameras eliminate this costly and environmentally damaging drawback.)

When light comes off an object, it radiates in all directions at once. The lens in your camera collects this light, and by means of the shape of the lens, redirects the light to a single point on the film or capture element (in the case of a digital camera). You can see this effect in a very simplified manner in the following image. The original object (or subject) — in this case a light bulb — sends light in all direc-

> One of the major disadvantages of film is that it's disposable; it can only be used once and cannot be reused. Digital cameras eliminate this costly and environmentally damaging drawback.

tions at once; when the light waves hit the lens, they're collected and sent to the capture element as a single point.

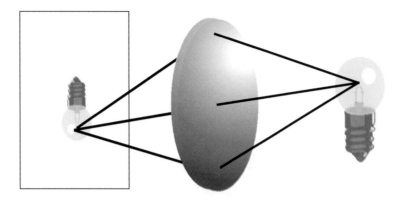

| Film/Capture Element | Lens | Subject Matter |

In Chapter 3, when we talk more about various lenses and how they work, we discuss this concept in more depth. For now, all you have to know is that the lens of a camera is used to grab light coming off a subject and redirect it to a surface where it's recorded for later use.

Film Cameras

As we've mentioned, the film camera represents a mature and well-thought-out science and art; it still remains the most common form of image-recording instrument. It comes in many forms and formats, and, in the hands of a photographer with a little knowledge and experience, is capable of recording incredible images. Note that the operative word here is *recording*, not creating, as real creativity is a combination of different factors, including the eye, skill, and talent of the person taking the picture.

A considerable debate still rages over the use of film versus digital technologies. There remains a core of traditional photographers who, ignoring all of the advances we have seen in imaging over the years, insist: "It's not photography unless you use film." Considering how far technology has advanced from its early days, when photographers were responsible for coating their own *emulsions* (light-sensitive chemicals) onto glass plates, to today's highly evolved and vastly superior films, the point seems to be purely academic. How we record an image is far less important than how well we record it. Photographers bring their own aesthetic and artistic expression to the work; technology is merely the tool that they use.

> How we record an image is far less important than how well we record it. Photographers bring their own aesthetic and artistic expression to the work; technology is merely the tool that they use.

Film and digital devices are alternate ways of using light to fix a moment in time. Each brings its own flavor to the process, and in the interest of your art, you should explore both. Only experience will determine which medium better serves your artistic ambitions.

Film does, however, offer certain advantages — even in today's increasingly digital world. Let's take some time to explore those advantages, as well as the characteristics of some of the more popular and useful emulsions.

> ●← Film and digital devices are alternate ways of using light to fix a moment in time.

Advantages of Film

The first advantage of film is its widespread acceptance and popularity. Film is both well understood and widely available in most parts of the world. Another advantage is its portability; its use isn't dependent on electricity or batteries, although that can't be said of all cameras that use film. Third, film is still capable of producing the highest-resolution images and, except for the very best and most expensive digital cameras, that will probably be the case for the foreseeable future.

Film is manufactured in a vast array of sizes and types. Almost certainly at least one, and often several, will be appropriate to whatever photographic job may come along. This diversity allows the photographer to alter the look and feel of an image merely by the choice of film and becomes one more item in the creative toolbox.

Many modern cameras automatically adjust themselves to match the film you use. They obtain the speed and category information from the bar code found on the outside of the film canister.

GRAIN, RESOLUTION, AND SPEED

Film comes in a variety of "speeds," expressed in ISO (International Standards Organization) numbers. The *ISO numbers* represent a way of rating the sensitivity of each film. Each doubling of the film speed number represents a corresponding increase in the sensitivity of the film, so that correct exposure can be made with half the amount of light on 200-speed film as that required by 100-speed film. Currently speeds range from ISO 25 all the way up to ISO 3200, and even higher with special processing. In general, it is safe to say that the finest grain and highest resolution are found at the slower end of the scale (lower ISO numbers), with reductions in both as speed increases.

A rule of thumb many photographers refer to is the "sunny 16" rule. This states that under sunny conditions, correct exposure results from setting the camera to f-16 and using a *shutter speed* (the amount of time the film is exposed to light) the same as the ISO number of the film. Thus using ISO 100 film, a correct exposure for a sunny scene would

be 1/125 (closest to 1/100) of a second at f-16. For 200-speed film, the shutter speed would be 1/250 of a second. (The concept of f-stops and how they relate to exposure and depth of field will be covered in our discussion of lenses in Chapter 3.)

We need to discuss one more aspect of film speed before moving on — the question of why we need so many different choices. As film speed increases, its ability to resolve fine detail and smooth tones is reduced. To make the film more sensitive to light, the size of the light-sensitive particles in the emulsion are made larger. At some point in this process, they become visible, creating what is referred to as "film grain." As the film speed is increased, so is the film grain. Thus photographers are forced to make an assessment of the conditions that exist during a photo shoot and choose a film that is best for the job. An example is action photography under less-than-ideal lighting conditions. A high-speed emulsion can allow the higher shutter speeds needed to stop the motion of a subject. It can also allow the use of a long lens at the higher shutter speeds required to overcome the additional camera motion caused by the magnifying effect of these

> The "sunny 16" rule is that correct exposure results from setting the camera to f-16 and using a shutter speed the same as the ISO number of the film.

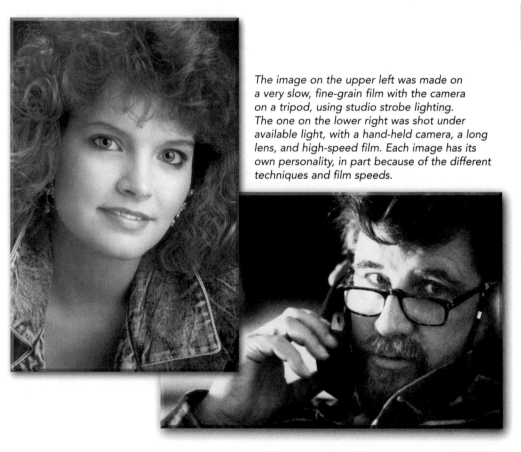

The image on the upper left was made on a very slow, fine-grain film with the camera on a tripod, using studio strobe lighting. The one on the lower right was shot under available light, with a hand-held camera, a long lens, and high-speed film. Each image has its own personality, in part because of the different techniques and film speeds.

lenses. Either or both of these situations might be present during a shoot. A side benefit to all of this is that we have many films to choose from and can use this choice in a creative way. One such way might be using a very grainy high-speed film in a studio setting, where plenty of light is available, because grain is the desired result.

The ultratelephoto lenses used by sports photographers are very expensive and out of reach for many image-makers. One of the factors in their high cost is the need for low-light performance. Good lenses can be bought for much less money when this low-light ability is reduced by even one f-stop. Choosing a higher-speed film is a very inexpensive alternative. Of course, sooner or later the upper end of the film-speed spectrum is reached, and the more expensive lens is the only way to go.

Today's films are light-years ahead of those of even 10 years ago, and manufacturers continue to improve them each year. High-speed film allows action-stopping photography, even at nighttime sporting events like pro football and baseball. The improved grain structure and sharpness of these high-speed emulsions allow for enlargements and excellent magazine reproduction.

VARIETY

Film today is available in color and black-and-white, as well as negative and transparency varieties. Each manufacturer produces several slightly different films in each type. An experienced photographer has a wide choice, and often uses different films for different jobs. Some films are at their best when bright rich color is the desired result, as in fall-foliage photography, while others work best when accurate color is needed, such as reproducing wood tones in a furniture catalog. Still others are optimized for the reproduction of skin tone.

Special-purpose films are also available for special uses, such as extremely high-contrast images, copying photographs to make duplicates when no negative exists, and other limited applications, such as transparency duplication (slides and larger transparencies are often copied to protect originals or when multiple copies are required for distribution).

Characteristics of Film

Each film has a personality. Some color films are designed to be very saturated and have a higher than normal contrast; these produce very bright and colorful images, providing an enhanced version of the scene. Others are biased in just the opposite way. Films designed to produce lower-contrast images are typically used when reproduction of skin tones is important, as a smoother blend of tones is flattering to most skin. This type of film is also often used in the studio where contrast can be controlled via lighting.

Some films are color balanced for indoor light while some are daylight balanced. (The color temperature of light is measured in degrees Kelvin [°K]. Because film lacks our ability to adjust to the differences between the 5,500°K of normal daylight and the 3,200°K of common indoor light, separate films have been developed to produce accurate color in each situation.) Some even are adjusted to work best in open shade or on overcast days. This is true of both major film types (negative and transparency).

The data sheet that is packed with each roll of film gives the photographer an idea of what to expect, but testing is the only sure way to know. Most professional photographers settle on several films of each type, which they have worked with intensively, and choose from them according to the needs of each job. The key here is accurate experimentation and good notes. Knowing what to expect from each film beforehand is a hallmark of a good photographer.

> Each film has a personality. Some color films are designed to be very saturated and have a higher than normal contrast; others are biased in just the opposite way.

FILM TYPES

The two basic film types are negative and transparency. They can be further broken down into color and black and white.

Color negative film is the type most often encountered by the average amateur photographer. It is the film most commonly used when prints are the final product. When processed, the tones of the scene are reversed so that bright areas are dark and dark areas are light, thus it is called "negative." When the film is designed to reproduce color, the colors are also reversed and the film has an overall orange color referred to as a "mask." This mask is designed as part of the color-print system; it is used to control contrast (keep it in a printable range), and is slightly different in each manufacturer's process.

This mask makes scanning negative film more difficult than transparency film, because the scanner operator has no point of reference as to what the scene looked like and so is forced to make judgment calls. Modern scanning software often includes software routines to make the process easier. Known characteristics of common films are stored as *LUTs* (look-up tables), which reverse the tones and colors as well as removing the mask and so are very helpful in getting good scans from negative film. The most common use of negative film is the production of prints on *photographic paper* (light-sensitive paper).

All around the world labs exist to develop and print this type of film. Many cater to the amateur and produce the typical 4 × 6-in. snapshot familiar to most of us. Pro labs also print from negative films, and most can produce custom-made prints of any size, often up to 50 in.

wide. Because the print is the final outcome for most images made on negative film, the person who makes the print has a lot to do with the final look of the image. The brightness and color balance of a print can be controlled over a fairly wide range at the discretion of the printer. Often when atypical subjects such as sunsets are printed on automatic printers, the prints fall short of the photographer's expectations. This is due to the printing machine attempting to average out the scene. As a sunset has many (read as too many by the machine) red and yellow tones and is usually toward the dark end of the scale (read as too dark), it is often "corrected" to the point that the color and density bear no relation to the original scene. A competent operator can solve these problems and reprint the negative properly. A skilled operator or, better yet, a skilled custom printer can produce stunning color prints. Although custom work costs much more, it is often worth the extra expense.

Another often-overlooked advantage of negative film is the wide exposure latitude it affords. Negative emulsions can capture a very wide range of tones, often much wider than the paper can print. For this reason, good prints can be made from negatives that are overexposed by as much as two or three f-stops or underexposed as much as two f-stops. The resulting prints will not be as good as those made from properly exposed film, but most will be useable.

Transparency film is the film that we see when we look at slides. The image is rendered correctly on the film at the time of development. Though 35mm slides are the most common use of this film type, it is available in all sizes and formats up to 8 × 10 in. and beyond. Transparency film is the preferred choice of most commercial photographers as it can deliver a very high degree of color accuracy as well as high saturation and sharpness.

Because image quality is determined by careful attention to exposure and composition and is not usually altered in development, the photographer gets real feedback and information about his or her technique. (A moderate overdevelopment, called a "push," is sometimes used to adjust exposure.) This is not always the case with negative film, as the person who makes the prints has wide latitude in color and density. Negative film is developed according to a standard process, but the prints made from the resulting negatives can be manipulated in many ways. They can be lighter or darker, and the color can be adjusted via the use of filters during exposure. Prints made by automatic equipment often do not reflect the highest quality that can be realized from the negative. Transparencies offer easier scanning, since they lack the orange mask and thus give scanner operators the ability to see just what they are trying to achieve by comparing the scan to the original.

In short, transparencies are most frequently the choice when reproduction of the image in a magazine or catalog is the primary use, and negative film is at its best when the desired result is a photographic

print. As with most areas of this industry, there is some crossover between these technologies, but in general this is accurate.

Currently there are two common chemical processes for developing color film: E-6 for transparencies and C-41 for negatives. Filmmakers have standardized these processes to make it possible to get film processed almost anywhere in the world. Most often photo labs that cater to nonprofessional photographers provide only C-41. Pro labs often offer both services, usually on a continuous basis, allowing for rapid turnaround times. Average snapshot shooters are never asked which process they wish to use as the lab personal know by looking at the film canister. More advanced photographers, however, should at least understand that these processes exist and which is which.

FILM SPEED

As stated earlier, film speed has some relationship to quality, especially grain and inherent sharpness. All things being equal, the slower the emulsion, the higher the quality of the image. But out in the real world, all things are not equal. Often, a compromise must be made between highest possible film quality and being able to get the picture at all.

Perhaps the easiest area in which to demonstrate this concept is sports photography. When working a night game in the NFL, photo-

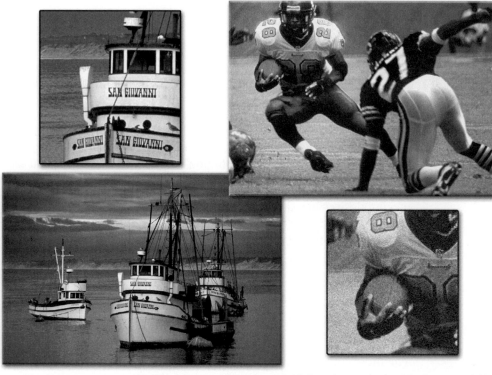

On the left, an image of several fishing boats made with slow-speed film enlarges well, showing little grain. On the right, an action-stopping shot made with high-speed film shows more grain as the image is enlarged.

graphers must contend with fast-moving action under the lights. Although the lights at a professional stadium are bright, they are nowhere near as bright as daylight. So while ISO 100-speed film might be useful for a daytime game, ISO 800-1600 is more often used at nighttime events. This is also a situation in which many pros opt for the wide exposure latitude of negative film over the precision of transparency film.

This compromise between quality and film speed is evident in all types of image-making. At times, the photographer can place the camera on a tripod and use slow film for the highest-possible quality, as long as the subject is not moving. At other times, holding the camera in the hand and following a moving subject might call for a faster film to keep the *shutter speed* (the amount of time the film is exposed to light) high enough for a good result.

Traditional Formats and the Cameras That Use Them

Film cameras can be divided into three major categories by the size of the negative or transparency they produce: small format or 35mm, 2.25 or medium format, and large format 4 × 5 and 8 × 10. As is often the case in photography, there are also special applications that do not fall into any of these formats, but we focus on the most common.

THE 35mm FORMAT

By far the most-common film format, 35mm is used in cameras from simple point-and-shoot cameras for amateurs to the most highly sophisticated of professional instruments. This film format was derived from movie film and still carries the distinctive sprocket holes along its edges. The size of the image area is 24 × 35mm or about 1 × 1.5 in. The *aspect ratio* (mathematical relationship of one dimension to the other) is 2 × 3, and print sizes have evolved to accommodate this, thus 4 × 6 rather than 4 × 5 is the common size at your local one-hour lab.

High-end 35mm cameras are among the most sophisticated image-making devices in existence today. They are literally picture-taking computers with auto focus, auto exposure, and high-speed motor drives to advance the film. In addition, the range of optics available for this format is unsurpassed. This range encompasses ultrawide-angle lenses, which can include the feet of the photographer in the image, to *ultratelephoto lenses* (usually defined as lenses longer than 300mm), which bring the space shuttle onto the pages of our newspapers with startling clarity. Most of the images we see of sports and news come from these cameras.

The most common type of professional 35mm camera is the SLR or single-lens reflex. It may seem strange to refer to a camera that can accept such a wide variety of optics as a "single-lens reflex," but the

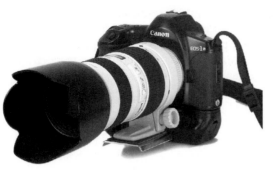

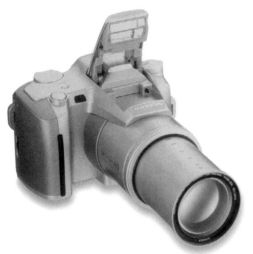

Left: This is a professional-level 35mm SLR (single-lens reflex) with a 70-200mm zoom lens mounted. Professional and advanced-amateur photographers use cameras such as this for a wide variety of imaging tasks.

Below: These are typical, consumer, point-and-shoot 35mm cameras. Equipped with zoom lenses and built-in flash, they are great, all-around, picture-taking instruments and are widely used by amateur photographers.

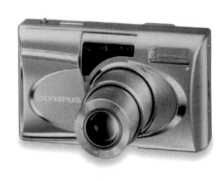

term reflects the way the photographer sees through the same lens that makes the final image. "Reflex cameras" are so called because of the mirror in the optical path that reflects the image to a screen, allowing the photographer to see what is to be photographed. There are two types of reflex cameras — single and twin lens. In a twin-lens camera (mostly seen in medium format), the photographer views through one lens and takes the picture through another lens that opens into the film chamber. A single-lens reflex uses a moving mirror that flips up out of the way to allow light to reach the film. Single-lens reflex cameras have emerged as the most popular camera type although makers still offer twin-lens models.

MEDIUM FORMAT

Medium format or roll-film cameras fall between the 35mm cameras and large formats, and are the workhorses of the photographic industry. They offer much of the mobility of the 35mm and much of the image quality of the larger formats. The film used in these cameras has no sprocket holes and comes on plastic spools sandwiched with lightproof paper. The image area is 6 cm or about 2.25 in. by however wide the camera builder wants to make it. Over time some common formats have developed. In order of size, they are 6 × 4.5, 6 × 6, 6 × 7, 6 × 8, 6 × 9, 6 × 12, and 6 × 18.

The first three sizes are most common, as each offers characteristics useful to the professional photographer. Both 6 × 4.5 and 6 × 7 offer the advantage of nearly perfect proportion to popular print sizes, such as 8 × 10 or 20 × 24, and because of this are often found in portrait studios. An additional advantage of the smaller of the two is that more shots may be made on a roll of film. The larger size allows for easier retouching on the negative and an increase in quality. (*Retouching* is a process by which artists make changes to a physical negative or print using dies and tiny brushes to remove blemishes and repair damage.) The 6 × 6 format offers the advantage of not needing to rotate the camera to change from vertical to horizontal, which can be important in the fast-paced world of the wedding shooter. It also gives an art director much leeway in how the image is presented in an ad.

The remaining formats are more specialized, becoming more panoramic as we go up the size ladder. The 6 × 18 format, for instance, works well for billboards and other ultrawide applications.

Most of the cameras in this category are SLRs, although at least one manufacturer still makes a twin-lens camera. Usually these cameras are designed as a system with interchangeable lenses, viewfinders, and film magazines or backs. Interchangeable film backs allow changing film types in the middle of a roll when warranted. Viewfinders range from simple, look-down, waist-level shades to sophisticated prism-type finders with built-in exposure meters. This system approach allows the photographer to configure the camera, as needed, for the job at hand.

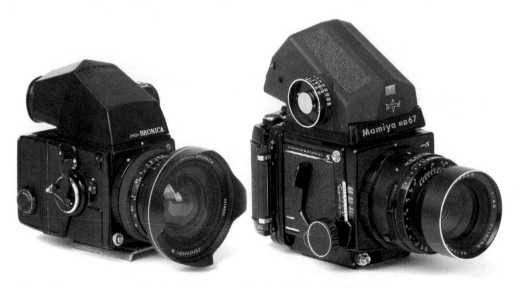

Shown here are two medium-format cameras. On the left is a square-format Bronica 6 × 6, and on the right is a 6 × 7-format Mamiya RB67. This larger camera is often referred to as an "ideal format camera" because almost no cropping of the negative is needed when making 8 × 10-format prints.

THE 4 × 5 FORMAT

This is the entry into what is known as "large format." Several types of cameras use 4 × 5 film, and at one time it was almost universal in the professional ranks. If you have ever seen an old movie from the 40s or 50s that shows a press photographer, the camera was almost certainly a Speed Graphic, usually with an attached flash gun using large flashbulbs. These rigs were the accepted norm for news photographers, even though they were heavy and slow to use.

The 4 × 5 film comes in sheets that must be loaded into film holders in the dark. Each holder carries two sheets of film and must be removed from the camera, turned over, and reinserted between shots. Additionally a dark slide must be removed prior to exposing the film and replaced thereafter.

Another type of camera that uses this type of film is known as the "view camera." Placed firmly on a sturdy tripod with the photographer hidden under a dark cloth, this type of camera harkens back to the earliest days of photography. The reason we include it here is that it is still very much in use today and is among the most-precise imagemakers available.

Much of the advertising and catalog photography as well as most of the architectural photographs made today are shot with these view cameras. Their ability to change the relationship of the lens plane and film plane allow corrections in perspective and control over *depth of field* (the zone of sharp focus) impossible to achieve with fixed or rigid cameras. Photographs made with the camera tilted up or down, to

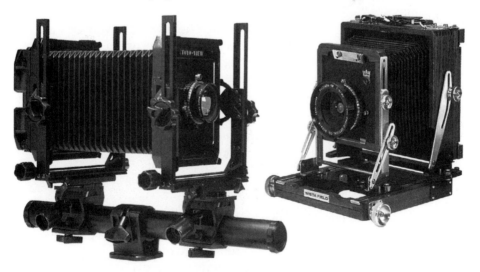

These large-format cameras use 4 × 5-inch film. On the left is a monorail view camera, so called because it is constructed on a single rail. On the right is a folding-field camera. These cameras are often made of wood and are fine examples of the cabinetmaker's art. They are constructed so that they can fold to a compact size, and are often used by landscape photographers and in other situations where size and weight are important considerations. Except for size, the cameras described in the next section are very similar to these.

This image shows several different film formats. They were arranged on a light table and shot with a digital camera.

accommodate the subject, alter the natural perspective. Because the film plane is not parallel to the subject, objects such as buildings look like they are falling over. The camera must be elevated to a point where it need not be tilted up, or the adjustability of the view camera must be used to allow the straight lines to remain straight. (This concept is covered in more depth in Chapter 6: Composition.) The fact that they are cumbersome and slow to use is not a factor in this type of image-making, and the large piece of film provides superb quality.

THE 8 × 10 FORMAT

The largest film size in common use is 8 × 10. Most of what was said about 4 × 5 applies here, as well. The expense of this large format, coupled with the increasing sophistication of scanners and the printing process, has reduced its popularity substantially. It still sees use by professional photographers, but is being overcome by 4 × 5 and digital imaging as factors other than ultimate quality become more important.

In the past, much jewelry, automobile, and furniture photography was done on 8 × 10 and even larger film.

Summary

As we have seen, film and the cameras that use it cover a wide and varied spectrum in the craft of photography. Each photographic specialty has evolved instruments to make the job easier or more precise. Film manufacturers have supplied a wide variety of emulsions, each tailored to a specific job. Photographers have chosen from this panoply of technology and have evolved uses that the camera builders and filmmakers never imagined. Bending the rules helps in the evolutionary process, as when a new use is discovered or defined, the industry makes products to support it.

Digital Cameras

Before we begin discussing the technical aspects of digital cameras and delve into topics like megapixels, image resolution, and appropriate file formats, it is a good idea to take a somewhat broader look at digital cameras. In many ways, digital cameras are having a social effect beyond their obvious ability to record pictures. After all, cameras have been around a long time, and, as we discussed in the first chapter, digital cameras function in much the same way as do film cameras.

The Impact of Digital Cameras

From a picture-taking standpoint, the "box" you use isn't — or shouldn't be — nearly as important as your creative ability and compositional skills. Once a picture is taken, it's next to impossible for a person (or a mass audience) to tell exactly how you took that Pulitzer-prize-winning shot. Nor does it matter much. The lens, the film speed, the light readings, the aperture settings, and whether the image was recorded on film or on a digital array are all really irrelevant. Only professionals (or serious amateurs) care one iota about the technical aspects of images that inspire or inform them. Great pictures evoke emotion; ISO speeds and film granularity do not.

AMATEUR PHOTOGRAPHERS

One can argue that the biggest impact of digital photography is what it means to the general public. While technology and productivity issues are critically important to professional photographers, that's not where digital imaging is changing the world. Professionals certainly spend a great deal of money on digital technology per capita, but the amount pales in comparison to the dollars being spent by individual consumers. Think about it — how many people do you know that have spent money on digital cameras? It seems as if almost every personal computer user either already has one or intends to buy one in the near future.

Amateur photographers fall into two broad categories. The first category includes the people who take pictures only when they go on vacation, those who record every moment of their children's developmental years, those who take pictures of their

watch-key collections, and some who just take pictures of their dogs playing in the snow. These people can be broadly defined as casual consumers.

The second category is comprised of the amateurs who are very serious about their art; they study, read, practice, spend (and spend more), and are essentially the same as professional photographers except that they don't make a living in photography. Their needs and interests are more focused on the technical; the equipment and technology are at least as much fun (or as important) for them as framing the perfect picture.

PROFESSIONAL PHOTOGRAPHERS

Digital cameras began to have an impact on real-world professional imaging about six or seven years ago. Early examples, such as Kodak's DCS series, entered the market at the outrageous price of $30,000.00, and, even at that price, some photographers saw the potential and spent the money. The ability to shoot and have the images available immediately became the new business model for many commercial studios in the fast-paced world of advertising and fashion. These early adopters paved the way for new development and more sophisticated technology, so that cameras today deliver better image quality, faster, and at a fraction of the original price.

Today digital cameras are exploding onto the marketplace. They are the hot product in the photo industry at the amateur level as well as in the professional ranks. Starting at about $200, point-and-shoot digital cameras compete quite well with 35mm-film cameras for the consumer dollar. While many of these low-cost units cannot equal the image quality of 35mm film, the difference is often not apparent. This is particularly true when printing the 4 × 6 images that are the mainstay of the amateur photofinishing market.

The continued development of the technology has made possible great strides in image quality at the professional level. Many studios have now converted entirely to digital capture, and the rest are including digital imaging in their workflow at some point, even if only in retouching and printing. Photographs that traditionally were the province of large-format film are now routinely made on digital cameras.

Technology

Digital technology is changing so rapidly that there may well be developments even as this book goes to press. At present there are three main types of digital still cameras — one-shot, multishot, and scanning — using two different types of digital sensors (CCD and CMOS). Each has its strengths and weaknesses. Understanding the advantages and disadvantages may help you make an informed buying decision when you are ready.

ONE-SHOT CAMERAS

Cameras using one-shot technology feel most like film cameras when making images. All of the normal activities associated with film-based photography come into play, with the exception of loading and unloading the film. Instead of film, these cameras save their images onto various types of digital media, such as compact flash cards (including IBM's Micro Drive), memory sticks (from Sony), *smart media* (a type of intelligent data-card device), and even compact CDs (one example of this strategy are 3-in. CDs that hold about 156MB of information; specifications vary by manufacturer). The primary advantage to this system is the ability to capture moving subjects in color.

All digital sensors image in grayscale. Color is created by combining three grayscale images made through red, green, and blue filters. In one-shot cameras, these filters are built into the imaging chip. The filters are arranged in a grid pattern and processed by the camera to create a digital (RGB) file.

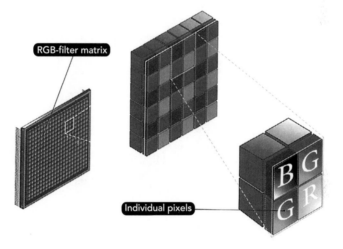

This graphic shows a typical imaging chip. The pixels are laid out in a grid pattern and are covered with colored filters. Because our eyes are most sensitive to the color green, green filters slightly outnumber both red and blue. The final image is built from the combined data at each pixel position.

As light hits each individual sensor (equal to a single pixel) on the chip, it is converted to an electrical signal and then to a digital value by a device called an "analog-to-digital converter." The processor in the camera stitches these individual pixels together to form the image. It's then written to the internal media in one of several common formats (which we talk about a little later in this chapter). From there, it can be viewed, printed, downloaded, and saved to a computer, or erased.

All of this takes place for each image captured. It is this for this reason that many lower-end cameras may take some time to be ready to shoot the next image. The time each camera requires to be ready to

make the next exposure is referred to as the "burst rate," and expensive cameras can often shoot more quickly than less expensive models.

MULTISHOT CAMERAS

Multishot cameras represent an earlier solution to color capture with digital cameras. Using the same theory as the earliest film cameras to capture color images on black-and-white film, the image is exposed three times — once each through red, green, and blue filters. The resulting images are combined to reproduce the colors visible at the time of exposure. Because all of the sensors capture data from each exposure, the final image from this type of camera often has superior color and accuracy. The main drawback is that the subject and the camera must not move between shots if a natural-looking image is the desired result. This makes it impossible to photograph anything that moves or is alive.

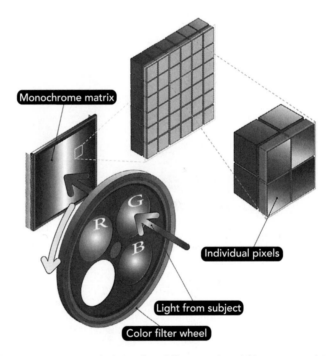

Monochrome matrix

Individual pixels

Light from subject

Color filter wheel

Three exposures, each through a different colored filter, are combined to make the full-color image. The multiexposure nature of this type of camera means that it must be used with stationary subjects.

Much photography, however, is of objects that aren't moving at all. Product photography, for example, is a prime example of imagery that's done under controlled conditions. You can even make a studio of your own, by draping a dark or light blanket over a couch, and placing the object on the improvised background.

Most often these units come as attachable backs for medium- and large-format cameras. They replace the removable film back used with these cameras, allowing the camera to be used for either film or digital capture. (A *camera back* is a device that hooks onto the back of a standard camera to convert it into a digital system.)

SCANNING CAMERAS

At present the scanning, digital camera back, usually mounted on conventional medium-format or 4 × 5 camera bodies, represents the highest resolution and quality available. This marriage of a high-resolution scanner and a large-format camera can make files measured in hundreds of megabytes. Many cameras of this type can also capture images at a bit depth greater than 8 bit, resulting in more levels of tone in each channel (8-bit = 256 levels of tone and 16-bit = 60,000 levels of tone). These cameras can record more information than film, making them the highest-quality image-recording devices available. Of course everything has its drawbacks, and in this case, the fact that the camera and the subject must remain still for the extended time it takes to make an exposure limits the usefulness of this technology. But landscape photographers and those who need to reproduce artwork with a high degree of accuracy are using the technology.

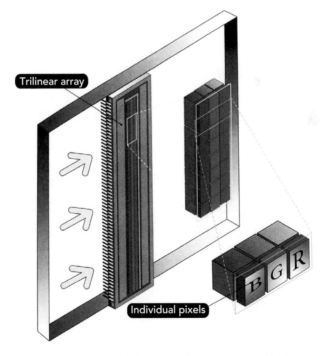

Scanning cameras move the light-sensitive array across the image area. These cameras can capture incredible detail and color but are slow to use and make exposures measured in minutes.

(*Bit depth* is a calculation of how much data is being recorded or stored in an image. An eight-bit image contains only 256 shades of gray — hardly enough information for a decent black-and-white photograph. Most digital cameras record 12-bit or more images. They can contain billions of colors.)

CCD VS. CMOS IMAGE SENSORS

CCD, or *charge-coupled device,* and CMOS, or *complementary metal oxide semiconductor,* are the two image sensors most commonly found in today's digital cameras. At the time of this printing, CCD sensors, which were designed from the beginning to capture images, are the accepted quality standard. CMOS sensors, which are adapted from the more mainstream, semiconductor-manufacturing processes, can be made more cost effectively and use much less power, making less heat in the course of doing their job. Heat is a major problem in digital imaging as hot sensors add noise to the image, degrading quality. The quality of images captured on CMOS chips has recently reached that of CCD-based cameras in several pro-level cameras. CCD is a well-understood and mature process, while CMOS is just now beginning to come into its own. All we can be sure of is that both technologies will be refined and upgraded to create cameras we can only dream about today. For additional information on these technologies refer to http://www.kodak.com/US/en/corp/researchDevelopment/technology Features/cmos.shtml

Types of Digital Cameras

Digital cameras do away with the cost of film and attendant processing requirements. They also allow image previewing, so that many photographers print just the images they like, rather than a whole roll for one or two images. Since many if not most point-and-shoot photographers neglect or discard their negatives, keeping only the prints from the one-hour lab, perhaps a new workflow will emerge — one where the removable media will be taken to the one-hour lab, printed, erased, and returned to the customer. While this presents an almost-frightening loss to serious photographers, for many it would be just fine.

More-serious photographers will utilize their personal computers to save, edit, modify, and print their own digital images, just as photo hobbyists have set up their own darkrooms in the past. An added advantage is the lessening of the environmental impact of photography. The chemicals used in the manufacture and processing of conventional images are, for the most part, damaging to the environment. Although labs in the US have solved the problem with strict controls, the advent of digital imaging will reduce the amount of film processed.

Speed of turnaround is another consideration. Digital images can be shot, edited, and printed in very little time, when necessary. This is an advantage of note in today's fast-paced world.

There are four major categories of digital cameras: point-and-shoot, high-end consumer/prosumer, digital SLR, and studio cameras. Each has its own capabilities, as well as advantages and some disadvantages.

POINT-AND-SHOOT CAMERAS

At the entry level of both digital and film cameras are the point-and-shoot cameras. Designed to be simple to operate and easy to transport, these cameras can be found in the hands of a wide variety of picture-takers. From recording a child's birthday party to casual artistic image-making, this type of camera seems well represented.

All of the major manufacturers, including Kodak, Fuji, Olympus, Nikon, and Canon, have offerings in this category. Several companies more often thought of as makers of computer peripherals, like Epson and Hewlett-Packard, also offer similar devices.

These examples of point-and-shoot digital cameras look much like their film-based cousins.

Items to consider when choosing a camera in this category include: resolution, lens focal length and quality, shutter lag time, burst rate, ISO equivalents, file formats and compression, and storage capacity.

- Resolution is expressed in *megapixels*, each of which contains about one million pixels. As a general rule of thumb, the higher the megapixel rating, the larger the file can be printed.

- Lens focal length — whether a lens is a wide-angle (short) or telephoto (long) (explained more fully in Chapter 3: Auxiliary Equipment) — is usually expressed as the equivalent 35mm focal length. Most digital cameras use a sensor smaller than 35mm film, so the actual numbers are difficult to understand. The 35mm equivalent figures, however, are easy to work with because more people have experience using similar lenses on their own cameras.

 The higher the megapixel rating, the larger the file can be printed.

- Lens quality is more difficult to quantify. Better lenses are often made from exotic glass formulas that allow very precise control over the light that will make the image. This precision is not

required of a system designed to make small prints, as the improvement is only noticeable at high magnification. One way to lower the cost of a new camera is to use a less-expensive optical system. When all other features are the same, the more expensive camera often has a better lens.

- Shutter lag has been an ongoing problem, especially with lower-end, point-and-shoot cameras. Due to the complex computations needed to capture an image digitally, cameras with less powerful CPUs can have a significant delay between the press of the shutter button and making the exposure. This can have an effect on the final photograph when you're trying to capture fleeting moments.

- Burst rate is also dependent on the capabilities of the camera's CPU. Some cameras need several seconds between individual exposures while others might be able to shoot several frames in a row before their internal buffer is full.

- ISO equivalents correspond to film speeds in traditional photography. Generally, the lower the ISO number, the higher the quality of the file. Higher ISO numbers allow you to make images under unfavorable lighting conditions and when high shutter speed is more important than ultimate quality.

> Generally, the lower the ISO number, the higher the quality of the file. Higher ISO numbers allow you to make images under unfavorable lighting conditions and when high shutter speed is more important than ultimate quality.

- File formats are most often JPEG, TIFF, or RAW (see File Formats later in this chapter for more detail). Most point-and-shoot cameras allow for different levels of JPEG compression and resulting file size. High compression and smaller files allow many images to fit on the chosen storage media. Larger files with less compression take up more room on the media but result in higher-quality final prints.

- Most cameras have media slots for one or several types of storage media. These can be compact flash, smart media, memory sticks, and others. They come in many sizes expressed, usually, in megabytes or gigabytes. The larger the card, the more images it holds and the more it costs. IBM makes a hard drive the size of a compact flash card. It comes in capacities ranging from 340MB up to 1GB. Cards in development may increase storage to 8GB or more.

Other features, such as movie mode and bundled software that enables you to stitch several images together, might also be useful, depending on what you intend to do with the camera.

HIGH-END CONSUMER/PROSUMER CAMERAS

A step above the point-and-shoot category are the so-called "high-end" and "prosumer" cameras. These are sophisticated image-making machines with high-resolution imaging chips and high-quality lenses. Several of the cameras in this class offer accessory lenses to extend the range of focal length. Some offer through-the-lens viewing and high burst rates as well as higher megapixel ratings (up to 5 megapixels in some cases). Through-the-lens viewing allows the photographer more precision in subject placement than the off-center viewfinder found on some cameras. An on-going debate among image-makers regarding this issue rages around whether a through-the-lens system that uses a video screen is better than an optical viewfinder with its off-center view. At present, the more-experienced image-makers seem to be in favor of an optical system, primarily because of the jerky motion inherent in a video-based system. Canon, Olympus, Minolta, and Nikon have offerings in the prosumer class.

> Prosumer cameras are sophisticated image-making machines with high-resolution imaging chips and high-quality lenses.

The Olympus E-20 is a prosumer noninterchangable-lens SLR. It creates 5-megapixel files that are suitable for some professional applications.

As the word *prosumer* suggests, these cameras often show up in the hands of advanced amateur photographers and help to bridge the gap for pros trying to decide whether or not digital imaging will fit into their workflow.

These machines produce images of good enough quality that they can be reproduced as 11 × 14 prints, and sometimes even larger.

DIGITAL SLR CAMERAS

Recent developments in this class of cameras have seen the price of interchangeable-lens SLRs (single-lens reflex cameras) come down to the point that most professional photographers can afford to own

one. Offering all of the features found on the equivalent film cameras, these are formidable picture-taking machines. Several manufacturers have more than one offering in this class. These can be optimized to perform specific tasks, such as sports and fashion shots, with their need for high speed as well as high quality, or can be made more affordable while maintaining the highest-possible image quality.

Most of the cameras in this category use larger image sensors than the point-and-shoot or prosumer cameras. Even so, they are not the same size as the image area of a 35mm frame. This smaller image area causes the effective focal length of each lens to be extended by about 1.6x. This multiplication factor is useful when telephoto images are

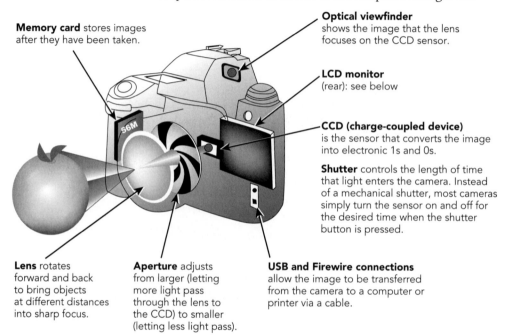

Memory card stores images after they have been taken.

Optical viewfinder shows the image that the lens focuses on the CCD sensor.

LCD monitor (rear): see below

CCD (charge-coupled device) is the sensor that converts the image into electronic 1s and 0s.

Shutter controls the length of time that light enters the camera. Instead of a mechanical shutter, most cameras simply turn the sensor on and off for the desired time when the shutter button is pressed.

Lens rotates forward and back to bring objects at different distances into sharp focus.

Aperture adjusts from larger (letting more light pass through the lens to the CCD) to smaller (letting less light pass).

USB and Firewire connections allow the image to be transferred from the camera to a computer or printer via a cable.

Data-display panel shows various camera settings, such as f-stop, shutter speed, exposure mode, and flash settings.

LCD monitor lets you frame, focus, and then evaluate pictures you have just taken. Some models permit evaluation only after taking the picture.

Jog dial on some models changes ISO rating, file size, compression levels, and other picture variables. Settings are visible on the LCD monitor or data-display panel, depending on the model.

Slot for memory card

the order of the day, but much less so when wide-angle optics are needed. (*Telephoto lenses* magnify the scene being photographed.) Most lens makers have added ultrawide lenses, some as wide as 14mm, in recent years, so traditional wide-angle photography is still possible.

Nikon, Canon, and Kodak are the leaders in this class, as we write this book, with Minolta, Contax, and Sigma all coming to market with new offerings. Kodak and Canon have just announced new cameras with full-size image sensors (no multiplication factor) and incredibly high megapixel ratings (approximately 11.1 megapixels), promising huge enlargements with excellent detail.

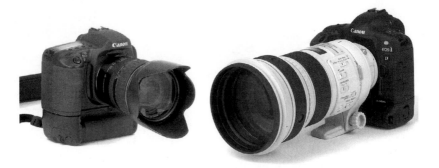

On the left is a Canon 10D with a 28-135mm lens; on the right is a 1D, also from Canon, with a 300mm f2.8 lens. These digital SLRs are formidable imaging machines.

STUDIO AND PROFESSIONAL CAMERAS

Medium- and large-format cameras have been the mainstay of the professional photographer for many years. These cameras have evolved into camera systems with a wide variety of accessories, such as interchangeable lenses, viewfinders, and film backs, to aid the pro in doing the job. As digital imaging began to make itself felt, it was only natural that digital backs for these existing systems would be developed. (A *viewfinder* is the part of the camera you look through to see the scene.)

Studio systems were designed for view cameras that incorporated live video viewing and elaborate software packages to aid the still-life and catalog specialists. These photographers were targeted as early adopters because of their very high production costs for film and processing. Sales reps could easily show a prospective buyer how the new system could be amortized quickly with these savings alone.

Backs for medium-format cameras have recently been introduced that create very large files — as large as 48MB in the case of the Kodak Pro Back. The Pro Back can operate as a *tethered camera* (hard-wired to the host computer), writing its data directly to the computer's hard drive, or completely untethered, allowing the photographer the

freedom to work on location while still bringing back large files. Other makers, such as Sinar, Leaf, Imacon, and Phase One, also have offerings in this category.

Recently, reduced-size view cameras have been introduced that are more closely compatible with the size of the digital chips contained in these backs. These smaller and lighter cameras are an elegant response to the new technology.

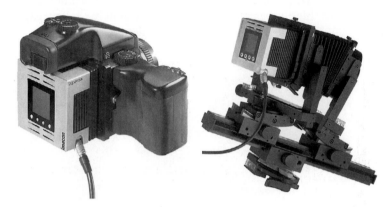

A digital back attached to a medium-format camera body and the same back attached to a view camera. The modular nature of this combination allows great versatility and the use of film, when needed.

File Formats

Digital cameras are not the first instruments to produce digital images. Scanners have been around much longer, and file formats have evolved to make dealing with digital pictures easier and to permit cross-platform use. Two formats that have seen near universal acceptance are TIFF, or Tagged Image File Format, and JPEG, which stands for "Joint Photographic Experts Group." Along with these, each camera maker has developed a proprietary format to capture the raw data produced by the image sensor. Most often these are listed as "RAW" files, although some have additional names. *RAW* is a format adopted by most camera manufacturers and is now supported directly as a file format by Adobe's Photoshop.

JPEG

JPEG is a file-compression system developed by a committee of experts in the photographic field. It is a *lossy compression system*, which means that some data is lost each time the image is compressed. The format is extremely popular — arguably the worldwide standard — when putting photographic images on the Web. Many digital cameras offer several levels of JPEG compression, allowing the photographer to decide between image size and quality according to the needs of the specific job.

TIFF

Tiff files are probably the single most-used format in publishing and digital photography — especially when used at their original size and resolution, and printed (as opposed to being published on the Internet). They are cross-platform compatible, and can be used within all the industrial-strength page-layout packages. They can also be compressed using several different methods that are available when you save them.

RAW

In general, the more tones that can be captured, the higher the potential quality of the file. The larger the number of bits, the more information is saved in the file. The information saved includes detailed color information, including many levels of tones that can be reproduced, potentially up to billions of colors

RAW files represent all of the data collected by the imaging chip at the time of exposure. Usually this data is higher than 8-bit — sometimes as much as 16-bit, but more often 10-, 12-, or 14-bit. All files larger than 8-bit are treated as 16-bit, even though they may have fewer actual bits of information.

This means that RAW data files may be processed much like a digital version of film. Like film, this RAW data may be pushed to reveal greater detail in the shadows or pulled to hold detail in the highlights. *White balance* (correcting the color to compensate for different color temperatures of light) can be changed to any of the preset values available on the camera or customized by selecting an area to be white within the file. The resulting file is distinct and separate from the original RAW file, allowing wide-tonal-range images to be composited from several versions, all derived from the same RAW data. So even if the image was made under tungsten light with the camera set for daylight, the RAW file can be reprocessed to correct the color with no quality loss. As can be seen, even though they take up more room on whatever media a camera might use, they more than make up for that with increased quality potential.

Summary

We have touched on the several types of digital cameras currently available as well as the technology used to produce digital images. Point-and-shoot, prosumer, digital SLR, and pro-level studio cameras are constantly under development, and changes will be rapid and quite possibly dramatic in the near future. Probably the traditional file formats will be with us into the foreseeable future, but anything can, and often does, happen in this dynamic arena. Constant reading of industry periodicals dedicated to digital imaging is necessary to keep up with the changes.

Auxiliary Equipment

Although the camera may be the primary item of photographic equipment, it is by no means the only one used in the production of good photographs. The skilled photographer also considers such items as lenses, camera supports, and light-modification devices. When working with digital capture, computer hardware and software are also part of creating the final image. In this chapter, we explore some of this necessary but often-overlooked equipment, and see how it relates to the making of fine images.

Lenses

The lens is the heart of any imaging system, and good quality is a requirement for producing excellent images. In recent years, due to the advent of computer-aided design and manufacture, many very high-quality lenses have found their way into the market. It is now quite possible to design a lens that can produce high-quality images while keeping the costs of production low enough to allow that lens to be used on an inexpensive, point-and-shoot camera. At the same time, advanced design and production techniques allow manufacturers to produce lenses with capabilities unheard of in the past.

Features such as auto focus and *image stabilization* (a technology that allows hand-holding of long lenses at relatively slow shutter speeds), along with large maximum apertures enable today's photographers to capture a higher percentage of technically excellent images. This can free the image-maker to be creative and attempt things not tried before.

As your ability and skill improve, the need to use interchangeable lenses is no longer merely an option; if you can't change lenses to meet specific conditions and requirements, you won't be able to take the kinds of pictures you'll want (or need) to take. It would be easy to devote an entire book to how lenses work and how to match the correct lens to the requirements of the image you want to create. For now, however, let's look at the three most important characteristics of interchangeable lenses.

FOCUS

It's easy to see when an image isn't in focus; edges that should be sharp are blurry, and the overall image lacks clarity. In worst-case scenarios, you can't make out any detail at all. The shape of a lens, the distance between the subject and the lens, and the distance between the lens and the recording component all have impact on focus.

The first term you might hear relative to focus and lenses is "focal length." The *focal length* of a lens indicates its magnification power. The farther an object moves away from the lens, the smaller it appears when the light hits the recording component.

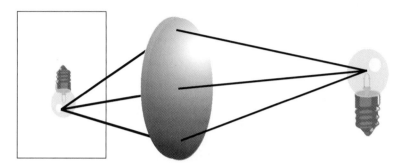

Film/Capture Element **Lens** **Subject Matter**

The closer the subject comes to the lens, the larger the image appears on the recording component.

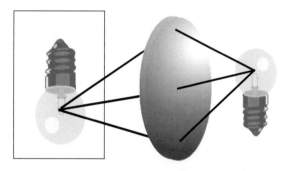

Film/Capture Element **Lens** **Subject Matter**

A telephoto lens, for example, has a focal length to accommodate subjects that are very far away — such as a mountain range or a close-up shot of a player's face during an important football game. Special types of telephoto lenses (known as "macro lenses") are also used to enlarge small subjects — a capability often called for in product photography, and particularly in nature photography. There, tiny subjects are often the stars of the show, and must be enlarged considerably to make them visible to the human eye.

Focal length, therefore, is a function of the shape of the lens, and the distance between the front of the lens and the recording surface. If you move an object too close for a lens' focal length, the object isn't correctly focused in the final image and becomes blurry.

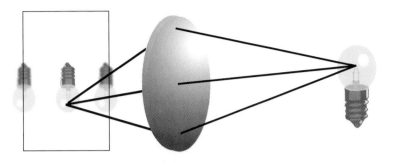

Film/Capture Element	Lens	Subject Matter

For doing close-up work, most nature and wildlife photographers either use special lens accessories called "extensions," or purchase macro lenses (specialized close-up lenses).

For general purposes, you will be able to capture just about anything you might come across if you own three or four lenses. For pictures of people, general photography, and any subject you want to capture at life-size, you can use a 50mm lens. (The focal length of a lens is measured in millimeters.) It's a great, all-around, general-purpose lens. Next, you'll want to purchase a good-quality zoom lens. A *zoom lens* features a sliding ring that lets you visually move closer to or farther away from the subject. A good one to buy would be an 80-200mm. This lens lets you take close-up images (within a few feet or so, not pictures of spiders eyeing a meal that just happened into the web), as well as close-ups of distant subjects. At 200mm, a telephoto lens acts rather like a telescope, allowing you to see detail not visible with the naked eye.

Finally, you might consider a 28mm lens, known as a "wide-angle lens." At their smallest sizes, wide-angle lenses take images that look like they were taken through the big, round eye of a fish (they're also called "fisheye lenses"). At 28mm, they're perfect for pictures of the sunrise or sunset, vacation vistas, landscape images, large crowds, sporting events, and other situations where you need to include as much of what's visible as possible. Another common use for 28mm lenses is interior shots of homes and businesses.

F/STOPS AND LENS SPEED

Another factor to consider in purchasing or deciding to use a specific lens is its relative speed. This measurement indicates how much light the lens is capable of gathering. Some lenses are much faster than

others. Speed is determined by dividing the length of the lens by the maximum diameter of the open aperture. Therefore a 50mm lens with a front diameter of 25mm would be considered a 50mm/f2.0 lens (50mm divided by 25mm is 2.0). Make the front diameter of the lens 35mm, and the aperture is reduced to f1.4 (50mm divided by 35mm = 1.4). The larger this opening, the "faster" the lens is said to be. That's because a larger front diameter results in more light being captured during the time the shutter is open. Faster lenses are more expensive than slower lenses, but under many conditions perform better because they work better in limited lighting conditions.

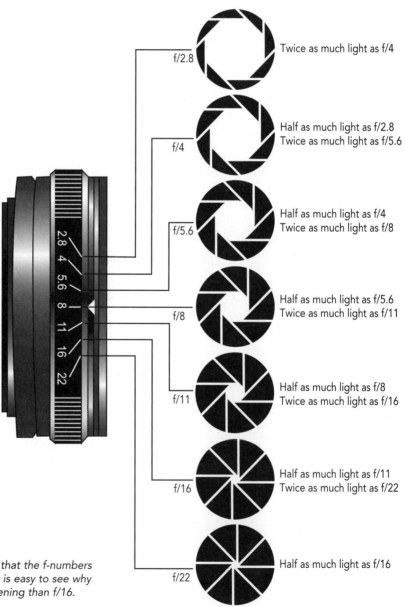

f/2.8 — Twice as much light as f/4

f/4 — Half as much light as f/2.8 / Twice as much light as f/5.6

f/5.6 — Half as much light as f/4 / Twice as much light as f/8

f/8 — Half as much light as f/5.6 / Twice as much light as f/11

f/11 — Half as much light as f/8 / Twice as much light as f/16

f/16 — Half as much light as f/11 / Twice as much light as f/22

f/22 — Half as much light as f/16

If you remember that the f-numbers are reciprocals, it is easy to see why f/4 is a larger opening than f/16.

There are drawbacks to very fast lenses, though — cost, size, and weight. As you increase the diameter of the front of the lens, it gets heavier. Using faster-speed films can somewhat compensate, allowing for increased light-gathering without the added weight and cost.

Each f-stop allows twice as much light as its next smaller neighbor.

The lens *aperture* is an opening created by a collection of leaflike structures that swing outward or inward, controlling the amount of light allowed to enter the camera. Correct exposure is arrived at through a combination of aperture and *shutter speed* (how long light is allowed to enter the camera).

The f-stop setting is a critical consideration when taking pictures. In particular, the setting controls what's called "depth of field." *Depth of field* defines how clearly focused the background and foreground in front of the subject appear in the final image. When you use a very low setting for your f-stop, let's say f/16 or f/22, only a small amount of light is allowed to strike the recording element. To compensate for this, photographers often select a slower shutter speed, and the result is less light but for a much longer period of time. This sharpens the background, and reduces blur on portions of an object that aren't on the same plane.

TYPES OF LENSES

Today's image-makers offer a wide choice of lenses. Most are very good optically, and modern technology has allowed lens designers to build amazing capabilities into some of the most recent lenses. Some basic terms and lens types follow, by no means a comprehensive list, but a start.

- **Fixed (noninterchangeable) lenses**. Permanently attached to the camera body and designed as part of the camera, these fixed lenses can be made inexpensively and still be of good to excellent quality. Most often cameras with these lenses use slightly wide-angle focal lengths and are very useful as *snapshot cameras,* recording day-to-day life as a series of small prints. Several makers have taken this type of camera to a very high level, by fitting high-quality, large-aperture, fixed (noninterchangeable) lenses, which make pro-level images and large prints possible within the limitations of one focal length.

- **Fixed zoom lenses**. Generally found on slightly more expensive point-and-shoot cameras as well as on some prosumer models, these permanently affixed lenses offer the photographer some optical versatility. *Zooming*, or changing the focal length from moderately wide-angle to medium-telephoto, these lenses can be used to make a wide variety of images, with some achieving up to 10× zoom ratios, (for example 28-280mm). The main limitation

of these optics is that the maximum aperture is not as large as many situations call for. When the light is adequate, however, high-quality images can be made with these lenses.

- **Digital zoom**. In the digital arena, zoom range is often enhanced via digital zoom. This can create quality issues as, instead of optically changing the focal length of the lens, the camera crops into the live area of the image sensor to achieve a tighter look at the subject. This cropping means that fewer pixels are used to form the image, resulting in a lower-quality image than if all of the sensor area were used.

- **Interchangeable lenses**. Found on most high-quality 35mm, medium-format, and large-format cameras, a system of interchangeable lenses allows the photographer the freedom to choose the optimum lens for the job at hand. The sky is the limit here — in price, quality, and types of equipment available — as befits professional systems. Everything from ultrawide and fisheye optics to the ultratelephoto lenses, seen along the sidelines at sporting events, is available to the image-maker, limited only by the size of the equipment budget. That budget needs to be a large one, in many cases, as a 400mm f2.8 ultratelephoto lens with image stabilization will burn an $8,000.00 hole in the photographer's wallet.

> A system of interchangeable lenses allows the photographer the freedom to choose the optimum lens for the job at hand.

A small sample of the vast array of quality optics available to today's image-makers.

Grip Equipment

The term *grip* comes from the movie industry and refers to those whose job it is to put together the equipment that is used to light and photograph the shot. Lights must be fixed in place, light-modification equipment brought into play, and the camera set in position. The variety of equipment used in this process has become known as "grip equipment." The variety of equipment that falls into this category is vast, and on a movie or television production can fill several trucks. Still photographers usually use only a small fraction of all of this on any one job. Some of the most commonly used pieces of grip equipment are reflectors, scrims, and gobos.

REFLECTORS

Simple to understand and use, *reflectors* add light to the shadow areas. Because film cannot record the full range of tones that our constantly adjusting eyes can see, and even the best press systems can't even reproduce all that film can record, it falls to the photographer to adjust the tonality of each scene so that the important tones fall into the four f-stop range that can be reproduced. (Any four f-stop range will produce a reproducible image.) Adding light to the shadows helps to accomplish this by compressing the contrast of the scene.

Reflectors can be as simple as a piece of white board or fabric. They can also be more reflective silver or gold metallic materials when more light is required. The light quality is affected by the choice of reflector — white reflectors give a soft smooth light, while metallic reflectors create a harder, more sharply defined, light.

Photographers refer to this quality of light as "specularity." Soft wrap-around light with soft or absent shadows is nonspecular or diffuse; hard shadow edges and areas of harsh reflection are indicators of more specular light.

SCRIMS AND GOBOS

Similar to and often used in conjunction with reflectors are scrims and gobos. *Scrims* are light modifiers placed between the light source and the subject. Usually their main function is to alter the quality of the light; a secondary characteristic is that they also reduce the light's intensity. These qualities allow the photographer to control the look and feel of the image. For example, a subject facing away from the sun on a bright day would require additional light from a reflector. If the photographer wants a warm feel, a gold reflector might be used. Often in bright sunlight, however, a metallic reflector is too harsh and can be quite uncomfortable for the subject. Introducing a scrim of translucent fabric, between the reflector and the subject, both softens and reduces the light, enabling the photographer to create a well-lit and exposed image.

This image of the model Tasha shows placement of a white translucent scrim as the main light; a black gobo, to protect the lens from the light behind the scrim (notice the light-streak on the floor); and a simple, white, foam-core reflector, attached to a light stand with A-clamps.

Gobos are light modifiers designed to remove or exclude light from portions of the scene. Their name is derived from the fact that they *go between* the light and whatever needs to be protected from it. Often gobos are used to keep excess light from shining directly into the camera's lens, as when this occurs, it can cause glare and lens flare, reducing the quality of the image.

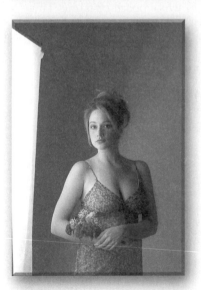

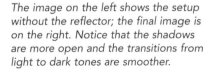

The image on the left shows the setup without the reflector; the final image is on the right. Notice that the shadows are more open and the transitions from light to dark tones are smoother.

Support Equipment

Since photographers come equipped with only two hands and the human frame is an inherently unstable platform, support equipment is essential to the process. Although the popular image of the photographer often includes a hand-held camera and an intricate dance between the image-maker and the subject, this is rarely the case. More often, when quality is paramount, the camera is mounted securely on a heavy tripod or camera stand. Camera movement during exposure has ruined more good images than any other cause.

TRIPODS AND CAMERA STANDS

A good-quality tripod allows the photographer to take advantage of the full range of shutter speeds the camera affords. Many excellent images are made at shutter speeds as slow as a quarter- or half-second. A good rule of thumb is to use a tripod whenever the shutter speed will be slower than the focal length of the lens. For example, when using a 200mm lens, most photographers should not use a shutter speed of less than 1/250th of a second. As you can see, a good tripod can allow the image-maker a lot more freedom to use the available shutter speeds, as it holds the camera steady and only subject

Baby the cat held perfectly still as these images were made. On the left, a tripod-mounted camera produced a sharp image; on the right, hand-holding the camera at a slow shutter speed showed blur in the image due to camera movement.

movement must be taken into account. Tripods fold for portability, and their three-legged stance gives solid support on virtually any surface.

> ●○ A good rule of thumb is to use a tripod whenever the shutter speed will be slower than the focal length of the lens.

Tripods come in a wide range of sizes and prices, and offer a range of features as well. Some extend to allow the camera to be placed high above normal head height. Some are very strong, allowing the use of heavy cameras and lenses. Some are made of exotic materials, like Kevlar or carbon fiber, to make them both lightweight and strong (at a premium price, to be sure).

Camera stands have evolved in the studio to make the photographer's life more efficient. Consisting of a heavy, wheeled base and a vertical post with a traveling, horizontal camera arm, they are indispensable to the busy, studio image-maker. The ability to lower the camera to floor level and raise it high off the floor, quickly and easily, saves time and

Left: Camera stands are too unwieldy for location use, but in the studio they are efficient and rock solid.

Right: A sturdy tripod can allow sharp images at slower shutter speeds.

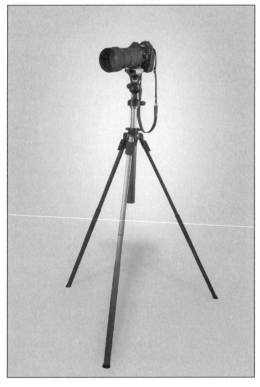

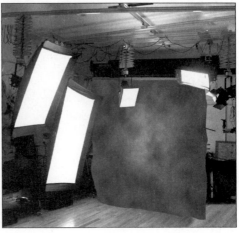

Left: A typical studio uses several types of light stands as well as background supports.

Below: The lights in this studio are mounted on tracks built directly into the ceiling.

energy. Many camera stands allow the camera to be swung away from the set, to give access to the product for adjustment, and then swung back, to make the exposure. Camera stands are large and heavy, making them hard to transport. For this reason they are almost always found only in the studio.

LIGHT STANDS AND SUPPORTS

Just as photographic light sources vary widely in size and purpose, so do the stands that are designed to support them. Tiny background stands are designed to be hidden behind portrait subjects. Large boom stands are designed to position a light above a subject while staying out of the image area. Some are lightweight and compact; others need to be larger and stronger to support heavy light sources.

Not all light supports are stands at all. Ceiling-mounted light systems allow lights to travel on overhead tracks, keeping the studio floor free from clutter and giving the photographer total freedom in light placement.

Matching Equipment to the Needs of the Shoot

It is obvious that not every photo shoot requires the same range and type of equipment. Defining the parameters of each shoot is a preliminary step in deciding what is packed and what is left in the studio.

Often photographers overpack, preferring to have it and not need it rather than risk missing a shot for lack of a piece of equipment.

Location work requires the photographer to plan ahead, with the goals of the shoot in mind as well as the physical limitations. A sports photographer working a football game would surely lug the long lenses along but most likely leave the lighting gear at home. The same photographer working a basketball game might well forego the ultratelephoto lens and pack enough lighting equipment to cover the entire court. Each assignment has its own unique needs. The only element common to all is the need for the skill and the eye of the photographer.

Summary

As you can see, the quantity and variety of equipment used by today's photographers is amazing. What we have covered here is, in reality, just a taste of what's out there for photographers to choose from. The craft is evolving as we go to press, and new and interesting equipment is offered every year. At least one manufacturer will offer a new piece of equipment designed to solve a problem we didn't even know we had, and soon we will think it is indispensable.

TAKING
GOOD PICTURES

Before you can learn about taking good pictures, you have to learn what good pictures are. This isn't as simple as it might sound. Many factors — some not so evident — come into play when you need to capture an image.

In this section, you learn about the fundamental building blocks that go into making an image that's effective, compelling, informative, or whatever combination of attributes you're looking for.

First, you learn about what it takes to generate a good image. This discussion includes taking pictures yourself, as well as how best to use commercial stock services, which provide existing images for use in your projects. Sometimes, you're best served by hiring a professional photographer — someone who has the knowledge, experience, and skill to get it right the first time. In many other situations, however, you're going to want to do your own photography. You'll have a much better grip on how to approach specific photographic requirements once you're done with this section. In fact, you'll understand most specialty fields within the broad definition of professional photography.

Once you have a feeling for the practical side of image-making, learning about lighting and composition are the next logical concepts to explore. Lighting comes in two basic "flavors": natural light, generated by the sun, moon, or stars, and artificial lighting, which is added to a scene using everything from flashes to strobes, spotlights, and track lighting. You'll discover that lighting requirements are also dictated by where the pictures are being taken — inside a building (or studio) or outside under the sky.

Finally, you explore composition, that elusive subject that tells you the best place to stand, or the perfect place to put that baby rattle when you're shooting a picture of a child. The rule of thirds, an almost inborn composition tool for a professional photographer, is covered in depth.

As in the rest of the book, we build slowly on the concepts important to effective photography. Once you have a good camera, understand which lenses work best for

particular conditions, and learn a bit about the business of photography, the next item on your agenda should be getting out there and taking plenty of pictures. This section gives you a solid understanding of what it is that makes great pictures stand out.

Photography in the Business World

As a society we are inundated with images. TV, magazines, and newspapers all vie for our attention — largely by way of graphics, animations, and photographs. We often make buying decisions prompted by advertising images. Our political thought is influenced by images on the news and in newspapers. Even memories often come from photographs of events far from where we live. Without question, photography has made the world a smaller place.

Images are in constant demand in just about every business environment. In today's visual world, people expect to see pictures representing the products they buy and the people they buy them from. Think how boring the Internet or your newspaper would be without pictures. Imagine a catalog with only descriptions of the company's merchandise. We feel as though we know the movers and shakers of our times primarily because there is often a camera close by, documenting their every move, both the praiseworthy and the embarrassing. In many cases, celebrity seems more important than substance.

The world of professional design and communications has been dramatically impacted by computer graphics technology, particularly over the last 10 years. The single biggest impact of so-called "desktop graphics" has been a blurring of the lines of responsibility between creative directors, photographers, writers, page-layout artists, production professionals, and printers. Add to the mix the capabilities and relatively low-cost of modern digital cameras, and you find that many designers are deciding to do the photography themselves. If you find yourself among the increasingly common do-it-all designers, you need to make sure you're cognizant of both your skills as a photographer, and, perhaps more importantly, your limitations.

Basically, you face four choices: (1) taking the best shots you can with your present skills and resources, (2) purchasing from a stock or existing source, (3) hiring a professional photographer, or (4) devoting the time needed to develop your own skills and abilities to a level close or equal to that of the professional photographer. The reality is that the line between highly skilled amateurs and professionals is defined largely by the fact that the professionals pay their bills taking pictures.

Taking (or Securing) Great Pictures on Your Own

When deciding whether to do your own photography, purchase existing shots, or hire the services of a professional, the most important consideration is the quality required for the specific application. Shooting images for your company newsletter is quite different than heading up a campaign for a fashion designer or designing a catalog for a leading retailer. In the case of the catalog or fashion campaign, it's highly unlikely that you already possess the skills, experience, environments, knowledge, and equipment required to produce a result that will please your customers.

PURCHASING STOCK PHOTOGRAPHS

Stock photography is images that already exist. In some cases, rights to the images are still in the hands of the photographers who originally took them; in other situations, those rights have passed into other people's hands. Sometimes rights are owned by the original photographer's estate; in many cases, however, professional images are marketed through what are known as "stock houses."

Stock houses have been around a long time. In those seemingly distant times before the advent of the Internet and online image catalogs, stock houses published books containing the images to which they had the rights. You looked through dozens, even hundreds, of pages, searching for just the right picture to fit your creative vision. When you found one, you called the company, told them what you wanted, gave them a credit-card number, and the stock house mailed you an original image — normally a transparency. You then arranged to have the transparency scanned, used it in your layout, and returned the transparency to the stock house.

Rights to such images usually extended only to a single use. If you wanted it for an ad campaign, you might arrange a special deal to use it in different layouts. Today, the nature of the stock photography business has changed dramatically — most of the players in the industry offer images online, and in several different resolutions. This way, you can buy a lower-resolution image for use on a Web site, and a high-resolution version for a print project. Usage rights have changed as well. Although one-time usage deals still exist, many houses offer unlimited rights to the images that they offer. For those designers without access to the Internet, most companies also offer CD-ROM versions of their image catalogs. Online access is often more cost-effective, however, since you can buy only the specific image you require, instead of a collection of context-related visuals.

A search on the Internet for "stock photography" will yield more sources than you're likely to use in a lifetime. For starters, you can try photospin.com (one of our favorites), photodisc.com, corbis.com, or Comstock.com. There are many, many more. Most of these sites allow

you to do a category search, so if you're looking for something related to, skiing, for instance, the site will show you only skiing-related visuals. Then you can select the one(s) you want, and download low-res, water-marked versions of them for design purposes. Once you've settled on exactly which ones you need, and at which resolution(s), the high-resolution images are only a credit-card payment away. Approval comes in seconds, and the download begins.

PHOTOGRAPHY FOR REGULAR PEOPLE

With the advent of good-quality cameras with features such as *auto exposure* and *auto focus*, where the computer in the camera takes care of properly exposing the film and setting the focus, it has become quite easy to make a technically acceptable photograph. In many cases, all the image-maker must do is point and shoot. When a record shot is all that's needed, anyone might be the photographer. It's a rare company that hires a professional to take pictures at the company picnic, although it is done. More often, an employee who is interested in photography will be tapped to do the job.

If you are the one asked to take these photographs, you can use the following tips to improve the pictures you take yourself. They may also help you recognize those times when you should engage a professional.

- Move in close to capture expressions. If you're taking pictures of children, animals, or other small things, think about getting down to the level of the subject, instead of shooting the image as if you were standing on a stepladder. Getting closer to your subject doesn't only apply to pictures of people or pets, either; being close can eliminate unnecessary details and backgrounds in a wide range of applications. Fill the viewfinder with the subject.

- Hold the camera absolutely still. If you're shooting with slow shutter speeds (slower than 1/60th of a second), use a tripod or some other method of supporting the camera. Consider using a *shutter-release cable* — a flexible cable that screws into the shutter button and let's you snap a picture without touching the camera.

- Be aware of how the light hits your subject. Look for flattering light. Often open shade will give a more flattering light than direct sun. When your subject is a building or something else that

doesn't move, spend some time walking around it and looking from different angles before you settle on the best position.

- Learn how and when to use the built-in flash on your camera. Even in bright daylight situations, you can often capture much more detail — particularly when shooting backlit subjects. On the other hand, if you can avoid using your flash and still capture the detail you need, try not using it. Faster films, those in the ISO 600-800 range, can capture great images, even indoors. For specialized situations, you can use even faster films. Remember that the flash on many point-and-shoot cameras is relatively weak and will not light subjects much more than 15 ft. from the camera.

- Turn your subject away from bright light, and use your flash to compensate for the backlit situation (or try a faster film). Bright light like the sun also causes people to squint.

> Anyone who truly devotes sufficient time, energy, and dedication to learning what it takes to be a solid, reliable photographer can do so; such development, however, is not going to occur overnight.

- When shooting people in general, avoid posing: the resulting images will be far more personal. Speaking of personal, a representative item like a toy, a fishing rod, a briefcase, or power tool (depending on the person) can add a lot to the picture. If you must have someone pose, tell the person to relax. If they're sitting up too straightly or standing too stiffly, it looks unnatural.

- Whenever possible, try to shoot during the early morning or late afternoon to take advantage of the lower contrast of the light at these times. Don't ignore the possibilities offered by cloudy and overcast days; the light is subtler and less likely to result in harsh shadows and unsightly contrasts.

- Try shooting images at night, as well. Streetlights, neon signs, and other subjects don't show up during the daytime. When you shoot at night, just use slower shutter speeds and wider apertures, and consider investing in a tripod.

- Reduce background clutter by using a smaller aperture setting.

When in doubt, be honest with yourself concerning your own skills. Anyone who truly devotes sufficient time, energy, and dedication to learning what it takes to be a solid, reliable photographer can do so; such development, however, is not going to occur overnight. If you need a great image tomorrow, hire a pro. In the meantime, take lots and lots of pictures. It's the only way we know of to develop your photographic abilities.

Taking good pictures requires a lot of experience, decent equipment, and an eye for what looks good. Even the most experienced and marketable photographers take dozens and dozens of images to make sure they get exactly the exposure, lighting, feel, and impact they're looking for in their photographs. Keep in mind that pros shoot and throw away more images per subject than the average amateur would ever consider doing.

HIRING A PROFESSIONAL

A general rule to follow is whenever your personal or business image is at stake, go with a pro. There are many different specialties in the field of photography, however, and you need to be sure that you're hiring the right one.

First you must determine what type of photograph you need. The correct photographer for your daughter's wedding, even though he or she might be fabulous in this chosen field, would probably not be the same person you should hire to create tabletop images of your company's products. The product photographer would also not be the best choice if you need action shots of a sports event. These disciplines require quite different facilities and equipment as well as different skills.

When hiring a professional photographer, be sure to communicate your needs clearly. During your first contact, explain the type of image you need and what you need it for. Doing this allows photographers to decide if they can fulfill those needs or should recommend someone else. It may seem strange, but most photographers know what they do well and what they don't, and will often send a prospective client to a colleague whose skills are more appropriate for the job. There may also be equipment or facilities issues. Only a few photographers in any area, for instance, can efficiently handle very large items or large numbers of catalog shots. These specialties require huge studios and lots of dedicated equipment. Even though a photographer may possess the skills needed for such a job, he or she may not have the required facilities.

> A general rule to follow is whenever your personal or business image is at stake, go with a pro.

One more item to discuss before you settle on who will shoot your job is the budget. If you have a figure that you must not exceed, let the photographer know. An excellent image of a product or a business image of a person can and often does have a very wide range of prices. A series of headshots done in the studio, where each individual is scheduled in at a time convenient to the photographer, could be far less expensive than an environmental executive portrait on location at a time that fits into a busy CEO's hectic calendar.

There are many specialties within the field of photography. Understanding the career options available within photography may help whether you choose to enter the field or to hire the correct person for the job when you next need photographic help.

Photographic Specialties

Many professionals and skilled amateurs focus on specific subjects or genres. These can be so different that a person skilled in one discipline might demonstrate little knowledge of another. Even though similar tools are used by all, the way they are used and the results produced can be quite different. Following are some recognized specialties in the field.

JOURNALISM

Journalistic photography is familiar to us all. We see examples every day in newspapers and magazines. Yet although the images are everywhere, few of us ever think about the people who create them. Photojournalism includes everything from a spot-news photo of a car wreck on a local highway to an in-depth photo essay, such as those produced by Margaret Bourke White on the effects of the depression or W. Eugene Smith on the pollution-caused birth defects at Minimata in Japan.

In a broad sense, journalistic photography can be broken into three categories: news, features, and sports.

NEWS

If news photography can be summed up in one phrase, it would be one that all new kids in the newsroom have had drummed into their heads: "f16 and be there!" The number refers to the f-stop on the lens, and is included to get the attention of new photographers who may be more worried about the technique of photography than the essence of the news business. The second half of the phrase is to remind them that being where the action is happening and getting the shot is far more important than technique to a successful news photographer. Robert Capa's images of D-day are not a technical tour de force, but they brought the war into America's homes with an intimacy that the written word could never do. As equipment continues to improve to the point that many cameras can make the technical decisions, being there becomes ever more important.

> Being where the action is happening and getting the shot is far more important than technique to a successful news photographer.

News photography can run the gamut from the deadly dull to the truly deadly. Waiting for hours at a local city-council meeting, hoping for something to happen, or standing outside a courthouse in the

freezing rain to get a shot of a just-convicted felon takes a special kind of masochist dedicated to the image. Often this is complicated by the ever-present deadline. Daily papers wait for no one, and images must be timely to be included in the paper. A great photograph that misses the deadline is like a tree falling in the forest. If no one hears the tree, does it make a sound (or, in the case of the image, if no one sees it, does it make an impact)? This means that time to make exceptional images is always at a premium and must give way to getting any image on time. War photographers go in harm's way, often unarmed; they point cameras at highly charged young men and women, armed to the teeth and just itching to shoot something, anything, as they are often scared out of their right minds by the prospect of war. Many of these dedicated men and women have been lost while providing the images we see daily in newspapers and magazines.

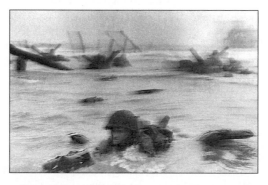

Robert Capa's image of a GI coming ashore on Omaha Beach during the D-day invasion is one of only 11 that survived a darkroom disaster. This image personifies his statement that "If your pictures aren't good enough, you aren't close enough."

Most photojournalists today use either 35mm or digital cameras. Digital is rapidly taking over as affordable, interchangeable-lens models are coming onto the market. The reason is speed. The ability to shoot an image and send it around the world in a flash has become a requirement rather than a convenience.

FEATURES

Often as a photographer acquires a reputation and the skill to go with it, he or she moves beyond straight news to become a features photographer. The editors of the newspaper or magazine assign a series of images to accompany a story. This is more proactive than reactive photography in that there is time to do some research and design what the image will look like before it is taken. The photo essay also falls into this category, although the design of an essay is determined more in page layout than in each individual image.

The images shot for use in magazines like *National Geographic* are prime examples of feature work. Generally they contain some images

set up by the photographer and some shot as events unfold before the lens. The entire take is then edited down to the relatively few images that will be used in the magazine. If the photographer is fortunate, one of these images might be chosen for the cover. Having your photo on the cover is a highly valued prize and can advance your career.

Features photographers often use 35mm- and 2.25-format cameras. The larger-format allows for more quality in enlarged images. Even though there is usually more time in this field, the digital camera is making inroads due to its ability to give the photographer instant feedback. Film shooters have long used Polaroid instant film as an onsite proofing method to get a visual reference before shooting film. Digital cameras often have a screen on which to preview images in the field. Some photographers also use laptop computers to view the images to be sure they have covered the requirements of the assignment before calling an end to the day's shooting.

A related form of features photography can be found in the creation of cover or special-use photography, as shown in the following image. You can find examples on the covers of many regionally and nationally recognized publications. Examples of such broadly distributed publications include *Time* and *Newsweek*, *Wired*, *Psychology Today*, *Scientific American*, and more. One example of a regional magazine use of this technique can be seen in the following cover from *Tampa Bay Magazine*.

This mock-up of a cover shot was later produced as shown here; only type style changes were made. The image was made on commission for the holiday issue of the magazine.

SPORTS

Some of the most visible of the photojournalists are sports photographers. We see them on the sidelines of every professional event. With their long lenses and motor-driven cameras, capable of up to nine shots per second, they are the envy of amateur image-makers

The long lenses used by sports photographers help to isolate the subject by allowing tight framing and shallow depth of focus.

everywhere. Plus they get the best seats in the house, right? Sure, but how often do the paying customers have to move out of the way of a half ton of charging linemen or be run over? That happens at least once a game, even if it is not always seen on TV. Travel, which seems glamorous to those of us who stay at home, becomes boring quickly when you're far away from home and you miss your family.

There are many more people who would like to do this work than there are jobs, which means that entry-level positions pay poorly and are hard to come by. For those who love it, however, there is no other job. Local newspapers are often looking for coverage of kids' events, and while they pay little, if anything, this is one way to get experience and a *credit line* (the photographer's name printed along the edge of the image).

The overwhelming favorite of the sports specialist is 35mm, due to the availability of long lenses and fast motor drives. Recently released digital cameras from Canon and Nikon are also quickly becoming common on the sidelines. These cameras make meeting deadlines easier, and many of them increase the apparent length of the long lenses used to get the look favored by sports magazine and newspaper editors.

NATURE

Nature photography, for which the marketplace seems to have an infinite appetite, requires more than lenses, lighting, and a sense of composition. Like several other categories, such as landscape and journalism, it offers its own set of challenges.

For instance, nature photographers often must deal with wind, waves, tide, time of day, and a host of other environmental conditions, which are, for all intents and purposes, out of the photographer's control.

Other issues come into play when photographing living creatures. If you've ever watched the history or nature channels, you're familiar with the concept of hiding in a cave, floating underwater, or avoiding the jaws of a marauding shark.

For more information on the challenges and requirements facing this type of photographer, see Chapter 8 in which we discuss taking pictures of places. Despite the demands and obstacles, nature photography represents a unique and very popular type of image-making that appeals to a wide audience and continues to intrigue photographers.

RETAIL PHOTOGRAPHY

Another photographic specialty with which many of us have had experience is the portrait and wedding photographer. This is the photographer or studio that took your high-school senior picture or photographed your cousin's wedding. Generally these are local, small-business entrepreneurs who provide photographic services to the public.

Businesses in this classification range from high-volume operations, like Olin Mills or Lifetouch, to low-volume, very-high-quality operations that are the modern-day equivalent of the portrait painter, run by a photographic artist of considerable talent. This latter group of businessmen and women often become a regular part of the lifestyle of people who want to document the lives of their children and can afford to have a professional do the work. These artists make their living by making their customers look fabulous and providing the service their customers demand.

PORTRAITS

Portrait photographers also make their customers look their very best. They work at optimizing each aspect of the session, from the choice of clothing to location, poses, and lighting, all of which are chosen to flatter the client.

Retouching has long been a part of the service offered by the finest portrait photographers — smoothing skin texture and eliminating wrinkles to portray an idealized image of the client, much as traditional artists have done over the years. The skilled retoucher can eliminate many problems, even items such as braces and burn scars. Traditional methods of retouching include dye, paint, and airbrush, and now the computer has added another dimension to what can be accomplished. With the advent of digital imaging, we have reached the point where the final image can be just as the photographer envi-

sioned it at the moment the shutter was tripped, with no compromises. Images retouched electronically can be reproduced at all sizes without degradation due to copying.

Traditionally portrait photographers have used medium-format cameras to provide a large enough image to retouch as well as the quality to make large prints. When all else is equal, the larger piece of film provides more quality. In this area, too, the digital camera is making significant inroads, as the quality has gotten to the point that large prints can now be made directly from digital files.

No discussion of photography — especially when talking about images of people — would be complete without a mention of the *paparazzi* — those ever-present professionals hanging around anywhere that any celebrity happens to be. It appears to be — for some — a very lucrative field. On the other hand, it incorporates the danger of shooting rare predators while they're having a litter, and the likely chance that you'll look sort of sleazy hanging around somewhere you're not invited.

WEDDING

Wedding photographers are the Rodney Dangerfields of the industry — they often get little or no respect. In reality, nothing should be further from the truth. Good wedding photographers needs as much raw talent and skill as the photographers in any other discipline, and possibly more. They work in an ever-changing environment, populated with emotional people, none of whom have the least idea how to prepare to be photographed. The professional wedding specialist is charged with bringing order out of chaos and, in the midst of all this, creating artistic images. That it ever works is surprising. That they do it every weekend is miraculous.

> The professional wedding specialist is charged with bringing order out of chaos and, in the midst of all this, creating artistic images.

There are wedding photographers working at every economic level, from the weekend warriors, who may even lose money on each wedding they shoot, to nationally known specialists like Dennis Reggie, Hanson Fong, and Clay Blackmore, who can command five-figure fees and are booked years in advance.

The late-afternoon light defines the faces of this bridal couple, and the long lens used helps to blur the background and isolate the couple. While to some this image might appear overly blurry, it was intentionally softened through the use of a filter. This digital capture was made with a Canon D60.

Because the equipment requirements are comparatively modest, almost anyone can enter this field. The term "modest" is used here in a relative sense, as the cost of several professional-level cameras, lenses, and flash units is breathtaking to the uninitiated. Even so, when compared to the equipment needs of most other photographic specialties, the requirements are quite modest. Many attempt to work in this specialty every year, but only a few survive. It takes a good mind for business, as well as photographic talent and skill to succeed in this competitive endeavor.

FORENSIC/SCIENTIFIC

This area of photography may be the most specialized of all. Images for scientific and legal purposes are often made by people with little interest in photography, as an end in itself, but with a need to document a process or series of events, often in a very precise way. The need for adequate photographic skills is a given, but even more important is an understanding of the needs of the legal process or of conforming to the standards of a scientific method.

Today 35mm and digital cameras predominate, but all formats have been used in this demanding task.

Accident Reconstruction

Accident-reconstruction specialists use photographs taken at the scene of the accident as well as images of the types of vehicles involved, shot at other times and locations. They assemble a series of these images to make a complex and dynamic event more understandable to the layperson on a jury. The skill and integrity of the person who takes on this job are his or her stock in trade. A clear and unbiased portrayal is needed in order for the legal process to function properly. The accident-reconstruction expert is often also the photographer, but not always. Usually the photographic requirements are not so complex that they can't be handled with the automatic cameras so common today. There are times, though, when a special skill is required, and a professional photographer is called in. In these cases, the reconstruction specialist takes on the role of art director, explaining what is required. Often, when this is the case, both are called to testify.

Crime Scenes

Police photographers shoot hundreds of pictures at a crime scene. These photographs are used to establish the relationship of objects and to preserve the scene as it first appeared to the investigators. Their job is not to make interesting images, but to record every aspect of the scene so that it can be referred to months or even years later as the case makes its way through the legal system.

Today these photographers most often use 35mm or digital cameras with auto focus and exposure. These cameras, used in this manner, make clear, sharp, and standardized images that are readily accepted in court, based on the integrity of the photographer.

Evidence

Beyond crime-scene photography, evidence photography comes into play when a photo may be all that's left of cuts and bruises from a domestic dispute or any other situation in which evidence might deteriorate over time. Often items that are too large to be brought into court, like vehicles or buildings, or subjects that might be distasteful or disruptive, if viewed in person, are photographed, and the pictures are introduced as evidence. Again, it is the personal or professional integrity of the photographer that is the deciding factor in what images may be used in this manner. The evidence photographer uses the same equipment as that used by the crime-scene photographer.

Process Documentation

Many scientific processes must be documented photographically in order to maintain a record. The camera's ability to see things that the human eye cannot is also of great importance to scientific observation.

The motion studies of Edward Muybridge and the high-speed electronic-flash images made by Harold Edgerton are only two examples of the importance of the photographic process to modern science.

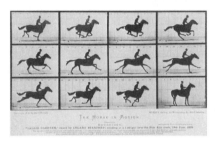

Edward Muybridge and Harold "Doc" Edgerton used photography to explore movement in the physical world. This led to animation techniques.

Anther example of how photography and science work together is archaeological digs. Here photos are taken at each stage in the excavation. These images document the process and the exact position of objects, and create a record of each layer before the archaeologists move on to the next. The photographic record thus produced may well be the only lasting evidence, either because the layer is removed to access the next or because political upheaval and world events may block access to some sites for many years.

Documentation of scientific processes is also a role that photography fills well. In order to be able to rely on the information gathered by a series of tests or experiments, careful records must be maintained. Photographs can be of great help in this area.

Many of the advances seen in the industry in recent years have come from the work done by agencies such as NASA. Digital technology allows images to be transmitted from space without waiting for film to be retrieved and processed.

Scientific photographers use all available film and digital formats in their work, even inventing new ones as the need arises. Edgerton's work, in particular, resulted in the widespread use of what we refer to as "electronic flash," which has, for all intents and purposes, replaced flash bulbs. Many of the advances seen in the industry in recent years have come from the work done by agencies such as NASA. Digital technology allows images to be transmitted from space without waiting for film to be retrieved and processed. The recent images from Mars are an excellent example.

COMMERCIAL PHOTOGRAPHY

Generally images made for business or advertising purposes fall under the loose heading of commercial photography. Because of the wide range of products and services that are sold throughout the world, many specialties have developed, such as architecture/real estate, product, food, people, and fashion.

Equipment has evolved over time to meet the needs of each of these specialties. Often this has resulted in crossover use, as much innovation has to do with the modification of light, which all photographers need to do.

Architecture/Real Estate

Buildings and interior spaces are photographed constantly. Because they cannot be carried around, pictures provide a way to convey information to those who cannot visit the site. During construction, wiring and plumbing that will be hidden when the building is finished are often photographed to provide a record of what is inside the walls, in case a question is later raised by an inspector.

> During construction, wiring and plumbing that will be hidden when the building is finished are often photographed to provide a record of what is inside the walls, in case a question is later raised by an inspector.

This image, made in a model home, shows both the spacious interior and the skill of the decorator.

Images are also used to promote the building, the architect, the interior designer, the decorator, and, often, the final use to which the space is dedicated, such as a theater or restaurant.

Most often, large-format cameras are used in this work, due to their ability to provide a corrected perspective. Digital imaging is making some inroads in this field, but more slowly than in most. Perhaps the reason is that imaging chips are smaller than film, in most instances, making the use of wide-angle optics more difficult. As this book goes to press, however, new cameras with larger image sensors are just coming to market. These larger chips coupled with already available lenses will definitely have an impact on the future of architectural photography.

Product

Perhaps more commercial photographers are involved in product photography than in all the other disciplines. There is a great need for this type of image, as every product must be sold to someone and photographs are instrumental in this process. Catalogs bombard us at every turn, from low-end publications printed on cheap paper to those produced by companies such as Brookstone or The Sharper Image; these catalogs use lavish imagery to sell high-end and, often, big-ticket items.

This is another area where large-format cameras were predominate, until the advent of high-quality digital. In fact, this is where high-end digital first became practical, as even the high cost of the first cameras was quite easily amortized over a very short time due to the savings on Polaroid proofing materials, as well as regular film and processing.

This image of die-cast parts was used on the cover of the company's capabilities brochure. High-level product photography can glamorize objects that are otherwise not very exciting.

Food

The photography of food is a world unto itself, even though it could be argued that it is another form of product photography. The perishable nature of the product and the difficulties inherent in preparation require a team of uniquely trained individuals. Often a chef, a stylist, the photographer, several assistants, an account executive, and sometimes the client, are present at a food shoot. Only fashion photography regularly gets this many complex personalities attempting to work together on a regular basis. It is most often the photographer's job to see that order comes out of chaos.

While large-format equipment dominated this field for years, digital has made inroads here, as well. In fact, the photography department at Kraft Foods in Chicago now records most of its images with direct digital capture.

Digital capture has made inroads into even the high-end photography of food.

People

Images of people are also needed for advertising and other business purposes. These images are usually quite different from those created for the private use of the subject. Executive portraits range in scope from the familiar image of the boss at his or her desk to more dynamic images showing the working environment and telling a story about the company. Pictures of people at various levels of a business's structure are also used in annual reports as well as in corporate advertising efforts.

At this level there is some crossover between the journalistic features photographer and the commercial people photographer. They may well be the same person with the primary difference being the end user of the images. In other words, a photographer, such as Annie Liebowitz, who made her reputation as a journalist, often takes on commercial clients, and usually for a far greater fee than is ever paid by a magazine for editorial use.

Medium-format and 35mm are the traditional equipment used in this type of photography. Digital is making inroads here, as well, and on occasion, large-format cameras see some use.

Images of people at every level in a company are used to add a human face to otherwise impersonal corporations.

FASHION

To say that the world of the fashion photographer is a hectic one would be to understate the case badly. Fashion photography, like the fashion world itself, is trendy, chaotic, and as changeable as a chameleon on a plaid shirt. This year's hot new shooters can just as easily find themselves forgotten if they don't stay ahead of the trends or even set the new ones. Although the job appears to be a form of people photography, the fact is that it is the clothes that are the star and often a mood is what the designer is trying to convey. Many times no consensus has been reached at the time of the shoot as to just what the creative team is going for, so things must be worked out on the fly. At other times a finely drawn concept is in hand, and the photographer's job is to execute someone else's vision. Rarely is one photographer a star in both ways of working.

> Although fashion photography appears to be a form of people photography, the fact is that it is the clothes that are the star and often a mood is what the designer is trying to convey.

The successful fashion photographer must juggle hair and make-up artists, stylists, seamstresses, designers, account executives, and clients, as well as dealing with the models being photographed. It is no wonder that their fees are among the highest in the industry.

Medium-format and 35mm reign here, with digital moving up very fast for many of the same reasons listed earlier.

Photography as Art

While not often thought of as a job, the pursuit of photography as an art form can and has evolved into a career for some photographers. Image-makers such as Ansel Adams, Edward Weston, Diane Arbus, Clyde Butcher, and others have made reputations that, in some cases, have far outlived the artist. As time passes and major collectors add photographs to their collections, more photographers will be able to earn a living from their art. Today there are many photographers traveling the art-show circuit, selling their images and making a living. The advent of new technologies has somewhat blurred the distinction between photography and more traditional art. Computer manipulation has opened a new door to artists to explore their vision.

Galen Rowell has redefined the concept of photographer as artist via his role as an outdoor-adventure photographer who makes such wonderful images, that many consider them art. His business model encompasses everything from educational workshops for other photographers, to print sales to collectors around the world, and magazine publication. Rowell is an excellent example of a photographer who refuses to be pigeonholed into one area of the craft.

Summary

In this chapter, the discussion turned to the real-world application of photographic skills. First, we considered situations in which you might be the photographer, including some tips for improving the quality of those shots. Next we considered when and where you might purchase images, rather then taking them yourself. Stock photography comes in many different categories, and in many cases, is the work of highly skilled and talented professionals. Add to this the low cost and ease of use, and stock photography should always be considered, when appropriate. We moved on to talk about hiring a professional, and finally explored the major specialties and categories of image-taking in the professional arena.

Lighting

Lighting is one of the most important aspects of high-quality photography. When well implemented, either by skilled use of natural light or auxiliary light units, lighting allows the two-dimensional surface of a photograph to portray the three-dimensional world with startling accuracy. Even when all that is required of an image is a record of events, light must be considered, if only to be sure that enough exists to make a good exposure.

A good measure of the skill of any photographer is his or her use of light, as well as the ability to see the differences that various lighting makes to the subject. Skilled image-makers use the diverse properties of light and their knowledge of how to modify and manipulate these qualities to create images with impact and mood. The camera used is much less important than the quality of the light. A photographer with a good eye for light will make great images with any camera, even simple point-and-shoots, while the finest cameras record only snapshots in the hands of one with no appreciation for, or knowledge of, light.

> When well implemented, either by skilled use of natural light or auxiliary light units, lighting allows the two-dimensional surface of a photograph to portray the three-dimensional world with startling accuracy.

You may have heard the term "available light." This term is often misused to refer to what could be better termed "existing light," as any light source the photographer might have brought along is surely "available" to be used. In our exploration of lighting, we will use the terms *natural lighting* to refer to existing light, used as is or modified by the photographer, and *artificial light*, when the image-maker uses light sources brought in to augment the existing light or be the sole light source for the image.

Natural Lighting

The light that exists in an area at any given time of the day, including any man-made light sources that may be part of the scene, falls under the heading of *natural lighting*. The skillful use of this light by whatever means — as is; by using scrims, light panels, reflectors, and gobos; by repositioning the subject; and by choosing the correct time to work — has much to do with making a successful image.

As you will see, light has a logic and follows a set of physical rules that are the same in every situation. Even though the surroundings may lack any kind of similarity, recognizing how the light reacts in any given area enables the photographer to successfully create an aesthetically pleasing image in most situations.

OUTSIDE

The great outdoors offers a wealth of photographic opportunities; every type of lighting condition exists at some point outside. The key to successful photography outdoors is an awareness of what the light is at any individual moment. The sun is constantly moving across the sky, and rises and sets at different times and in different places on the horizon, according to the season.

Daylight is made up of two components: the sun and the dome of the sky. The relationship of those two elements is the first thing to look for when contemplating outdoor photography. The first hours around sunrise and the last hours around sunset are often referred to as "sweet light" by professional photographers. This light is valued because the ratio of the bright light of the sun and the light from the dome of the sky is closer at these times. This is due to the fact that the sun must travel through hundreds of miles of our atmosphere when it is close to the horizon. As the sun climbs higher in the sky, it travels through less than 10 miles of atmosphere. As anyone who has been at 14,000 feet of elevation can testify, the air gets very thin and hard to breathe. This thinner air has much less effect on the sunlight passing

This graphic, even though it is not close to scale, clearly shows the longer path through the atmosphere taken by the light rays when the sun is on or near the horizon.

through it. The result is that the sun seems much brighter at noon than it does at sunrise or sunset. Since the dome of the sky does not vary nearly as much, the light ratio between areas lit by the sun and areas lit by the dome of the sky are closer at each end of the day and father apart during the middle of the day.

All of this is well and good if the only time you plan to photograph is the sweet-light times at the beginning and end of the day, but often we don't have that luxury. Deadlines are a real-world reality, and clients' needs and expectations must be met, so frequently we must photograph during less than perfect times. This is where the ability to modify the light comes into play. Equipment, such as scrims, reflectors, translucent light panels, and gobos, as well as choice of location is used to help the photographer get the shot.

As an example, let's imagine a location shoot with several setups and changes of clothes. The budget allows for only one day of photography, so we must work through the whole day to have enough time. We were able to scout the location, so we have a good idea of what equipment to bring, and were also able to create a preliminary shooting schedule based on the predicted position of the sun. Hair and make-up talent are booked, and the models are scheduled with time allowed both for fitting and for cosmetic preparation. First shot is planned for just after sunrise, so all early preparation is done in the dark or under work lights. Several outfits can be photographed during the sweet-light period, and we can even push past the best light by bringing in reflectors, light panels, and scrims, as needed.

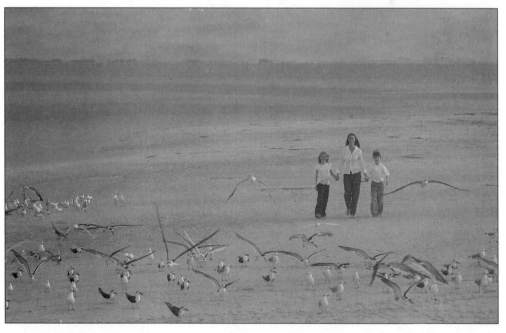

Early-morning sweet light as the sun just begins to show over the horizon on this beach on the west coast of Florida. Note the edge of the subjects' faces and the long open shadows.

As the sun climbs higher in the sky, we change venues to an area of open shade and another where the subject and background are backlit by the sun. Open shade allows the light from the dome of the sky to become our main light source. The large area of sky provides a soft yet directional light that is flattering and even. Because the light is quite blue, due to the color of the sky, we use a warming filter on the lens. Alternatively, if we were using a digital camera, it might have a means of adjusting white balance electronically. The sunlit area requires more light modification but has the potential for very interesting shots. We use reflectors, scrims, and gobos to create a light that will allow good reproduction and show off the clothes to their best advantage.

The dome of the sky alters lighting conditions in these examples.

The preceding images provide two examples of natural lighting conditions. The photographer encouraged the subject family to assume natural, relaxed positions underneath the thick canopy of a live oak. The light from the dome of the sky is entering from the right side of the image (from the standpoint of the viewer, not the family). Although the light is quite soft, it's still directional, providing an effective three-dimensional effect.

The image on the right utilizes lighting that's considerably different than that used in the first image, even though it was taken at roughly the same time and place. This time, the model was moved so that she's

backlit by natural sunlight. The photographer set up a silver reflector that effectively bounced that same natural light source; the illuminating effect on the woman's face is apparent, now that you know how it was done. If you look closely, you can even see tiny specks of white in her eyes. When you're analyzing photographs, if you look closely into the eyes of the model(s), you can sometimes see these highlights. *Catch lights* — these highlights or bright spots — are the result of light bouncing off reflectors set up around the location of the shoot, usually in close proximity to the subject matter or live models.

Images such as these are important for you to study — they were taken at times that are far from what are usually considered optimal from the standpoint of natural-lighting conditions. While we've mentioned that certain times of the day are "sweet," you can't always control exactly when and where you're going to find yourself taking pictures. Using what you have on hand and applying a bit of imagination can often turn a mediocre image into an award winner.

Speaking of what you have at hand — a lot of at-hand materials and objects can be put to use to create lighting effects. A sheet of glass, a mirror, or even a shiny, new, garbage can lid can reflect light. You can also find the right kind of shade — not too deep and not too dappled (so you avoid overly busy shadows) — if you study the location before you start clicking.

> ●✄ When you're analyzing photographs, look closely into the eyes of the model(s). You can sometimes see catch lights. These highlights, or bright spots, are the result of light bouncing off reflectors set up around the location of the shoot, usually in close proximity to the subject matter or live models.

INSIDE

Shooting inside a building or other structure significantly changes lighting conditions. There are thousands of possible situations; we can only cover a few of them here.

Lighting an interior with natural light is normally done through an opening in the walls or roof of a building that lets sunlight into the room or space. As we saw in the close-up shot of the model at the end of the last section, using reflectors, or at least reflected lighting, is very important to fill in details and balance the tones of an image. After all, the tones you capture on your film are a direct result of light bouncing off a subject. If you have professional equipment, position a reflector in various locations around and near the model or subject, and use the light coming in the windows, through the skylight, under the garage door, or through the partially fallen wall of an old barn.

You'll need, as always, to consider lighting relative to film speed and target usage. Use daylight-balanced film, and to avoid the need for too much flash, consider using higher-rated ISO films. Typically, interior film is rated at 400 ISO or faster.

Natural lighting, such as that coming through unobstructed windows, can also be supplemented with normal interior lighting. You do have to take into consideration that the light generated by light bulbs and florescent lights can introduce unwanted color casts into your photographs. You'll need to develop some experience working under different conditions if you really want to master the craft. This is particularly true of understanding lighting conditions. Again, be sure to study the work of others.

> If you supplement natural light with normal interior lights, you have to take into consideration that the light generated by light bulbs and florescent lights can introduce unwanted color casts into your photographs.

You can see the effective application of available, natural light coming through a window in the two following images. They are quite different in their approach and use of available light, but both use it quite effectively. In the image on the left, the little girl is lit from a window above and behind her right shoulder; you can see the effect in the highlights showing on the right (to the viewer) side of her dress. This is a compelling image and shows what can be done with natural lighting and an interior location.

The image on the right is another example, but this time using very subtle, balanced natural light. There's a distinct difference in the

These images, made by Ed Poirier of Woonsocket, RI, illustrate the use of window light.

apparent brightness and intensity of the light source. The photographer may have covered the window with a film or sheet, and softened the light. On the other hand, the light source might be from a window looking out on cloudy day. Either way, you can see natural light being used to provide very balanced, soft illumination of the two child models. Notice the details of the image are sharp and clear, indicating a slower shutter speed and resultant longer exposure.

Interior or inside lighting isn't strictly limited to walled or totally enclosed locations, either. Keep in mind that open roofs, canopies, and other solid objects that are positioned overhead also create situations that simulate interior conditions. Harsh sunlight, which might otherwise result in overly sharp and contrasting shadow lines, is blocked, and the light that does come in does so at a lower angle than it would without the existence of the overhead obstruction. Rather than being directly (or nearly) overhead, this directional light is modified, and affects the subjects differently. Reflectors can go far towards balancing light under overhead objects. Although the general outside lighting conditions might not be conducive to optimal lighting, an innovative photographer can capture excellent images nonetheless.

As the day progresses, the position of the sun changes — affecting both outdoor and interior lighting conditions. At the end of the shooting day we have, with luck, sweet light and sunset shots to cap off our shoot.

Look at the image to the left; as the sun approaches the horizon, the resulting light is strongly directional. Shadows, however, are often still quite bright and balanced (which professional photographers call "open"). When possible, use this type of light to provide a three-dimensional feel to your images.

Artificial Lighting

There are two major divisions of lights for still photography: flash and continuous. Each has its strong points and drawbacks, and each is better suited to particular aspects of the photographic arts than the other.

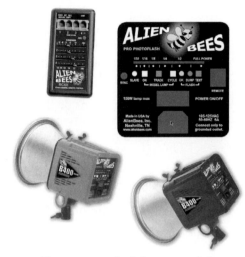

Due to the quick burst of light, flash aids in stopping movement, both of the subject and the camera. Flash is also cooler and produces a lot of light in a small package. Because flash is daylight-balanced, it can be used in conjunction with natural light without the bother of color-correction filters. One disadvantage of flash is the inability to see what the light is doing to the scene. Polaroid proofing materials, experience, and the use of a small continuous bulb as a modeling light in studio flash units help photographers get around this limitation. The advent of digital imaging has made using strobe easier, because you can preview the effect on the LCD panel built into the camera or on the computer screen.

*The power pack of these monolight-type flash units is built into the lamp head. Each unit is independent of the others in a lighting setup. Each unit incorporates a **slave sensor** that fires the flash when triggered by the flash of one directly attached to the camera. All controls are on the rear panel, and up to four units can be controlled via the wired remote control.*

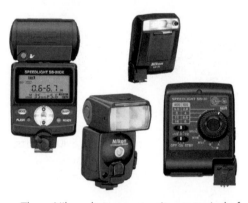

These Nikon shoe-mount units are typical of the small to medium electronic flash units favored by those who need more power and features than built-in flash can provide.

Continuous-light sources, such as tungsten bulbs, florescent tubes, quartz bulbs, etc., are also often used for still photography. Each of these light sources emits light in a different part of the spectrum, requiring either film balanced to that color temperature or filters on the light or camera. This can be a problem when you're trying to

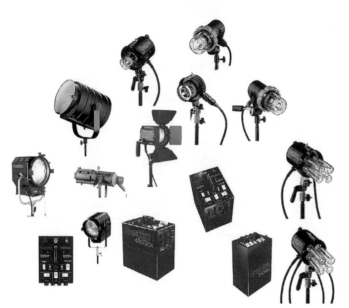

These are examples of a pack-and-head system. Various combinations of power-pack and light-head configuration can be chosen for any particular job. This type of system offers the option of very high power to one head as several packs can be attached to either of the two heads at the right. Other heads offer various specialty configurations, such as focusing and Fresnel spotlights.

use these lights in conjunction with natural light. At times photographers can use this characteristic as a creative tool (such as evening cityscapes where the lights record normally and the sky takes on a deep blue tone). More often the disparity of color balance just creates one more problem. With the exception of florescent tubes, these lights get very hot and can make the subject uncomfortable. Still-life photographers often use these lights, as their subjects are inanimate and don't complain. An advantage to continuous-light sources is that long exposures can allow the lens to be closed down to extend depth of field. Another advantage is that, as these lights are constantly on, the photographer can see the effect they are having on the subject, allowing easier creative control. At times photographers want to include motion blur in their images, and continuous light makes this possible. A newer development in continuous-light technology is daylight-balanced HMI lights. Developed for the motion picture industry, they are available in a variety of sizes from 1200 watts to more than 5000 watts. They are very expensive but enable image-makers to see what's happening and permit easy blending of artificial light with daylight.

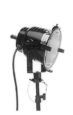

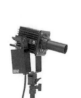
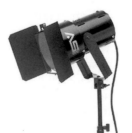

Typical examples of continuous-light units.

USING FLASH

Electronic flash units, commonly referred to as "strobe units" even though this is not a technically accurate term, come in a variety of configurations. (*Strobe* properly refers to a flash that fires repeatedly.) Tiny units are built into many point-and-shoot cameras; shoe-mounted units are designed to be used on SLRs; hand-held or camera-mounted, large, portable units have been developed for heavy professional use; and heavy-duty AC-powered systems have been designed for professional studio and location use.

These units make light by exciting a normally inert gas like xenon, sealed in a vacuum tube, with high voltage until it suddenly becomes a conductor, producing a bright spark contained in the tube. This technology can produce a great amount of light. Output of these lights is sometimes rated in "watt-seconds." This term refers to the amount of light produced, as, for example, 4,800 watt-seconds or the equivalent of 48 100-watt light bulbs burning for 1 second. As you can see, that is a lot of light, especially when it happens in about $1/1000^{th}$ of a second. Units are available to produce from 25 watt-seconds up to many tens of thousands of watt-seconds. More properly, the term *watt-seconds* refers to the amount of potential energy stored in the capacitors, inside the power head of the flash, rather than actual output of light. The term has been misused for so long, however, that it is now common to refer to the power of flash units by their watt-second rating. Actual light output of units with similar ratings can vary due to factors such as reflector efficiency, flash-tube design, and length of connecting cords. Determining proper exposure with these units is best done with a light meter that can read the brief burst of light. These meters are referred to as "strobe" or "flash meters" by photographers.

USING PORTABLE AND AUTOMATIC FLASH UNITS

Recent technology has made control over most portable battery-powered units fully automatic, with some even dedicated to and integrated with the CPU of a particular camera model. Computer technology has simplified many of the complex calculations formerly required for intricate flash setups.

Today it is difficult to find a battery-powered flash unit that is not able to function in automatic mode. *Thyristor* (a type of solid-state control) technology was developed in the early 70s. A light meter in the flash unit reads the light returned from the subject and shuts off the flash when enough light for proper exposure has been emitted. This all happens incredibly quickly, with some flash units having a 1/50,000-second flash duration. This is fast enough to stop a bullet in flight. Nondedicated auto-flash units incorporate the light sensor in the body of the flash unit and are designed to provide a set quantity of light at each of several power settings. The photographer is responsible for setting the aperture and shutter speed on the camera to correspond

with the settings on the flash. Dedicated auto-flash units are designed to integrate with the CPU in a particular camera. In the most-automatic mode of the camera, all decisions are made by the built-in software that controls the system. In other modes, input from the photographer is taken into account and integrated into the decisions made by the software. Generally the photographer's input need only be results-oriented, such as lowering the fill amount by one stop; the automatic onboard systems take care of just how this is accomplished. Each manufacturer has its own system, and the best way to get information regarding these differing systems is via the manual that ships with the camera.

> When the flash is set in automatic mode, a light meter in the flash unit reads the light returned from the subject and shuts off the flash when enough light for proper exposure has been emitted.
>
> The photographer is responsible for setting the aperture and shutter speed on the camera to correspond with the settings on the nondedicated auto-flash unit.

Using nondedicated flash is somewhat more complex than the set-it-and-forget-it auto-everything systems, but is by no means beyond even a casual photographer. Understanding just a little about light and flash technology can make it fairly simple.

The first point to remember is that light diminishes in intensity according to the distance from the light source to the subject. Photographic technicians refer to this property of light as the "inverse square law." Simply stated, this law says that as the distance from the light source is doubled, the amount of light hitting the subject is only one-quarter as much. This is easily seen when using flash in a large space or outdoors. Even though the subject might be perfectly exposed, people or objects just beyond the subject by even a small distance begin to show signs of underexposure. This is also the reason why the small units built into some cameras will only provide correct exposure to about 15 feet from the camera. Beyond that distance light falloff is so great that there is not enough to provide proper exposure.

The second point is that the light meter built into the flash unit is designed to average the tones returning from the subject and calculate an exposure for middle gray. This works well on the majority of subjects, but can be fooled by subjects predominantly light or dark. When pointed at a white wall, the meter cuts off the flash when the illumination

> Remember that light diminishes in intensity according to the distance from the light source to the subject. As the distance from the light source is doubled, the amount of light hitting the subject is only one-quarter as much.

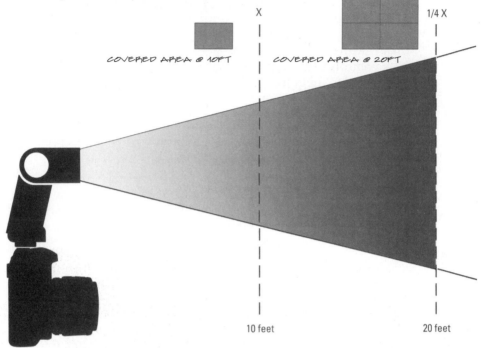

This graphic illustrates the inverse square law. As a light source is moved away from the subject, it covers more area (in this case, at twice the distance, it covers four times the area) at any point in the coverage area. At 20 feet there is one-quarter of the amount of light that was available at 10 feet.

X

1/4 X

COVERED AREA @ 10FT

COVERED AREA @ 20FT

10 feet

20 feet

reaches middle gray, and when pointed at a black wall, light is emitted until the same gray value is reached. As long as the photographer is aware of how this all works, he or she can adjust the camera (opening or closing the aperture) to compensate.

Most nondedicated auto-flash units have a range of apertures that can be used to allow the photographer some control over depth of field. These are generally color-coded or otherwise marked on the control dial on the unit. The range in feet over which the unit will provide correct exposure is determined by which aperture is chosen. A wide aperture that lets in a lot of light will work over a larger range than a small aperture that provides greater depth of field.

With some experience and forethought, the photographer can control the ratio between the flash and any ambient light to create a variety of effects, from a barely perceptible fill to an overpowering, flash-as-main-light effect. Many social-event photographers work with a flash on at all

> The light meter built into the flash unit is designed to average the tones returning from the subject and calculate an exposure for middle gray.

> The range in feet over which the unit will provide correct exposure is determined by which aperture is chosen.

times, even outdoors. Setting the flash to one or two f-stops below the ambient light assures that the fill effect of the flash will keep all exposures in a very printable range. Remember, when using cameras with focal-plane shutters (most 35mm SLRs and some medium-format cameras) to check the camera manual to see what the highest shutter speed is that will work with flash. The nature of focal-plane shutters is that they cut off part of the flash effect when set at too high a speed to synchronize with the flash. Generally 1/60th or slower is safe on 35mm cameras. Some can go much higher than that, so be sure to read your manual.

On-camera fill flash can be used outdoors to allow detail in the subject to show as well as the background.

USING FLASH UNITS IN THE STUDIO

Studio flash units generally come as either power-pack-and-head systems or as monolights in which the power pack is integrated into the light unit itself. Pack-and-head systems offer higher maximum power, and most packs can power more than one light head. Units from both types of systems can be configured as floods, spots, or focusing spots, or modified with soft boxes, light panels, and umbrellas through a system of interchangeable accessories mounted at the lamp head. In recent years, many companies have taken advantage of the miniaturization of electronics to bring to market powerful monolight systems. The advantage of building a system of lights based on this design is that should one power pack fail, the other units in the system will still work. When the power pack of a pack-and-head

system goes down, the photographer is out of business until it is fixed.

Both types of studio flash equipment use integral modeling lights. These are continuous-light bulbs, usually quartz or tungsten bulbs, which allow the photographer to see the light pattern that will be cast by the flash when it fires.

As technology has advanced, these modeling lights have become very accurate, on some models allowing very precise light control with little or no trial and error.

The action-stopping ability and cool operation of flash makes it a preferred choice of photographers who work with people. Exposures are virtually instantaneous, and the great light output allows a small aperture, enhancing depth of field. Even still-life and product photographers have made the move to strobe, using multiple pops or flashes to achieve the very small apertures required in their work.

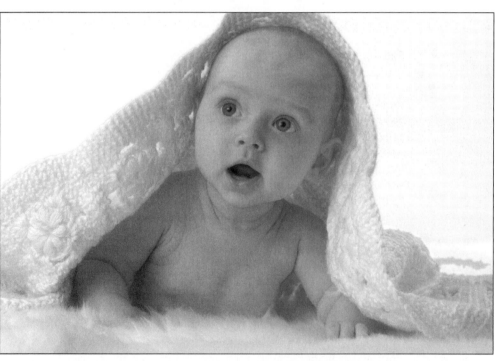

This photograph of a four-month-old little girl was made with strobe in the studio. The main light was modified with a medium (36 in. × 48 in.) soft box. Additional lights were bounced off the white walls and ceiling to provide fill and light the background. The quick burst of light from flash units made it possible to capture the fleeting moment of expression as the baby moved around.

USING CONTINUOUS-LIGHT SOURCES

Continuous-light sources, because they are continuous, are easier to see and use than flash. If it were not for the heat they produce and the difference in color temperature, they might be the best all-around solution to photographic lighting. "Hot lights," as they are called in the trade, come in a wide variety of configurations, including floods from 150 to more than 2000 watts, spots in all sizes, and *banks* (a group of flood lights placed close together). Their light output can be controlled via the same array of tools used to control flash, including diffusion panels, soft boxes, and umbrellas, as well as scrims, gobos, and reflectors. The only proviso is that all light-modifying devices used with hot lights must be designed to withstand the high temperatures generated by these lights.

There are several points to consider when deciding if hot lights would be an appropriate choice in your particular situation. Even if the heat they generate is not a problem, for example an unheated studio in a cold climate, the electrical requirements may well be more than typically provided. High-wattage lights require lots of electricity, and often a special service box is needed to avoid overloading the lines. A qualified electrician should be consulted whenever there is any doubt. The color temperature of the lamps is also a consideration. Most photo lamps are balanced at 3400 degrees Kelvin or 3400°K. This light is seen by daylight-balanced film as very yellow/orange. Filters must be used either on each light or at the camera to bring the light to the 5000°K of normal daylight, or film balanced for 3400°K may be used without filters. In either case, problems arise when attempting to use these lights in conjunction with daylight. Seasoned professionals have evolved creative uses to

This shot of pro drummer Vinnie Colaiuta was made under the stage lights. Obviously stage lighting must be continuous, but here the lighting was used purposefully to allow the motion of his hands to show, adding a sense of action to the shot.

exploit the differences, such as using daylight-balanced film for evening shots of homes with the lights burning inside. The warm glow of the mismatched color balance gives this type of shot much of its appeal.

An advantage that hot lights still hold over strobe lights is cost — initial purchase price is usually far lower for hot lights. This factor should not be weighed too heavily when making a decision, however, as lighting equipment is a long-term investment, and the choice should be made based on which system best satisfies the photographer's need. Many pros eventually acquire both types of lights, using each when it is best suited for the specific job.

Summary

In this chapter, we discussed a few of the important aspects you need to consider regarding lighting and lighting conditions. You learned about the best times to use natural light, and how to deal with changing conditions during the course of a typical day. From there we moved to the use of artificial lighting — specifically flash units of various types. Both manual and automatic flash units are used in the professional's tool bag, and you should consider investing in flash units if you intend to get serious about your photography. You explored studio systems — the foundation of most product, fashion, and indoor photography. As you've learned, lighting is a critical factor in the creation of solid, effective, and compelling photography, whether you're using digital or traditional film cameras.

Composition

Composition is one of the two main factors that can move an image beyond the ordinary. (The other is lighting.) Deciding where to place elements within the frame is key to directing viewers in their visual journey through the photograph. For many photographers, one of the aspects of the craft that works early and well is an almost instinctive ability to make images interesting solely through composition. In fact, many image-makers say it was this ability that caused them to think that photography might be their calling.

Several informal experiments have been conducted using disposable cameras and young children in an attempt to identify right-brain-dominant, artistic individuals. These tests show that some individuals seem to place objects in the frame naturally, even when they have not been exposed to the theories of good composition. There seems to be clear evidence that some individuals tend more to the creative side than others. For those who do not fall into this category, however, all is not lost — composition can be analyzed and broken into its component parts, to be referred to later during the image-making process.

Content Positioning

This analysis is useful for all image-makers, even those who have an instinct for composition, as the process helps define why we see the way we do and can help expand the individual's compositional skills into new areas of photography.

Many elements work together to create what we call "good composition." Subject placement, leading lines, lens choice, depth of field (or lack of it), color harmony, tonal range, and lighting can all have a profound impact on the final look of an image.

> Subject placement, leading lines, lens choice, depth of field (or lack of it), color harmony, tonal range, and lighting can all have a profound impact on the final look of an image.

RULE OF THIRDS

As we have seen in previous chapters, many different formats are available to the photographer. What they all have in common is that each is a section of a greater reality. Whether we are thinking in terms of the 2 × 3 aspect ratio of 35mm, the 4 × 5 ratio of a view camera, or the square frame of the 6 × 6 camera, we must consider what ultimately will be included in the frame of the image. Beyond the restrictions of the native format of whichever camera is in use, image-makers always have the option of cropping the image to realize their vision of the scene. This makes some form of previsualization useful, if not essential, to the creation of good images. A concept known as "the rule of thirds" can often be helpful in this previsualization.

Any frame, no matter what its aspect ratio, can be divided into thirds. Elements in the composition take on added importance when they are placed at or near the areas where the lines cross. These areas are commonly referred to as "crash points."

Another aspect of composition is known as a "leading line." A *leading line* is a naturally occurring shape or line in a photograph that leads the eye into the main subject. You can see this phenomenon in the next picture. To help you visualize the concept, we've drawn an arrow showing that the lines of the dock draw your eyes upward and to the right, exactly where the lighthouse happens to be.

You can see the rule of thirds at play in this image.
You'll also notice a diagonal leading line indicated by the arrow.

The lighthouse is placed in the right third of the frame, and is visually balanced by the flag in the left third. The base of the lighthouse is almost directly on one crash point, and the flagpole is very close to another. The docks in the lower third of the image give a base to the

composition, although their tones are dark enough to keep them from distracting from the main subject.

The lighthouse itself shows just enough detail to hold the viewer's attention. Although the brightest area of the sky is close to the center of the composition, you'll notice that it's slightly off-center to the left.

Another consideration is that the photographer chose a location where the camera is slightly elevated above the level of the docks. This allows the viewer to look down into the dock basin rather than looking straight across it. The elevation also creates a more expansive sky and avoids having to point the camera up to catch the top of the lighthouse. The result is a very compelling, interesting, even striking photograph.

Now that the composition techniques used in this photograph have been pointed out, it's easy to see how the rule of thirds (combined with imaginative camera positioning) can really make the difference between a mediocre and an outstanding photograph.

Let's look at another example.

Compositional elements work together to make this image more than a snapshot.

In this familiar image, which we analyzed in Chapter 6 for lighting effects, the baby's head is purposely positioned slightly off center (to

the right) and high in the frame. Her left eye is precisely on a crash point, and the blanket forms a strong diagonal leading line. This line directs the eye quickly to the main point of interest. The vertical line formed by the blanket to the right of the face helps keep the eye of the viewer from leaving the composition, and the gentle curve there directs the viewer back to the baby. Cutting off the blanket at the top of the image keeps the eye inside the area of interest and adds a little tension to the image due to the abrupt edge. The low camera angle helps to make the small subject more important. As simple as this image is, these compositional elements work in harmony to create a sense of completeness and give the image a chance to stand on its own as a finished piece.

PERSPECTIVE

The use of perspective helps to give a three-dimensional feel to the two-dimensional image that is a photograph. The photographer can control perspective in a variety of ways. Lens choice, camera position, and angle of view all have an effect on our perception of perspective.

The level camera (not tilted up or down) records vertical lines as straight and parallel. When a *rigid camera* (one on which the lens is not adjustable in relation to the film plane) is pointed up or down, vertical lines inside the frame are distorted, appearing to recede in the direction in which the camera is tilted.

In the image of the lighthouse shown earlier, the camera position was elevated above the level of the docks. This allowed the camera to be held level and square to the plane of the ground while still encompassing enough inside the frame to tell the story of the image. Distortion from tilting the camera can be used creatively, as when a distorted image is made for effect, but more often this type of distortion should be avoided. One example of this distortion as a disadvantage is a view of a building when the camera is pointed up to include the top — the result is a shot that looks as if the building is about to topple over. Interior shots also exhibit this phenomenon, showing severely tilted walls whenever the camera isn't level. Study the two following images to see how perspective can be corrected as well as used to enhance an image.

> When a rigid camera is pointed up or down, vertical lines inside the frame are distorted, appearing to recede in the direction in which the camera is tilted.

The image on the left was made with a 6 × 6cm camera equipped with a 40mm lens. This is quite wide for the format, and, as a result, the picture exhibits noticeable distortion of perspective. The image on the right shows corrected perspective from the same viewpoint. This type of correction can be made with an adjustable camera (called a "view camera") or through image-manipulation software, as was the case

here. Notice that even though the vertical lines have been corrected, we are still drawn into the image by the converging lines. This use of perspective adds a three-dimensional quality to the image.

Often perspective can be used to draw the viewer into the image. Whenever there are lines in the image that seem to converge, the eye attempts to follow them to their point of convergence, referred to as the "vanishing point." It makes little difference whether the lines are diagonal or straight, the apparent perspective still draws the eye. In the preceding image of the swimming pool, for example, there are many converging lines, which draw the eye of the viewer into the image. This use of perspective helps places more emphasis on the sitting area to the rear of the composition. Note that the dining set in the image is placed on the upper-right crash point, adding further emphasis to what is a small but important component of the image. Camera position also plays an important role here. The image was made from a second-floor balcony, which has a view down into the pool area. This angle of view shows the various elements that make up the pool and sitting area from an unusual perspective, adding to the initial impact of the image, and possibly causing the viewer to linger just a moment longer over the photograph.

> Whenever there are lines in the image that seem to converge, the eye attempts to follow them to their point of convergence, referred to as the "vanishing point."

Perspective plays in important role in this image, as the converging lines suggest that the mallet keyboard extends some distance beyond the frame.

Take a moment to study the effect of perspective in this image of a mallet keyboard. The area of primary interest is placed on the lower-right crash point and is also one of the brightest areas in the image. These factors direct the eye of the viewer to the area the manufacturer wants to emphasize. The instrument is sectional, and each section represents a scale. The impression is that the musician can use as many scale sections as needed to customize the instrument. The open area to the left of the instrument is useful to the designer as a place to position type for the ad, which was the ultimate use for this image.

Through the Lens

As we have seen with the three previous images, camera position is also often important to the ultimate success of an image. Such thought must be given to the point of view of every image. When you approach the scene you want to photograph, keeping an open mind is important to allow the particulars of the area to suggest several possible points of view. Often the most obvious one is not the best.

CAMERA POSITION

Decisions concerning camera placement must be made whenever an image is shot. All too often the camera is simply raised to eye level and the button is pressed. This rarely results in the best possible image in any given situation. The photographer must consider whether a high or low angle might work best, whether to move to the right or left, or even whether to climb a tree or get on the roof of a nearby building. At times, just lowering the shooting angle by crouching down can lend a sense of impact to an otherwise ordinary shot.

When approaching a scene you want to photograph, there are often several considerations. At times the scene is static and can be analyzed before the first exposure is made. At other times the area to be photographed is in motion, and the scene is changing as the photographer tries to get the shot. This is often the case in sports photography and when shooting breaking news. Taking the time to analyze a scene before shooting, whenever possible, facilitates the best kind of snap judgment so often critical to the photographic event.

> All too often the camera is simply raised to eye level and the button is pressed. This rarely results in the best possible image in any given situation.

When shooting a subject that is positionable according to your wishes, the potential positions of your camera are virtually unlimited. Often there are many possible positions, any of which is capable of producing a memorable image. For example, imagine shooting a place setting on a dinner table. Two possible camera positions that might come to mind are the camera placed where the eye of a person seated at the table would be and, as an alternative, the camera placed immediately overhead. The first camera position results in an instantly recognizable image, as everyone is familiar with that point of view. The alternative overhead angle offers a less typical point of view, and, for that reason alone, might cause a viewer to look at the image just a little longer. It also offers a better look at the shape of the plate and other accessories, which could be a plus in this situation.

Professional photographers can frequently be picked out of a crowd of amateurs by noticing their extended coverage of any particular subject. Experience has taught them that there is often more than one way to look at a scene, so they try to capture as many different points of view as possible whenever the opportunity presents. They make both vertical and horizontal compositions, whenever possible, and shoot from many different angles. This extended coverage allows the art director or designer some latitude when placing the image into a page layout or ad.

The best way to develop skills in this area is to get out and take some pictures with camera placement firmly in mind. Explore as many options as you can think of, and review the images. It will soon be

evident that some images work better than others. Analyze the better images to determine what works best for you. As photographers, we all have a unique vision, and what is just right for one may not work at all for someone else. This is, after all, a matter of perception, and it is rare to be able to say that any one way is the best or only way to see a scene.

Professional photographers can frequently be picked out of a crowd of amateurs by noticing their extended coverage of any particular subject. Experience has taught them that there is often more than one way to look at a scene, so they try to capture as many different points of view as possible.

As you examine the next two photographs, keep in mind the impact of well-chosen camera positions. The image of the barn just needed the camera moved a few feet to the left to improve the composition. The image of the model home required renting a lift to place the camera precisely where the photographer wanted it. While you might find renting a lift an extravagance for personal work, in this case the expense was justified in order to produce images used in the sales material.

For example, the following pair of images of a barn in Ocala, FL shows that often the most obvious camera position is not the best. The unobstructed view at the top left was the initial approach and worked well, as far as it goes.

The bull was moving along as it was grazing, and the image was made as quickly as the tripod could be set up. After frantically making the initial exposures, the photographer found a better camera position in a grove of trees somewhat to the left of the original position. By the time the tripod was repositioned, however, the bull had left the scene (and would have been hard to direct anyway). By combining the two images with image-manipulation software, the photographer was able to create a more-striking composition than either image alone. The framing effect provided by the trees and foreground foliage add a three-dimensional quality to that image, helped by the relatively shallow depth of field that keeps the foreground elements soft and forces the eye deep into the composition.

Another example of the impact of camera position is the following image of a model home. The camera was set up on a lift truck and raised about 15-20 feet. This unusual camera angle catches the attention of viewers more accustomed to images of this type shot from ground level. In addition, the raised camera position allows the viewer to look down into the front yard, which shows off the landscaping.

LENS CHOICE

Today's photographers enjoy a broad selection of available optics. From extreme-wide-angle lenses, which can bring the viewer inside the scene, to ultratelephoto lenses, which bring the viewer close to sometimes-dangerous action, the choice of lens can completely alter the final image, even from the same point of view.

Sometimes camera position is restricted by the conditions imposed by the shooting area. Sporting events, for example, often restrict the

areas from which photographers can shoot, due to safety considerations. Photographers, being the kind of people they are, would often risk life and limb for a great shot. Auto racing, in particular, has been made safer for both the drivers and those who shoot the races by the liberal use of concrete barricades and safety fencing. To accommodate the needs of video and still photographers, camera ports are cut in the fences at points of interest around the course. Even at these locations, lens choice can result in completely different images, as seen in the next set of images.

Sometimes camera position is restricted by the conditions imposed by the shooting area. Sporting events, for example, often restrict the areas from which photographers can shoot, due to safety considerations.

These photographs, made at the inaugural running of the St. Petersburg Grand Prix in Florida, show different images made from the same camera position. The photographer on the left, working with a wide-angle lens, captures images much like the one at the lower right, while the long lens used by photographer 0129 shows the action earlier in the turn. Both images convey the excitement of this high-speed turn. The stresses these cars are under can be seen in the twisting of the chassis and the right-rear tire of the car in the wide-angle shot.

The cars pass the camera position at such high speed that even a shutter speed of 1/500th of a second still shows motion blur. You can see the effect if you look closely at the wheels and tires.

Lens choice is also a consideration when the subject is less dangerous and more cooperative, as when photographing people for publication or personal use. The following images were taken at the Leepa-Rattner Museum of Art in Tarpon Springs, FL for an article in *Tampa Bay Magazine*. These photographs illustrate how different focal-length lenses can be used to create widely differing images of the same subject. On the left we have a conventional head-and-shoulders portrait using a long lens. The 200mm optic frames the subjects tightly and softens the painting used as a background. The image on the right was made with a wide-angle lens to show the museum environment, including the architectural details.

The image on the left was made with a 70-200mm zoom lens and the other with a 15-30mm zoom. The 70-200mm, used at the longer end of its zoom range, framed the couple tightly and allowed the artwork used for the background to go slightly soft, making the subjects pop. In the environmental shot, the wide angle was used to include the interior of the museum. (As a side note, the wide-angle image was made with tungsten light, through a translucent light panel, to match the existing room light, while strobe was used, also through a translucent light panel, for the close-up shot.)

Following is another example of the effects of lens choice on perspective, the position of the subject within the frame, the feel of the picture, the apparent location of the photographer relative to the subject, and the immense impact focal length has on the end result of your efforts.

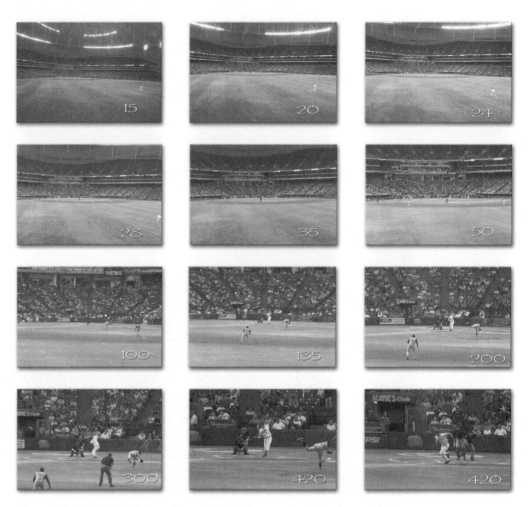

These images were made on a Canon D-60 with a magnification factor of 1.6.
The actual focal lengths are shown for each shot.

Leaving the comfort of his first-base seat, the photographer walked to the center of the outfield and took these pictures with four different lenses. The difference in perspective and detail is quite apparent: from hundreds of feet away, with a supertelephoto lens, you can see almost the perspiration on the player's forehead.

Photographers today have an incredibly wide range of lenses from which to choose. Manufacturers have pushed the envelope at both ends of the scale, resulting in high-quality wide-angle and telephoto optics, previously either unavailable or priced beyond the reach of most image-makers. Computer-aided design techniques have stream-lined the complex process of lens design and, for the most part, elimi-nated poor designs. In years past, a basic professional kit would include a moderate-wide-angle (28-35mm), a 50mm normal, and a

short-to-medium telephoto in the 100-200mm range. Today many pros and many amateurs carry a selection of zoom lenses that cover the spectrum from 15mm to 300mm. With the addition of tele-extenders, designed to work with the longer lenses, the range is often extended into the 400mm range and higher. This versatility allows photographers to capture images as never before. Also more available today are special-purpose lenses, such as macro and tilt-shift optics. *Macro lenses* are specially corrected for shooting small objects at very close ranges. Most lenses of this type allow the photographer to capture an image at 1 to 1. This means that the image of the object on the film or chip is the same size as it is in life. Tilt-shift optics enable some of the movements associated with view cameras to be used on rigid camera bodies, allowing some perspective correction and depth-of-field control at the time of exposure.

Lens versatility has long been the strong suit of the 35mm format. With the advent of digital imaging, this versatility has opened up to image-makers who have traditionally needed larger-format film in their work. Since most imaging chips are smaller than or the same size as 35mm, film manufacturers have made the logical step of incorporating them into SLR bodies that use the same lenses as their high-end film cameras. Features such as auto-focus, fast maximum aperture, and extended zoom range are sure to become common for these cameras, as well.

SUBJECT POSITION

Often the photographer has at least some control over the position of the subject within the frame. In the earlier museum images, the cooperative couple could be posed at the discretion of the photographer. In the wide-angle shot, they are placed at the lower-right crash point, with the strong leading lines of the bench and floorboards bringing the eye to them. In the close-up image, they dominate the frame and are the brightest and sharpest items in the shot, bringing the viewer's attention where it is supposed to be.

Even when all aspects of the scene are not under the control of the photographer, like the bull in the image of the barn shown earlier, image-manipulation software can often allow the image-maker to recreate the image that was intended from portions of other shots.

Experimentation is the best and quickest way to learn about subject position. With the advent of digital technology, images are quickly available for examination and critique. Take advantage of the reusability of digital media, and shoot lots of images; soon you will be able to previsualize the image you are after. When this is the case, the battle is more than half won because, when the final result is in the mind of the image-maker, the rest is just construction.

DEPTH OF FIELD

There's an intimate relationship between shutter speed and aperture. The aperture setting controls how much light hits the film, or how large (or small) the opening is that lets light into the body. Shutter speed also affects the amount of light coming in. Naturally, a faster shutter speed gives the light less time to hit the film (or recording) surface. Combine shutter speed and aperture settings and you gain a tremendous amount of control over background focus, moving subjects, lighting conditions, and a whole host of other factors that can make or break that once-in-a-lifetime photo opportunity.

Depth of field refers to how shallow or deep is the area of the photograph that's completely in focus — looking at foreground, middle ground, and background. It's a direct result of the aperture setting you select before you take the picture. The smaller the opening of the aperture (the higher the f-stop setting), the more focused the entire image becomes — even the background behind the subject. This factor impacts close-ups as well as any images that fill the viewfinder.

The following image offers a simple way to understand the relationship between depth of field and the f-stop you use when taking the shot. The flower on the left was taken at an f-stop of 22, resulting in the aperture opening only a tiny bit. On the right side, the aperture was set to 2.8, and the opening in the aperture is almost as large as the diameter of the entire lens. The smaller opening was combined with a slower shutter speed, and the entire flower — even the petals in the back of the picture — is crisp and clean. On the right, you can see that only the very foremost petals are focused; the back petals — even though they're only a fraction of an inch away from the front of the lens and the surface of the film — are blurred and out of focus.

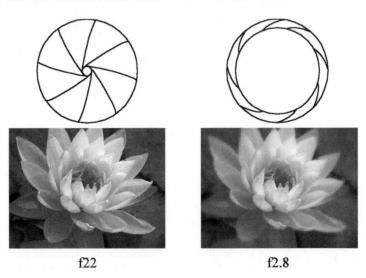

f22 f2.8

At f22 and a 1/30th of a second shutter speed, the entire flower is in crisp focus; at f2.8, only the foremost details are clear.

Another way of looking at the issue is to say that *depth of field* is the range of sharp focus evident in an image. Effective control over and use of depth of field is one mark of a seasoned photographer. Done well, you can soften the foreground to frame a scene, while encouraging the eye to slide past the frame and enter the image. A shallow depth of field also has the effect of causing a sharp main subject to stand out.

> ◼️◀ Done well, you can use depth of field to soften the foreground to frame a scene, while encouraging the eye to slide past the frame and enter the image. A shallow depth of field also has the effect of causing a sharp main subject to stand out.

You can clearly see the effect in the following image; both the foreground and the background are slightly out-of-focus — the result of excellent control over depth of field.

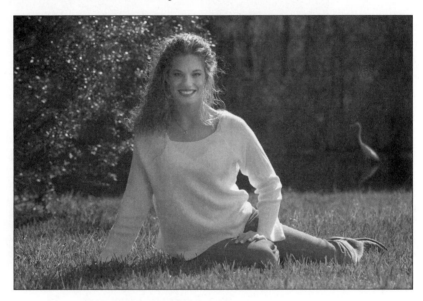

You can see the effect of depth-of-field control both in front of and behind the model in this image.

This image demonstrates how a soft background can help the subject. A relatively long lens used at a wide aperture creates a shallow depth of field. Look at the grass to see where it is soft in front of the model and again goes soft just behind her. The eye is drawn to the sharpest area of an image, in this case the young woman; the background conveys some environmental information without becoming too important.

Depth of field can also work to create a composition that seems to go on forever. Wide-angle lenses at small apertures extend the depth from several feet in front of the lens to infinity, offering the image-maker another tool with which to work. In the following image,

everything is sharp from the silhouette of the young woman watching the sunset to the horizon itself.

Depth of field is controlled through the aperture setting on the lens. Smaller openings extend the zone of sharp focus while larger openings restrict the sharp focus to a shallow area. When used in conjunction with appropriate shutter speeds, this allows the photographer to control the areas that are sharp or soft in any given situation.

Depth of field can also work to create a composition that seems to go on forever. Wide-angle lenses at small apertures extend depth from several feet in front of the lens to infinity.

The extended depth of field offered by wide-angle optics at small apertures seems to go on forever.

Summary

In this chapter we have explored composition and how it is affected by perspective, camera position, lens choice, subject position, and depth of field. We've learned about the rule of thirds, and how crash points and leading lines both add to the effectiveness of the image without being apparent to an untrained eye. Composition is a subtle, yet incredibly important consideration when you're looking to capture that perfect image.

PEOPLE, PLACES, AND THINGS

The vast majority of the photography that's done in the world today falls into three broad categories: capturing effective images of people, places, and inanimate objects, and that's what you explore in Section 3.

The first category — taking pictures of people — is by far the most popular among amateur photographers. Whether it's photographs of the grandkids, a wedding, or just a group of people sitting around doing what they do best — pictures of people are often the most important ones you'll ever take.

To improve the quality of your pictures of people, you first learn about the difference between candid photography and controlled photography. Candid images are often the most popular, and show people who were either unaware they were being photographed or involved in an activity at the time so apparently unaware of the process. Controlled photography occurs when the subject is looking into or conscious of the lens — posing and fully aware that this image is being preserved for posterity.

Taking pictures of places is another category that comes with its own special requirements and considerations, Travel photography falls into this category, as does photojournalism. In this chapter, you come to understand the use of wide-angle lenses in location photography, and how artificial lighting can dramatically enhance what natural lighting happens to be available. Shooting cityscapes at night, sunsets and sunrises by day, and composition are all discussed in the context of location imagery.

Lastly, you discover how to take better pictures of things — objects both big and small. In fact, the discussion of this type of photography starts out with the division of subjects into two broad size categories: objects that can fit on a table and those that can't. You learn about shooting static objects, as well as requirements for shooting objects on the move. Concepts you're already familiar with, such as composition, lighting, lenses, and depth of field attributes, are discussed in terms of product photography.

Take the knowledge you picked up in the first two sections, and combine it with the issues covered in this one, and you're going to be well-equipped to approach almost

any photography assignment with confidence. As you know, shooting many images is the real learning experience — not just reading a book. But if you take what you'll know at the end of this section and devote some time to looking through the viewfinder, you might be surprised at the result of your efforts.

People

In this chapter, we explore the most popular of all photographic subjects: pictures of people. The family portrait that hangs above the sofa in the living room and is a prized possession, the wedding album that holds the memories of a special day and becomes a part of the family history, images of workers and executives used to promote business, even news photographs from around the world — all feature people as the principal subjects.

In many ways, taking pictures of the people around you is the most challenging task you face when you assume the role of the photographer. When you take a picture of a building, a product, or some remarkable scenery, the object of your attention remains relatively constant. True, fall foliage might require a different film and lens selection than the same scene would in the wake of a nighttime snowfall, but the landscape and topography don't change all that much from year to year.

That's certainly not the case with human subjects; in fact, no two moments are the same for a person. Facial expressions, color, mood, and mental and physical activity at the moment you're taking the picture — all impact the results of your efforts.

Good lighting and casual posture can result in an apparently candid image that's really not.

Until this point, our discussions have been somewhat academic. You've read about equipment, lighting, and composition. Now you're going to see exactly how these concepts are applied in the real world.

In general, pictures of people can be broken into two main types. Those in which the subjects are actively engaged in (and cooperating with) the photographic process, such as portraiture, fall under the heading of *controlled photography*. Those in which the subjects are either unaware of being photographed or are engaged in an activity that requires their concentration (so apparently less aware of the photographer) are considered *candid photography*.

The first step in taking a good picture is visualizing what you want from the photograph before you do anything. This is true regardless of the subject matter, but particularly true when taking pictures of people.

In this chapter, we discuss posing and positioning your subjects, and explore some ideas and techniques for taking successful pictures of the people around you.

Controlled Photography of People

Images made with the cooperation of the subject, most often under controlled conditions of location, time of day, and lighting, are often referred to as "formal" or "controlled photography."

There are two obvious advantages to shooting under controlled conditions. First, you're able to either build or select a location or environment that's perfectly suited to the results you want to achieve from the process. Second, in a controlled situation, you're able to concentrate more on factors like the expression on the person's face, as well as the pose, posture, positioning, and other conditions, all without having to deal with technical issues "on the fly." There are many fewer surprises if you're able to control the time, place, and conditions of the shoot.

This isn't to say that producing effective conditions for a professional-quality photo shoot is something that you're going to learn by reading a book or two. The more you learn about lighting conditions, interaction with models (sometimes called "the sitter"), and the limitations and advantages of the equipment you're using, the better your results will be. This isn't only true when you're taking pictures of people, however — it's true for all aspects of photography.

Another factor that comes into play under controlled conditions is the cooperation of the subject — something you can't always take for granted.

> ☞ In a controlled situation, you're able to concentrate more on factors like the expression on the person's face, as well as the pose, posture, and positioning without having to deal with technical issues "on the fly."

Cooperation is evident at events such as weddings, reunions, corporate-event coverage, and parties. At all of these, the photographer is an invited participant, delivering a needed and wanted service. Of course, the level of cooperation varies, depending on whatever else is demanding the attention of the people involved. In general, if the photographer is diplomatic and has good interpersonal skills, the subjects respond with enough enthusiasm to allow very good images. It is the photographer's job to make the experience of being photographed as pleasant as possible, while working in an efficient manner. This is accomplished by a thorough knowledge of the technical aspects of the craft as well as a clear understanding of what shots are needed in each situation. This type of preplanning helps the session go smoothly and keeps those to whom the images might not seem important from becoming bored or restless.

LENS CHOICE

The most commonly used lens for photographing people is a short telephoto. The perspective you achieve when using this type of lens is flattering to the shape of the human face. This might sound strange, but it's true: faces shot with the correct lens are rendered in a more pleasing manner. The incorrect lens can change a person's facial character to a degree that would surprise a lot of people.

This is not to say that other types of lenses are never used. Sometimes special environmental considerations dictate the use of wide-angle or supertelephoto optics, but generally these are used for creating special effects. In recent years a trend has developed of using wide-angle optics from a point above and close to the subject, causing intentional distortion. This can be effective as an attention getter, but rarely presents the subject in a flattering manner. The image on the right shows an effective use of wide-angle optics when creating a composite image.

Although this example shows what can be done with alternative optics, a short telephoto lens, in most situations, is more appropriate

Two images shot with a very wide (40mm on 120 film) lens were merged using Adobe Photoshop to create this arresting final image. While the image of the human model is clearly distorted, it nonetheless works to give the impression of movement as she leaves the cannon.

to the task. Good choices for this category of lenses include an 80-105mm for 35mm, or a 150-180mm for medium format.

Let's take a look at two examples that were shot using short telephoto lenses. You'll be able to see the difference almost immediately. The first photograph is a family portrait taken at a preselected outdoor location.

Controlled Conditions — Case Study 1

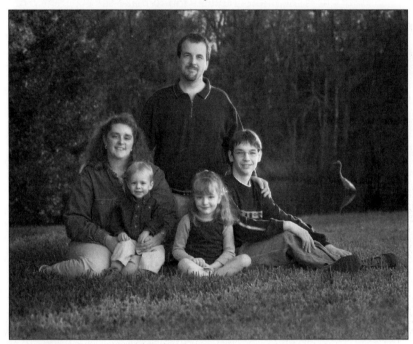

This family portrait is a prime example of the effect of a short tele-photo lens on an image of people. The lens causes a slight compression of the scene, which creates the impression that the trees on the other side of the pond are closer than they actually are. This has the effect of filling in the background and providing increased interest. At the same time, the depth of field is soft — the result of a larger aperture opening. (As you recall, a lower f-stop number means a larger opening in the aperture when the shutter button is pressed.) This soft yet interesting background causes the subjects to pop, or stand out in the photograph.

In addition to lens choice, this photograph illustrates other advantages of controlled conditions. The image was taken by afternoon light, which was coming from the left side of the models (the right side of the image you're seeing). You can see this if you take a good look at the *highlights* (the brightest areas in the scene); just look at the father's shoulder, the son's hair and arm, and the back of the lovely wading bird seen in the background.

Just off camera to the right is the family's house. Light is reflected from the white-painted wall into their faces, creating studio-quality lighting for this outdoor family portrait. The choice of location made this image work well on a number of levels, as the excellent light quality allowed the photographer to concentrate attention on the young children's expression and pose without distraction. A proven technique used by many professional portrait photographers is to scout the location ahead of time. In this way, you can identify one or more areas where light and background work well together to maximize the people images you're planning to create.

> Many professional portrait photographers scout the location ahead of time to identify one or more areas where light and background work well together so they can maximize the people images they're planning to create.

Controlled Conditions — Case Study 2

The next set of photographs also represents controlled conditions. This time the images were shot inside a studio. Whether you're shooting inside or outside, the more control you have over environmental conditions, the more opportunity you have to interact with the people being photographed. This results in a level of spontaneity that's apparent in the images.

The model commissioned this series of images to be part of her portfolio. Since these portraits were meant to be presented to professionals in the advertising and modeling industry, it was important that they show her prospective clients how well she works in front of a camera, not how well the photographer could control lighting conditions. The images on the left and right were shot in a studio, and the center image was taken at the same location as the family portrait we just discussed.

In the studio images, a large translucent light panel was placed high and in front, with a reflective panel placed just below the model. This technique helped to brighten the shadows. The small studio where it was shot is painted white; white is quite reflective, and bounces light onto the model.

The background was created using seamless white paper. It appears to be light gray, because the photographer intentionally underexposed the shot. This type of light allows the model the freedom to change poses and work for the camera while providing consistently soft illumination. The outdoor location required more discipline from the model; the natural light is strongly directional, so the subject needed to work with her face toward the light.

POSING AND LIGHTING

Taking pictures of people offers unique challenges, one of which is that the pose assumed by the subject has a tremendous impact on the quality and the effectiveness of the results. *Posing* is the position in which you place the subject relative to the lights and the camera lens. It's not a simple subject, but we'll give you enough information to get started.

Once you've come to understand these concepts, take the time to experiment with real live people. You'll be amazed at how much better your portraits and people pictures will turn out armed solely with a few basic posing concepts.

Lighting and Its Effect on Posing

There are a number of different poses, each of which offers specific advantages or disadvantages for the general appearance and build of the subject being photographed. These poses were developed over many years and through the creation of thousands of photographs, and each provides specific results. Once you've become familiar with them, you'll know immediately where to put your subject and where to put your primary lights.

We've supplied a series of drawings to illustrate the different positioning options. In all cases we've drawn the pictures from above — looking down at the subject, the camera, and the lights. This angle enables you to easily see how the pose is meant to be staged. To better indicate the direction in which the subject's face is positioned in relation to the camera, we've added a baseball cap on each person's head.

A few points to keep in mind when selecting the proper pose for a specific subject are also important:

- **Skin Type.** Other than children and people who have naturally smooth skin, most people display visible texture in their skin. Some have what's referred to as "ruddy" skin — exhibiting a reddish tone often associated with exposure to the sun and the

elements (although it might instead be the result of high blood pressure or a little too much liquor). Others have facial hair, the evidence of adolescent skin conditions, or a hundred years of wrinkles and character. Each face is — thankfully — totally unique and individual.

- **Apparent Width of Face.** Some people have very narrow faces, showing distinct facial structure; others have wider faces. How you pose and light such faces can either make a wide face look even wider, or a narrow face even thinner. The idea in this case is to add width to narrow faces and reduce the apparent width of wide faces.

Rembrandt Lighting

A commonly used type of lighting for portraits is known as "Rembrandt" lighting, so named because the great master (and many other portrait artists) used this lighting type in his paintings.

When achieved using relatively hard (small) light sources, Rembrandt light can emphasize skin texture. Larger or softer sources minimize this effect. This light pattern can be used to alter the apparent width of a face. When the shadow side of the face is closer to the camera, the face looks thinner; when the highlight side is closer to the camera it will look wider.

The subject's face is turned towards the light, with the eyes on the lens of the camera. The light is in front of and to the right of the camera.

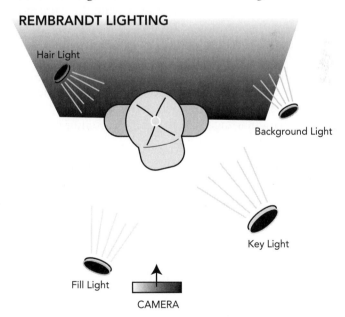

REMBRANDT LIGHTING

Hair Light

Background Light

Key Light

Fill Light

CAMERA

This pattern is defined by a triangular highlight on the shadow side of the face, and is often used in low-key (darker) images.

Split Lighting

Split light, as its name suggests, lights only half of the face. The key light is positioned at appoximately ninety degrees to the left or right of the subject. This pattern is often used on men because it makes a strong statement that works well on a more rugged face.

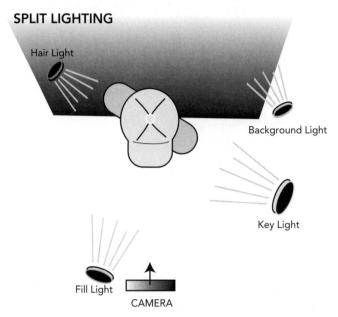

SPLIT LIGHTING

Hair Light

Background Light

Key Light

Fill Light

CAMERA

A fill light is placed even with the camera and higher than the lens. The key light is further away from the camera than in Rembrandt lighting, and to the right of the subject's face.

Loop Lighting

Loop light is closely related to the Rembrandt pattern. The difference is that the loop of shadow formed by the nose does not join with the rest of the shadow side of the face. Loop lighting thus breaks the triangular highlight that defines Rembrandt.

LOOP LIGHTING

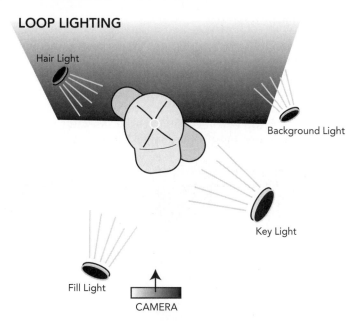

Butterfly Lighting

Butterfly light results from placing the key light high and in a direct line with the subject's nose. Usually the subject is asked to look up and into the light. This pattern calls attention to the eyes and cheekbones and causes its namesake shadow under the nose.

BUTTERFLY LIGHTING

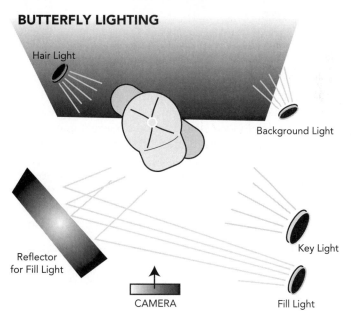

Variations

Naturally, there are many variations on these basic themes. For example, you can turn the body in the opposite direction in any of these examples. Each variation — particularly those involving the key and fill lights — produces different results. If you start with these standard poses, understanding what happens when you make changes to the setup becomes much easier. As you gain more experience, your ability to shoot professional-looking portraits will develop quickly.

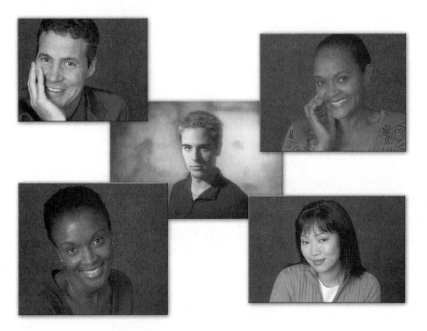

In the preceding montage, you'll see a number of different poses and lighting configurations. Take a moment and try to determine, in each instance, where the key and fill lights were positioned in relation to the model and the camera, and the exact angle and position of the model's shoulders in relation to the position of the photographer and the lights. To get you started, note that the center image represents classic Rembrandt lighting, while the one on the lower right displays Paramount lighting. The other three are not purely any one category of lighting; they illustrate variations on the basic themes and visually accentuate physical characteristics of each individual.

Once you've mastered the basic types of poses, the creative possibilities are almost limitless with only slight variations in the position of the subject's body and face in relation to the lighting.

LIGHTING CONDITIONS

In Chapter 5, we discussed indoor and outside lighting conditions and techniques. We discussed use of natural light, and setting up different types of artificial lights as well as using other supplemental equipment that can create and enhance lighting effects.

The studio provides the ultimate controlled conditions, ideal for photographing models and other sitters. While you will organize your own studio to suit your personal working style (and budget), consider the following example as a means of understanding how one can organize a small but efficient space, both for lighting and other conditions.

The following studio lighting setup illustrates a simple solution to creating a pleasant, soft light for model work. This studio is small, by most professional standards, with definite limitations and advantages. This space is adequate for photography of up to five people (cropped tightly, not full length), but is very good for smaller groups, couples, and single sitters. Babies also don't require a lot of space, and the white painted walls keep the lighting very open and soft.

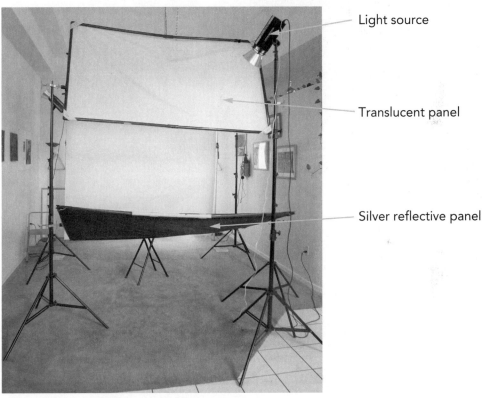

Light source

Translucent panel

Silver reflective panel

This image shows the lighting setup for the studio shots of the model seen earlier in this chapter. The light source is arranged so it shines through the translucent panel directly onto the reflective panel, creating a very soft and even light at the subject's position. The legs of a stool show the area where she was positioned. The other light visible at the left rear of the set adds some bounce off the walls and ceilings and helps adjust the level of exposure on the background.

Larger studio spaces, of course, offer more separation between subject and background, thus allowing the flexibility of lighting each separately. This gives the photographer greater control over the final outcome.

As we've already discussed, taking good pictures indoors (whether in a studio or not) presents a special set of challenges, because under

natural conditions, there isn't very much light inside a structure and what there is tends to somewhat weak.

If the room is lit from an outdoor source, try to use indirect light from, if possible, a north-facing window or another window that isn't admitting direct sunshine. Overly bright outdoor light sources, when used indoors, often produce harsh, hard shadows. Also, consider positioning yourself and your subject so that light from a window illuminates the model's face.

In addition to appropriate lighting, the right clothing, hair styling, and makeup can contribute dramatically to a successful portrait.

The key is the cooperation between the photographer and the subject. This cooperation allows you to preplan the session so you can be totally prepared when the session starts. Deciding in advance what the final image will be allows you to make this kind of preparation.

Candid Photography

The *candid image* is, by definition, one in which the subject is either unaware of the photographer or engaged in an activity that diverts attention from the photographer, such as participating in sports or performing arts. In both circumstances, participants are surely aware that they are the focus of numerous cameras, but find it such a common occurrence that they barely notice it, for the most part.

The candid photographer must be comfortable with the equipment for the specific job in order to be able to watch for the expression, light, and precise instant when it all comes together to make the exposure.

Documentary photography, photojournalism, travel photography, and even the photography of the infamous celebrity paparazzi all involve shooting subjects who range from the unaware to the openly hostile.

In order to deal with the many challenges of candid work, the photographer must be comfortable with the equipment chosen for the specific job. This familiarity is important in order to be able to watch for the expression, light, and precise instant when it all comes together to make the exposure.

These candid images of a street artist in Cozumel, Mexico were made with a digital point-and-shoot camera. The final image in the series was posed with the cooperation of the subjects.

THE SHOT THAT IS REMEMBERED

Often candid images suffer from a lack of technical quality but are important because a significant moment has been captured. We have all seen the still images made from the Zapruder film of JFK's assassination. The image quality is poor, but the subject matter makes it compelling. This is often the case in the fast-paced world of photojournalism. It does not excuse poor technique, but to point out that, at times, the fact that an image was made at all can be more important than its aesthetic value.

> In candid photography, the fact that an image was made at all can be more important than its aesthetic value.

Given all of the problems inherent in candid image-making, it is clear that some candid images stand out from the rest. The ability of talented photographers to see a situation from a different point of view, prepare to capture some aspect of it, and anticipate the instant

when all of the uncontrollable elements come into alignment sets these image-makers apart from the rest of the pack. It is the photographer with the presence of mind to take a second look at whatever situation presents itself and see it differently from others who takes that one image that becomes a Pulitzer-Prize winner rather than one more image just like the rest.

So much is uncontrollable in candid photography. The light changes from one venue to the next and is rarely what would be considered good. Subjects, preoccupied with what they are doing, don't often position themselves in flattering poses or in the best light. Often today, photographic access is restricted, and even those allowed access may find themselves packed into a small area not well suited to image-making. Overcoming these obstacles and coming away with a good image is a mark of competence in the candid photographer.

These images, shot at the inaugural running of the Grand Prix of St. Petersburg, FL are representative of candid photography of people. In all cases the lighting was natural, supplied by the sun and intensified by the bright reflections from surrounding buildings and from the surface of the water of Tampa Bay, which was in direct proximity to the event.

SHOOTING INDIVIDUALS AND SMALL GROUPS

In many ways, the photography of individuals and groups is similar, differing mostly in the magnitude rather than the approach. People are people, after all, and they often respond to the efforts of a photo-

grapher in similar ways. Being photographed can be classified as an unnatural act; very few of us are subjected to this process on a regular basis, and it can be intimidating.

Putting the subject at ease is the first and most important ingredient in making a successful image. When working with a cooperative subject, starting a conversation before the picture-taking process begins can relax your subject. Getting your subjects to talk about what interests them (and really listening) can often overcome any uneasiness they may feel. When working with busy executives or celebrities, keep in mind that their schedule is often very tight so being prepared (set up, tested, and ready to go) is important. Often a real interest in what they have to say, however, buys you more time than they originally budgeted for the shoot. Having a plan for what you wish to accomplish keeps your shoot focused and on point.

When the session is more relaxed, as in an individual or family portrait, there is often room for experimentation. Save this for the end of the session, after you have made the more traditional shots. In that way, you have the security of knowing you have some good images on film or disc before attempting the more difficult lighting or posing challenges.

With an individual or couple, the traditional camera orientation is vertical or "portrait" (that's where the name in your software comes from). Don't be afraid to experiment with horizontal or "landscape" views. Many wonderful images of one or two people have been made that way.

Most often, move in close to your subject, making the person the most important element in the composition. Use the longer end of your zoom lens on a point-and-shoot or a short telephoto lens on a more sophisticated camera to avoid the unflattering perspective that results from close-up photography with wide lenses. If you only have a wide lens, as is often the case with fixed-lens point-and-shoot-type cameras, plan to include an appropriate environment for your subject. This is often a good strategy to employ with interchangeable-lens cameras and zoom-lens cameras, as well. Often the subjects' surroundings can help to tell a story better than a close-up. When possible, try to make several variations to give the subject some choice.

> Most often, move in close to your subject, making the person the most important element in the composition. When possible, try to make several variations to give the subject some choice.

This nontraditional, horizontal view of the model is effective due to the position of her arms.

The preceding two images, analyzed previously for composition, also demonstrate the strength of vertical formatting for pictures featuring people. In both cases, the format provides more interest and better composition. The one on the left shows the impact of close-up positioning of the subjects; the one on the right is equally effective while including a broad sweep of the museum where the images were shot, as well. Again, try to see the picture in your mind's eye before engaging the shutter — the results will show a difference.

When making portraits on a retail basis, an environmental image often sells at a larger size than a more traditional head-and-shoulders shot. Some photographers have made a specialty out of producing images that look their best only when printed at 20 × 24 in. or larger, often as large as 40 × 60 in.

SHOOTING LARGE GROUPS

Conditions change when groups are larger than five to seven people. Large groups become an exercise in crowd control as much as they are an example of photographic experience and skill. Precise portrait lighting is often impossible with groups of this size, and the best bet is to plan for even light at an intensity level high enough to provide the required depth of field. At one time, this type of image-making was such a popular specialty that cameras were designed just to photograph large groups. Called "circuit cameras" because of the clockwork drive that moved the whole camera in a semicircle, these cameras made large-format negatives of groups posed on grandstands arranged in a horseshoelike configuration. A popular stunt during this type of photography was for a subject to stand at one end of the group, and when the camera had passed his or her position, to run around the back of the grandstand and stand at the other end of the group before the camera had finished the exposure, thus appearing twice in the same image. Several of these cameras have survived or been restored, and the large-group photograph is making a comeback.

This image was made with an antique circuit camera.

Naturally, large groups can also be photographed with more traditional equipment. Usually a wide-angle lens is employed along with large umbrella-type light modifiers. The image is often cropped as a panoramic, and long thin prints are made. Family and high-school reunions are good prospects for this type of work. With today's digital-imaging techniques, prints are often delivered before the end of the evening's festivities.

Very large groups, on the order of hundreds or even thousands of people, can be more effectively photographed by placing the camera high — on a rooftop or a crane, for example — and

> ⊶ Very large groups can be more effectively photographed by placing the camera high and asking everyone in the group to look up at the camera.

asking everyone in the group to look up at the camera. The resulting angle keeps the depth-of-field requirements within reason, and a group of a thousand people can be photographed in less than an hour, including setup and teardown, given some cooperation from the group.

Summary

In this chapter we explored several techniques and considerations important for taking good pictures of people. We looked at the two primary categories — controlled and candid photography. With the high level of cooperation between the subject(s) and photographer in controlled photography, the photographer can optimize such elements as lighting, environment, location, facial expressions, pose, and more. In many ways, it's easier than shooting candids. When the subjects either are unaware that they're being photographed or are engaged in an activity that requires their attention, your focus is on rapidly assessing the particulars to identify the moment when the uncontrollable factors come together for that ideal shot. You learned about using lenses, lighting, careful positioning of the model, and other techniques to improve your chances that you'll achieve exactly the results you expect.

Places

Almost by definition, the photography of places involves shooting on location. In this chapter we discuss what to bring along to make the job easier, how to "shoot for the process" in this age of digital capture, and the inevitable crossover of disciplines that occurs throughout photography.

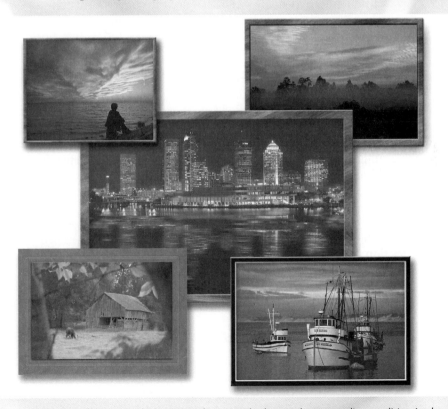

Landscape and cityscape photography have a long-standing tradition in the craft.
These images are a representative sample.

Many photographers, including some famous ones, prefer to shoot places rather than people. Landscape photography, both in color and in black and white, has long been a major part of the art and craft of photography. Perhaps one of the reasons landscape work appeals to so many image-makers is that it can be a solitary pursuit, if necessary. No great amount of equipment is needed beyond a camera, lenses, and, perhaps, a good tripod.

Working on Location

For some photographers, the very thought of moving outside the carefully crafted environment of their studio is frightening. Others welcome the challenge of location work, and have adapted both shooting style and equipment to the special needs involved. In large part, these needs are unique to each image-maker, according to the locations in which he or she shoots and the nature of the subjects.

Equipment needs for landscape photography are quite simple. This holds true for much of what's generally referred to as "travel photography," as well, where the subjects tend to be broader vistas, sunset, sunrise, and pictures of the city. Any decent camera with interchangeable lenses and a good tripod enables the photographer to capture the natural and man-made vistas that are the staple of this photographic genre. All camera formats have been successfully used to capture landscapes. The large formats have been the traditional ones, but today, medium format, 35mm, and digital are all being used.

As far as lenses are concerned, professionals normally use wider-angle lenses because of their ability to capture a broader range of the horizon. When we discussed lenses earlier, we mentioned that one good choice of lenses for beginners was a zoom lens. Many manufacturers offer zoom lenses that go from 28mm to 200mm (or something similar). The lower end of the zoom — when the effective focal length is infinite — represents a very common lens specification used by professionals for landscape or travel photography. A 28mm lens, by itself, can be quite expensive; as part of a zoom lens, its cost goes down proportionately, and the added ability of the zoom (200mm) function can bring far-away details and subjects close to hand, as if they were right next to you in some cases. (We discuss wide-angle lenses a bit more later in this chapter, so you'll get to see a few examples of their use.)

> The lower end of the zoom — when the effective focal length is infinite — represents a very common lens specification used by professionals for landscape or travel photography.

An important consideration, when working on location, is what else to bring. Items such as filters, tape (duct tape, that historically useful material often used to repair airplanes in flight, is a good addition to your road bag), clamps, stepladders, flashlights, weather protection,

and sun block, as well as appropriately warm, dry, or cool clothes, and transportation all contribute to the success of a location shoot. The photographer must give some thought to these items during the planning stages of the trip. In order to plan successfully for a location job, however, the first task is to decide the main purpose of the shoot, and what you and/or your client expect as an end product.

Under the loose heading of places, there are distinct subcategories. Are the areas to be photographed *static*, that is, stationary subjects like landscapes, cityscapes, properties, building interiors and exteriors, or landmarks? Is the subject, instead, an *event*, in which case the photographic discipline is almost certainly a combination of portraiture, photojournalism, and location, all rolled into one?

> If the subject is an event, the photographic discipline is almost certainly a combination of portraiture, photojournalism, and location, all rolled into one.

LANDSCAPES

As simple as this genre of photography appears on the surface (you just walk up and take a picture, right?), there are many points to consider when making a landscape image. Light, composition, lens choice, and more, all have important roles in the final outcome. Good light in landscape photography is something that the photographer

The long lens used here compresses the scene and allows the photographer to eliminate distracting elements. The various layers of the background are rendered larger than if a shorter lens were used.

can control only peripherally — by choosing the time of day to shoot. Of course, weather conditions can and do have an effect on the light as well; for example, thin clouds can lower contrast while still offering the look of a sunny day. Persistence and the willingness to wait may be the most important traits of the successful landscape photographer. These traits, along with the instincts that come only from experience, help to raise the success rate of these photographers.

One aspect that can be controlled by the photographer is what to include in the frame. By choosing where to stand and what lens to use, the photographer can add his or her own interpretation to the scene. A common misconception is that most landscapes are made with wide-angle lenses; while many certainly are, it is often the unusual perspective offered by a long lens from farther away that gives the viewer a unique view.

Shooting across a distance with a long lens flattens perspective and sometimes allows a new look at an often-photographed venue. Lens choice can also affect composition, as shown in the following image. The sun becomes an important compositional element when a long lens is used. This is because the long lens renders the sun much larger in the frame than would be the case with a shorter lens used closer to the bird.

> Shooting across a distance with a long lens flattens perspective and sometimes allows a new look at an often-photographed venue.

This image was shot with a long lens, not because the heron was unapproachable, but to make the sun larger in the background. Other shots made from closer to the bird with shorter lenses did not have the impact this one has.

After composition and lens choice, the final component needed to make an extraordinary image rather than just a record shot is exceptional light. Due to the size and nature of this type of subject, the photographer generally has little or no direct control over this critical component. In fact in most cases, all that can be done is to visit the area several times while getting a feel for when the light is at its best. Careful observation of the orientation of the scene (facing north, south, east, or west) and the surrounding terrain can help the photographer to make some preliminary guesses as to when the light might be best.

The sun rises and sets at different times of the day, and at different spots on the horizon, according to the time of the year. Books like *The Farmer's Almanac* can give you a head start by listing sunrise and sunset times by date. There is no substitute, though, for scouting the location before attempting to photograph. Observing the light as it plays across the subject from early in the morning to late in the evening gives the image-maker a depth of understanding, allowing a return at the best period of light over several days. This process helps to optimize the chance of making an exceptional image, as most often there is only a narrow window of optimum light, and that can be affected by other variables, such as weather.

If all this seems like a lot of effort, it is, which helps to explain why a relatively small percentage of photographers make a very high percentage of extraordinary landscape images.

If landscape photographs seem to require a lot of effort, they do, which helps to explain why a relatively small percentage of photographers make a very high percentage of extraordinary landscape images.

In general, early morning or late evening provides the best chances for great light, the sweet light discussed in Chapter 5. As you recall, during these times, the light is strongly directional yet lower in contrast, due to the sun's position near the horizon. The long shadows cast when the sun is low in the sky help to define the texture and detail of the subject, and often the atmosphere is clearer, as well.

MAN-MADE OBJECTS

Many of the same requirements as those of landscape photography exist when the task is photography of large, man-made objects, such as buildings, bridges, railroads, and other large items in their natural surroundings. An additional complication is added to the mix, because rarely are these objects positioned optimally for the needs of the photographer. North-facing buildings, for example, may only receive direct light on the front during a few days around the summer solstice, when the sun is as far north as it goes. Global position comes into play, as the best time depends on where the building is located.

Some front doors in urban situations never receive direct light due to the surrounding buildings.

Techniques have been developed to deal with these difficult situations. Graduated filters that darken the sky while leaving the lower portion of the scene untouched can help even a tough lighting situation.

Digital imaging enables you to seamlessly combine two or more images to extend the range beyond what any camera can capture in one exposure. The following image shows an example of what today's image-makers call "shooting for the process," i.e. for the processing after the photograph is taken.

The images on the left were combined in the one on the right to provide detail in the trees as well as detail in the sky and bright office spaces.

The image at the far left was exposed to optimize the sky and provide excellent detail inside the brightly lit office spaces. The center image was exposed for the shadow detail in the trees at the bottom of the image (perhaps even overexposing the trees a little). In the final image on the right, the two have been combined to create an image that shows good tonality and detail over a wider range than any camera could capture in one exposure. These images were made on 4 × 5 sheet film and scanned. The job would have been easier if they had been made digitally as, with care, the images would have fit perfectly, pixel on pixel; scanning makes it all too easy for some misregistration to occur.

The next image shows the problems inherent in shooting north-facing buildings. The lower image represents about the best that can be done in this situation and, as you can see, it is not very good. Even the use of a graduated neutral-density (ND) filter could not solve the contrast problems posed by this scene. The cloud cover helped, as the harsh sunlight was softened to a great degree, but the overall look is bland

and lacks snap. The original image was scanned and brought into Adobe Photoshop. The sky was made more dramatic via masking and a curves adjustment, and the home itself was adjusted to add contrast. The final image was a vast improvement, and the client was very happy with the results.

Each of these last two examples shows the advantage of shooting for the process. Experienced photographers know what their materials can do and how best to take advantage of the tools available to them. In the first example, making two exposures provided the extended range needed to show detail throughout the scene. In the second example, the photographer determined that if enough detail were captured in the original image, then software manipulation could result in an excellent image. The use of a neutral-density filter kept the clouds from being overexposed, and skilled use of Photoshop did the rest.

The lower image represents the image as shot using a graduated neutral-density filter to help darken the sky. The upper image resulted from manipulating the original image in Photoshop. The use of the ND filter enabled the photographer to capture enough tonality to allow the manipulation.

In both images, note also the careful camera placement. The camera was placed above ground level to allow the viewer to look down at the plantings in the front yard and the trees in the atrium. This placement also allowed the use of a rigid camera in the shot of the home. The camera was not tilted up or down, so the vertical lines remain parallel.

INTERIORS

Our final static subject is the photography of interior spaces. Camera placement and lens choice are important here, but are usually dictated by the confines of the space, itself. Often there is really only one suitable angle, and the widest lens available is likely to be the best choice as long as it can ensure that the abundant straight lines, inherent in most interiors, remain straight. In most cases, the photographer can make the strongest statement via the use of light. Combining the lighting design of the architect with additional light units to enhance the best points of the design creates an image that welcomes the viewer into the space and makes it seem natural.

> Often there is really only one suitable angle, and the widest lens available is likely to be the best choice as long as it can ensure that the abundant straight lines, inherent in most interiors, remain straight. In most cases, the photographer can make the strongest statement via the use of light.

Here's another example of a professional interior shot; let's take a moment and analyze what makes it so interesting and effective.

A combination of natural and artificial lighting, combined with an appropriate lens, resulted in this highly effective interior image of a game room.

This interior game-room space was primarily lit by a bank of several windows to camera right. Two flash units with grid spots are hidden in the hallway through the arch to the right of the popcorn machine. One lights the face of the cabinet beyond the pool table and adds a little light to the palm tree at the right of the image; the other is aimed just above the mirror seen through the arch. Another light is to camera left, just beyond the plant, and opens the shadow side of the pool table. The existing incandescent light fixtures were switched on for a portion of the six-seven second exposure to add a warm glow to the room and draw the viewer's attention into the composition.

In both of these images, a combination of daylight, strobe, and incandescent light makes the room look natural and inviting. The key to good interior light is to show what detail you want, direct the eye of the viewer, and do both while giving the impression that the light is natural.

> ✎ Each room has its own requirements, and setup takes time. A good day is four to six shots, but the results are worth it.

When packing for a job like this, most photographers bring a wide variety of lights and accessories, preferring to have it and not use it rather than need it and not have it. Each room has its own requirements, and setup takes time. A good day is four to six shots, but the results are worth it.

Daylight through the windows to camera left and visible in the image provides most of the light for this next interior image. Strobe units augment the daylight. One is hidden to camera left and bounced off the white wall and ceiling; the other is tucked into the offset in the wall just beyond the entryway. The raw light from this second unit

This image has an intimate feel, partially the result of the natural light visible in the left rear of the image, where the window allows afternoon sunlight to illuminate the room.

provides detail and correct color on the coffee table and sofa at the far end of the room. The well-defined shadows under the table and chair are the result of using the light directly with no modifier. The shadows are not objectionable, as they seem to have been caused by the window light; the light area of carpet draws the viewer into the space.

Capturing Events and People on Location

Last in our lineup of places is the photography of events. From photojournalism to sports, from state fairs to weddings, this type of location work combines the disciplines of people and places, tossing in a dose of unpredictability for added flavor. At many events — news, sporting, and personal — the location is a key element, almost a participating personality. Capturing the personalities of both the people and the place is an essential skill of the events photographer.

PHOTOJOURNALISM

As stated earlier, the most important aspect of journalistic image-making is to *be there*. Once the image that tells the story is safely in the can, the photographer can set out to make a more interesting composition or well-lit scene. Of course, the best photojournalists seem to be in position to create interesting, well-lit compositions while the rest of the pack are still setting up. That ability to anticipate is one of the marks of a superior, journalistic image-maker.

Digital SLR type cameras have all but taken over in this speed-dominated world. The ability to send breaking-news photos via e-mail has revolutionized the profession. Several camera bodies, a selection of lenses, a portable strobe, and sometimes a tripod or monopod, are all the tools needed by the photojournalist. Good communication gear is also on the list, as often the photographer is directed to the action by a contact at the news organization that publishes the images.

Photojournalists are called on to be very adaptable, since one minute they may be working at an elementary school covering a visit by a newly elected politician, and suddenly they find themselves in the middle of the most important story of their careers, as happened on September 11, 2001. The ability to cover both ends of the journalistic spectrum, with little or no warning, is a necessary aspect of the photojournalist's personality. These image-makers bring us the events of our times, recording for posterity their unique view from an insider's perspective. This gives the people who view the images a sense of familiarity with the people who run our world.

> Photojournalists bring us the events of our times, recording for posterity their unique view from an insider's perspective.

SPORTS

A particular type of photojournalism, sports photography, has become a separate specialty in its own right. The photographers who enter this field are many; the ones who can make it a career are few. The lifestyle is being on the road with few of the perks enjoyed by the pampered athletes they cover. This can "get old" quickly, but for a few elite shooters, it is the only way to live. We see them on the sidelines with their giant telephoto lenses and multiple camera bodies, so close to the action that they sometimes become a part of it (not usually a good idea). The part we don't see is the business side that includes getting the images out to potential buyers, following up, and sending out bills that may or may not get paid in time to make the next credit-card payment. These photographers put the viewer in the best seat in the house, at the track, or on the court, and bring us images of poetry in motion. We have become so used to seeing the coverage they provide that it no longer seems unusual. Only when it is missing do we notice.

> Sports photographers put the viewer in the best seat in the house, at the track, or on the court, and bring us images of poetry in motion.

This image, made at the Grand Prix of St. Petersburg, FL brings the action "up close and personal" in a way that the average race fan will never see. Shot using a wide-angle lens to include the very recognizable buildings in the background, the slow shutter speed emphasizes the incredible speed of these cars.

The very long lens used here helps to separate the player from the crowd with shallow depth of field. The exuberance of Martin Gramatica is captured for all to see.

OTHER EVENTS

Of course the photography of events includes many other types as well. Weddings, bar or bat mitzvahs, parties, political gatherings, and other social events are a staple in the business life of many photographers. These events require the skills of a portrait photographer blended with the diplomatic skills of an ambassador, as well as the ability to react quickly as events unfold around you. Proms, awards dinners, company outings, and a host of other events all require coverage, whether by a full-time professional or a part-time "weekend warrior." These events and their venues offer interesting photographic opportunities and unique challenges.

Most often, these events are covered with a hand-held camera, mounted on a bracket that allows the flash to sit high above the lens. This arrangement eliminates red eye and lets shadows fall directly behind the subject, creating a clean look in the images. The better practitioners of this type of photography are not satisfied with only producing these high-quality snapshots and are always on the lookout for more interesting photo opportunities. Window light, flash fill outdoors, and even studio lights brought on location allow them to make interesting and flattering images of a wide variety of clients.

Also falling under the heading of other events are the sometimes unpleasant, sometimes dull, sometimes quite beautiful, but always very important images made by forensic and scientific photographers. Crime-scene photography, legal-support photography, as well as special-assignments from historical societies, museums and other institutions are several related photographic categories, as are medical, architectural, and other highly specialized photographic fields. These image-makers are often doing a job of which photography is only a part. Today the equipment has evolved to a point that, in many instances, this type of photograph does not require a photographer as much as a trained technician with strong photographic skills.

Summary

We have touched on many aspects of the photography of places and, in some cases, the people who inhabit them. For images of static places outdoors, scouting the location to identify the best angles and best time of day for ideal lighting are essentials. Learning to determine when to shoot for the process, especially on objects that don't get the best light, is also the mark of the skilled photographer. Interiors focus the attention of the photographer on lighting to compensate for conditions, whether opening shadow areas or drawing the viewer's attention to the points to be featured.

At events, photographers need skills specific to portraiture and more. They need to ensure that not only the people, but also the location and the activity are featured, as planned for the purpose of the photograph. Photojournalists must rapidly capture the event, but also find the best angles and lighting while doing so. Sports photographers and others must bring out the location while capturing the essence of the activity. Whether you're on your way to becoming a professional photographer or are just interested in taking better pictures, understanding the essence of the photo you are trying to capture, and therefore the approach required, will certainly be important to your abilities and skills development.

Things

In this chapter, we focus on the photography of items, products, and other objects, both for commercial use and as art. The techniques and the problems they solve are quite similar, regardless of the final use of the image.

In many ways, it's difficult to separate the photography of objects from other classes of image-making, for instance photographing people. Fashion photography presents one such situation. Although models are certainly one critical component, in fashion imagery it's not really the person that's the focus, but rather the clothes the person's wearing. Advertising images for the sales and marketing of sports paraphernalia are another prime example of object photography that includes people.

To take the concept one step further, think about product photography that also includes location as part of the composition. An ad or product brochure showing how a mobile communications network works well while you're abroad might include a model and a background of the Leaning Tower of Pisa as well as the mobile telephone in the person's hand.

In short, the object or things category crosses several different genres. As a result, the more skills the photographer brings to the table, when shooting stationary or inanimate objects, the more likely the end result will appeal to the photographer, the client, and the prospective customer. Remember, in the case of advertising or marketing imagery, the ultimate goal is to appeal to the client who makes a buying or adoption decision, influenced by the visual.

Objects That Can Fit on a Table

For our purposes we define *small* as that which can be placed on a table. Since studio tables can be large and strong, they can support objects somewhat larger than you might imagine for a tabletop setup. The first consideration, then, is studio tables and their effect on the images made on them.

CHOOSING THE CORRECT TABLE

Shooting tables may be as simple as a hollow-core door supported on sawhorses and as complex and expensive as hydraulically operated, trans-illuminated, custom-made pieces of equipment. They are the heart of the tabletop photographer's environment. The ability to adjust the height and angle of the tabletop can also make the photographer's life a little easier. Many tabletop specialists keep an inventory of materials on hand to construct temporary tables, as required by the object to be photographed, with the size and weight of the item to be photographed being two of the more important deciding factors.

> Shooting tables may be as simple as a hollow-core door supported on sawhorses and as complex and expensive as hydraulically operated, trans-illuminated, custom-made pieces of equipment.

These shooting tables represent both ends of the price spectrum. On the left is a table with an integrated lighting system; on the right is a simple folding table. Photographers often construct tables, as needed, from sawhorses and hollow-core doors purchased at building-supply stores.

USING BACKGROUNDS TO CREATE THE SCENE

Backgrounds are another consideration of the tabletop specialist, and can range from simple paper or cloth to elaborate constructions designed to simulate other environments. Often a set is constructed to mimic real life. One reason for this apparent extra work (after all, why not just go on location?) is to afford the photographer space to position the large light sources used in this type of work. Another consideration is the cost of going on location, which can be considerable, depending on the requirements and physical conditions at the place where you intend to shoot. Staying in the studio offers other advantages, as well, such as easy access to all of the special accessories that the photographer has collected over time. These items are usually

adapted to solve unforeseen problems and are added to the studio's bag of tricks. It is impossible to pack everything when going on location. It seems that whatever is left behind is just what is needed when working away from the studio. Over time studios that specialize in small-product work collect a wide variety of surfaces for use as backgrounds. These are stored against the time they can make the perfect compliment to an as yet unknown subject. A significant amount of space in most product studios is dedicated to this storage. Some large studios keep set-construction specialists on the payroll to build whatever the photographer needs. In most smaller shops, that task falls to the photographer, as does almost everything else involved in running a small business.

DRESSING THE SET

Once the table and background are in place, the object to be photographed is added to the scene. Often at this point a *stylist* is brought in to dress the set, adding the small touches that help bring it to life. Stylists spend their time planning what props will be needed for each up-coming shoot and shopping for or borrowing the items needed. Good stylists cultivate and maintain relationships with antique dealers and other small-business people, trading favors so that when a particular item is needed to dress a set, it may be borrowed rather than purchased. This saves on production costs and, often, on a big job with many props, a stylist with the right connections can save the studio more money than he or she is paid. Most but not all stylists operate as independent business people, often serving as decorating consultants as well as photo stylists. When the set building is finished and the stylist has finished decorating, the task of lighting is in the hands of the photographer.

> A stylist is brought in to dress the set, adding the small touches that help bring it to life.
>
> Good stylists cultivate and maintain relationships with antique dealers and other small-business people, trading favors so that when a particular item is needed to dress a set, it may be borrowed rather than purchased.

LIGHTING THE TABLETOP SETUP

We've already explored the importance of good lighting. Good tabletop photographers, using the lighting tools available today, can replicate virtually any lighting condition that exists in nature and can go far beyond natural-looking light to employ special effects.

Lighting tabletop sets is often done with large, soft-light sources like soft boxes and light panels. These light modifiers provide a means for duplicating the soft wash of light of an overcast sky. They can be

directional enough to show form and shape, and can be augmented with reflectors and harder-light sources to show texture and added dimension. Multiple light modifiers can be added to replicate the shadows cast by window blinds, a shaft of raw sunlight, or virtually any other effect the photographer has in mind.

Good tabletop photographers, using the lighting tools available today, can replicate virtually any lighting condition that exists in nature and can go far beyond natural-looking light.

Often the lighting is, in part, dictated by the surface characteristics of the object to be photographed. A basic determination of whether the subject would be best defined by highlights, shadows, textures, or a combination of the three must be made at the start. Dark, shiny, reflective subjects, for example, must be defined via the highlights. This is seen when black objects are photographed against a dark background, which is often done to give a sense of mystery to an otherwise ordinary object. In this situation, even a very bright, small, hard-light source does not define the subject, and the image that results is unsatisfactory. Changing from a small, hard source to a large, soft source completely changes the look and feel of the image by spreading the resulting highlights along the reflective surfaces of the subject. These highlights follow the curves and contours of the subject, allowing us to see its form.

A large, soft-light panel allows these parts to be defined by highlights and shadows. Each surface reflects the light panel according to its own shape, causing the highlights to follow the contour of the part. Shadows add depth and dimension, creating an interesting image in this black-on-black composition.

Light-colored objects are often defined by the shadows cast by their three-dimensional form. Without a shading of the light, a ball, for example, would look like a disk when reproduced in the two dimensions of a photograph. We are fortunate in that a wide variety of lighting techniques work to define an object via shadows. This allows significant latitude in designing a light setup for this type of shot

Mirror-finished subjects, such as jewelry, offer another challenge. This type of subject reflects the light source at a value close to 100%, requiring a large soft source to act as a reflecting surface to give tone to the highly reflective metal. In addition, the stones and background require another source of light to bring out their color and texture. This additional light is often a smaller and harder source. The reason that two separate sources are needed is that when the exposure is based on the reflection of the light source in the metal, other objects in the scene that return much less light to the camera are underexposed. The second source is there to raise the light level of these nonreflective objects into a range that can be captured and reproduced.

At the other end of the lighting spectrum are objects that must be defined by their texture. One example of this would be a dark sweater with a pattern in the knitted design. Soft light, which tends to minimize texture, would

This jewelry shot requires two light sources — a broad, soft-light box to reflect into the mirror-bright metal and a smaller harder source to bring out the texture on the bottom necklace and raise the light level on the nonreflective background.

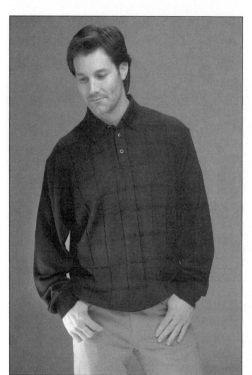

A strong, hard-light source skims the sweater to bring out the texture in this shot.

be the wrong choice here; instead, a more tightly focused, hard-light source that comes from an extreme angle would bring out the pattern in a way that is easy to see and photograph.

Between these two extremes are the majority of subjects that are defined via a combination of highlights, shadows, and textures. These subjects allow the photographer the most latitude in lighting design. Because this type of scene may contain specular highlights, diffuse highlights, midtones, and shadows, the image-maker has a wide variety of tools with which to achieve the look desired. (As discussed previously, *specular highlights* are reflections of the light source in shiny areas of the subject.) Speculars are very bright as the shiny surface returns almost 100% of the light from the light source. *Diffuse highlights* are the areas of a subject that receive the most light from a given source. They provide contrast to the midtone areas and shadows, and together they all work to make a two-dimensional image represent a three-dimensional reality.

PRODUCT PHOTOGRAPHY

It is fair to say that the majority of tabletop photography is done for commercial reasons. While there is certainly a large amount of tabletop work shot in the name of fine art, most of this type of work is made to sell a wide variety of products. Everything purchased from a catalog was photographed so it could be reproduced on the page. This type of photography requires studio space in which to work, storage space for the products to be photographed, shipping and receiving facilities to get products in and out of the studio, and someone to coordinate the work. Large studios have evolved to service the clients who require this type of work. Often the photographers on staff in these operations have also evolved as specialists in one or several areas of product photography. One such specialty is food photography.

Commercial-product tabletop photography requires studio space in which to work, storage space for the products to be photographed, shipping and receiving facilities to get products in and out of the studio, and someone to coordinate the work.

Photographing Food

The photography of food can be compared to other aspects of tabletop work but with some major differences — the subject is perishable and quite delicate. Another aspect of this specialty is that in order for food to look good on camera, it must be prepared for looks rather than for taste.

The profession of food stylist has evolved as a specialty of its own. These stylists, often a combination of chef and set-dressing artist, use their skills to enhance the food for photography. They must follow a complex set of rules and laws concerning what techniques may be used in differing circumstances. For example, while it is OK, in an ad for the stoneware, to use marbles in a soup bowl to lift the solid ingredients of the soup out of the broth, it would not be OK if the ad were for the soup itself, as that would be considered misleading advertising. The ins and outs of the labyrinth of rules are too complex to go into in a book like this; in fact, several whole books have been written on food styling.

For many photographers, a job that includes food photography must have a budget for a food stylist. Without a stylist, many turn down this type of work. There are image-makers who have made food a specialty. They equip their studios with modern professional-level kitchens, and either learn to prepare the food themselves or keep a stylist on staff or retainer. This is a large commitment, and they promote this specialty heavily. For these photographers, food quickly becomes most of what they do.

Food photography often requires the services of a food stylist. The raspberries that add the final touch to this scallop plate were picked from among several dozen.

Photographing Fashions

Fashion photography has long been a slave to whatever the trend of the moment happens to be. There is some movement between the clothes as product and a more intimate view of the models as personalities; at times, it is the creation of images in which attitude is more at the forefront than either of the more obvious choices. Conversely, fashion alone often isn't the sole subject matter. Models wear and show off the features and the "lay" of the garments. Lighting, location, and a host of other environmental conditions come into play, as do the personalities of those who make a living as "clothes horses."

This genre crosses many of the boundaries, and, at times, fits into all aspects of image-making. Fashion can be event photography, as well. The skills of many disciplines must be a part of the fashion photographer's bag of tricks. Often people specialize within this demanding field, leaving it to others to deliver the images outside their narrow field of expertise.

Color quality, clarity, extremely accurate control over depth of field, and focus all play critical parts. Although all genres of photography require attention to these details, nowhere do demanding clients rear their heads more than in the fashion world.

There are plenty of examples of high-quality fashion photography available to you — just about everywhere you look. (Spend some time fanning through magazines the next time you're in the grocery store.)

ARTISTIC TABLETOP PHOTOGRAPHY

Art photographers who do tabletop work face the same problems as their commercial counterparts. Their main advantage is that they get to choose what they photograph. Lighting considerations are much the same, with the use of unusual lighting often being pioneered by shooters working only to satisfy themselves. Often these techniques find their way to the commercial side of the table when an art director sees something he or she likes in the personal work section of a photographer's portfolio. Some famous photographers have worked both sides of the table, such as Helmut Newton and Robert Maplethorpe. Many innovative techniques and alternate points of view have been brought to light by photographers working in a studio environment to realize their unique vision. From still-life images reminiscent of the old masters to highly disturbing images filled with symbolism and emotion, the art of the tabletop is well established and going strong. In the next two images, for example, notice how a technique of "painting with light," which was developed by a tabletop artist, was then used in a more-commercial application.

> Lighting considerations are much the same for art photographers as for commercial photographers, with the use of unusual lighting often being pioneered by shooters working only to satisfy themselves.

When working only to satisfy a personal vision, a photographer in pursuit of art can experiment with lighting and other techniques. Often these techniques are later used in more commercial work. The image shown here, by Pierre Duterrte, is an example of painting with light.

This is an example of the same technique (light painting) as used in the previous image. This example is a more commercial application. The highlights, added via a small high-intensity light source held very close to the subject, bring attention to the important details of the jackets.

COPY PHOTOGRAPHY

Another often-overlooked area of tabletop work is copy photography. This aspect of photography is fast being replaced by scanning technology, but is still used for items too large for the scanner and where digital would add a step to the final use, as in copying artwork onto 35mm slides for submission to art shows. Copy work is best done using a stand built for the purpose. These copy stands include a baseboard to hold the item to be copied and lights placed at 45° angles on either side to provide even illumination. The camera is mounted on a traveling arm, and can be positioned directly above and square to the item to be copied.

Objects Too Large for a Table

Not all products are sized to fit on a table; even special studio tables have their limits. Items of this sort can be divided into those that can be brought into the studio and those that cannot. This determination must be made individually, based on the size of the studio and the needs of the client.

SHOOTING LARGE OBJECTS IN THE STUDIO

Some images that, when first seen, give the impression that they were shot on location, are in fact shot in giant studios. An example is an advertising campaign done for Anderson Windows several years ago. A huge space was used inside of which whole rooms were built, designed for easy light placement and photographic access. Rear-projection material was stretched over frames outside the windows, and the image seen through the windows was projected and captured via a long exposure. Prephotography production costs on this job were well into the hundreds of thousands of dollars, but the resulting images were deemed well worth the expense. While, of course, this is an extreme example, it does serve to show that sometimes an image is not what it seems.

In many markets there are only a small number of studios that can accommodate large items. Facilities needed include a loading dock and a door large enough to permit entry of large items.

Lighting Large Objects in the Studio

Generous ceiling height is another requirement, as lights often must be positioned high above the product. Special lighting is also required, as a softbox that would be considered large when used to light something the size of a computer would be considered small when lighting a pool table. Light panels 20-feet square are not uncommon in large-product studios. Very powerful strobe systems and multiple light heads add to the costs of such an operation. The overhead involved in a large-product studio is very high. The fees charged for this work must also be high, just to pay the bills.

One photographic specialty that falls into this category is studio photography of automobiles and other vehicles. The studios that are capable of this work are enormous. Cars and even tractor-trailers can be driven onto the set, and lights can be positioned, as needed. Often, the images created in the studio are later added digitally to locations shot by other photographers. One instance of this process is the ad campaign for Jeep several years ago. The final ads showed Jeep vehicles on rafts floating down the Amazon River.

The lighting techniques for these large items are governed by the same physical laws that govern all aspects of light; the challenge is the sheer size of the sets. Heavy-duty stands, huge light panels, powerful strobe systems, and large sturdy camera supports are needed to work in this field. Once past the sheer size of all this equipment, we see that the techniques discussed in the section on tabletop photography hold true here, as well. The same considerations regarding highlights, shadows, and texture still apply, and given the correct working environment, the photographer can create lighting with impact and style.

This studio photograph of Aerton Senna was made on a very large set. Huge light panels provide overall illumination, and smaller sources were used as accents. The original shot is shown as an insert in the retouched version in which a sunset sky was added. Also note that in the retouched version, some motion blur was added to contribute to the overall effect.

PHOTOGRAPHING LARGE STRUCTURES OUTSIDE THE STUDIO

Some subjects, by their nature, are not likely to be photographed in the cozy confines of the studio. Items such as model homes, commercial buildings, monuments, and other structures fall into the classification of things, but only in rare instances is there a reason or the budget to bring them into a studio environment.

Lighting Structures to Compensate for Conditions

When money is no object, equipment exists that can render any scene to perfection. We need only spend some time at the movies to see that this is so. Movie crews can and do spend all night erecting light panels along a city block so that the mornings shots look natural and softly lit. Rarely in still work does the budget allow for such large and complex productions. Most often, the substitute is time spent waiting for the right time of day or perfect light-overcast weather to render the light required to show a subject at its best. With the addition of digital imaging to our bag of tricks, some lighting problems, once very difficult to solve, can now be handled. The image-maker needs a strong

This model home faces north, creating problems for the photographer. Early morning light offers a lower contrast and, allows a balance to be struck between the sky and the front of the house. Additional light was used to open the shadows, and the image was finished in Adobe Photoshop.

sense of what the final image should look like, and an understanding of which elements must be captured for later assembly.

Camera position can be especially important when the subject cannot be moved. Sometimes moving away from the subject and using a long lens can offer a look at a subject that is unusual and eye-catching. At other times, getting in close with a wide-angle lens can eliminate distracting elements such as wires and poles. Lighting issues that cannot be solved during daylight often cease to be problems under evening light or at night. Commercial buildings are often photographed at night to eliminate distracting elements around them. Homes photographed late in the evening offer a welcoming look as warm light streams from their windows. This look is often enhanced when there is a contrast between the blue light of evening and the warm illumination from within the house. Setting the light balance of a digital camera for tungsten light makes the sky in an evening exposure go a deep blue while keeping the interior lights close to their real value. The same can be done on film by using tungsten-biased emulsions. In fact many photographers use both daylight-balanced and tungsten-balanced film when shooting this type of subject to be sure to capture a range of effects.

The same house shot after sunset. The night shot eliminates some distracting detail and adds emphasis to the front of the building. Additional light from a moving tungsten-based source was added to the areas of the home the photographer wanted to bring out.

Night Shoots

Night shoots of large subjects can be easier than one might think. The trick is to carefully plan what you are trying to accomplish. A single, powerful, continuous-light source can be used to paint the subject with light. The moving light source creates a soft light, as any shadows it generates move as the light moves, rendering their edges soft and indistinct. As noted, using film balanced for the warm light of a tungsten source allows the sky to shift to a deep blue, creating a color contrast that many viewers like very much. Using a daylight-balanced continuous-light source, such as HMI lighting, allows the interior lights to come through as warm and inviting. When dealing with buildings that use fluorescent interior light, a split exposure can be used — first exposing with a moving source for the exterior of the building, then switching on the interior lights and using a filter over the lens to remove the green cast from the fluorescent fixtures.

Even very large objects can be photographed at night by leaving the shutter open while moving through the scene with a portable light source. Over the course of what might be several hours, a photographer with a hand-held flashlight can illuminate anything that can be approached. The trick is to keep moving and never point the light source back at the camera. This technique also works with flash, although the soft edges produced by a constantly moving light source will be missing. This highly effective technique is far from new, and has been used for years to illuminate large objects and interior spaces.

Summary

We have covered the photography of items that do not fall into the categories of people or places. The lighting issues are common to both large and small objects; as objects scale up in size, so must the lights used to photograph them. We discussed the surface characteristics of items to be photographed, and the best way of dealing with each type. Finally, we touched on painting with light to illuminate large objects over a longer than normal exposure.

DISTRIBUTING YOUR IMAGES

Whether you're using a digital camera or taking pictures with a conventional, film-based camera, at some point your photographs are going to become digital images. Unless they're destined solely for rarely seen photo albums stored somewhere in your attic, they're going to require some method of distribution to their intended audience.

In this final section of the book, that's exactly what we talk about: digital images and how they're formatted, as well as different ways you might get those images into the hands of your target audience.

In some cases, your images will be used as a component in a larger design, such as a newsletter, product brochure, technical publication, or magazine. Catalogs use many images, as do related Web sites. The eventual use of your images dictates the file format you should use when storing them. Adding to the complexity of the subject is the increasingly important process of *cross-purposing* specific images, or using them in more than one way. A few short years ago, the Internet wasn't even on people's minds as an effective or appropriate distribution or publishing venue. Today, no discussion of marketing or information distribution happens without the Web occupying a significant proportion of the conversation.

Knowing the proper formats for different applications has become increasingly important. An image file created and saved for use in a printed catalog is far different than the same image formatted for the client's Web site. The accuracy of its color, space it occupies on a hard drive, resolution, and a host of other factors need to be considered when you plan to show your image to the world. Even the time it takes for an image to download on a Web site can make or break your efforts.

Print usage requires very exacting and repeatable conditions, whereas Web publishing can be, in some ways, more forgiving as a method of publishing your pictures. In either case, you need a solid understanding of the differences between the two applications. While working through the details of file formats, resolution, and other technical issues may seem, at times, overly technical and not nearly as much fun as the other subjects we've been covering, it's well worth the effort.

Trust us — the time will be well spent.

Working with Digital Images

In this chapter, we explore the practical application of digital images, and how to convert traditional, analog images into digital formats. Today, virtually all printing is processed digitally. Even printing plates — large sheets of metal engraved with the image being reproduced on paper — are, in most cases, processed from computer files.

An *analog photograph* is made on light-sensitive film that needs to be processed chemically before it can be viewed. To move from analog to digital, the analog image must be scanned to convert its information into a form that can be read by the computer. As we explained earlier, analog images fall into two categories: positive images and negatives. The conversion process can handle either format.

Scanning Technology

In recent years, scanning technology has progressed from the exclusive province of highly trained and skilled professionals operating equipment that cost tens or even hundreds of thousands of dollars to an operation that can be performed on the desktop by almost anyone. Each individual must decide how much effort and money must be expended in order to meet his or her final requirements. Scanners exist that cover a wide range of price, complexity, and quality. As might be expected, high quality means higher prices and more complexity; professional-level equipment requires the biggest investment of money and time. Scanners quite adequate for adding images to a newsletter printed on a laser printer are not up to the task of professional reproduction on high-end output devices.

FLAT BED OR DRUM SCANNERS

The basic division in scanner technology is the light-sensitive device that generates the digital signal. There are two basic types: the CCD or charge-coupled device, and the PMT or photo-multiplier tube. In recent years, the formerly wide quality gulf between these technologies has narrowed greatly, at least in the higher-end devices.

The traditional imaging champ has been the PMT-based drum scanner. A PMT-based device has only one image sensor, so the material to be scanned must be

moved past the image sensor. In most cases, that requires that the image be mounted on a spinning drum that can be passed by the PMT. Both transparent and opaque materials can be scanned, as the scanners have both a reflected and transmitted light source. PMT devices capture a wide range of tones from highlights to shadows, and can be set to very high resolutions by controlling the speed at which the image is passed by the tube.

This wide range and high potential resolution are advantageous when images must be enlarged, such as when a 35mm slide is used on the cover of a magazine. The disadvantages come with mounting the images on the drum, which must be done precisely, and can be messy when oil is used to help eliminate surface defects. Coupled with the fact that drum scanners cost $10,000 and up, sometimes considerably more, it is easy to see why they have traditionally been the equipment of service bureaus rather than individual image-makers.

The advent of the charge-coupled device or CCD allowed the introduction of other types of scanners. CCDs, arraigned in a tightly spaced row, can be passed by the item being scanned, creating a digital image. Early scanners of this type suffered from low resolution and lack of range. Improvements have been rapid and dramatic, and now the best CCD-based devices rival PMT scanners in resolution and dynamic range. There are still differences between the technologies, but at the upper end of the scanner quality scale the differences are slight, and the final decision is based on factors other than image quality.

HIGH BIT-DEPTH IMAGING

CCD technology has provided a wide range of quite good scanners, even at the middle of the quality range. These devices, when fed well-exposed and otherwise technically excellent images, are capable of professional-level reproduction. It is when images of less-than-excellent quality or images that require great enlargement are scanned, that higher-end equipment comes into its own. Film can capture a greater range of tones than can be reproduced on paper; unless the photographer takes this into account, the scanner operator must make decisions that affect the final reproduction. High-end scanners can capture an extended range, allowing the operator more latitude in the tones preserved in the final reproduction.

Eight bits of information allow for 256 levels of tone in an image. (A *bit* is the smallest unit of information in our digital world; it represents either a 1 or a 0 in the binary system of math used by our machines. There are 256 combinations of 1s and 0s in 8 bits of information.) Color files in our computers are made up of 3 grayscale, 8-bit images or channels. Multiplying the 256 levels of tone in each channel gives a total of 16.8 million potential colors (256 × 256 × 256 = 16,8000,000) or what is known as "24-bit color" (3 channels of 8 bits each). When we use a sensor that is capable of capturing more than 8 bits of information, we extend the possible range greatly. Sixteen bits of information contain more than 60,000 levels of tone, and as a three-channel color file, more than a billion potential colors.

If you have managed to wade through the preceding math and are still following at this point, you may well ask, so what? As noted, paper cannot reproduce more than a small amount of what we can capture using modern scanning technology and digital image capture. The reason that we need, whenever possible, to capture high bit-depth information is so we can decide which set of 8-bit (grayscale) or 24-bit (color) information is ultimately used in the reproduction of our images. Having an excess of information allows an image-maker to build a file with no gaps in its *histogram* (a graphic representation of the tones in an image), which allows smooth transitions from one tone to the next in an image. Starting with more information allows more tonal correction during the postproduction process. Each step in tonal correction throws away some data. Every time you use levels or curves to adjust an image, some data is lost. Starting with much more than is required allows the final image to contain a full range of tones.

In the following image of a train in Amsterdam, the image on the left contains only 8 bits of information, and is therefore limited to 256 colors. The image on the right contains a full 32 bits of data, resulting in millions of different shades. When you magnify both and compare them, you can see that the image on the left appears much grainier, and that the colors aren't nearly as smooth as they are on the right. This smoothness is known as "gradation," and is much finer and smoother at higher bit depths.

Most midlevel and higher scanners and digital cameras capture more than 8 bits of data per channel. Better scanning software, such as SilverFast by LaserSoft, and Adobe's Photoshop image-manipulation software allow access to this data. (Photoshop is the program professionals use for manipulating digital image files. While other software is available, it's not generally used by pros nor as fully featured.) Using this high bit-depth data to perform global tonal correction is one step on the road to obtaining the highest-quality digital files. Photoshop can apply levels, curves, hue and saturation, and some filters, such as unsharp mask, to files composed of this high bit-depth data. These files open as 16-bit files, even if they were originally captured at only 10 or 12 bits per channel. Many features of the software are not available when working with 16-bit-per-channel data, but correcting the overall color is possible and should be done whenever possible before converting the file to 8 bit (grayscale) or 24 bit (color). The newest version of SilverFast allows manipulation of the high bit-depth data before opening into Photoshop. This scanning software is available for most mid-to-upper-level scanners, and is the final tool in the toolkit that makes them into professional-level tools.

Reflective vs. Transparent

Although the basic division in scanner technology is between PMT and CCD units, there is another decision to be made — that is the choice between flatbed and film scanners. Each has its advantages and drawbacks. Flatbeds are ubiquitous; they can be found on the desktop of most imaging and design professionals as well as in many home offices. They are handy tools, quick and easy to use. They can also be serious professional equipment, when their specifications are good and they are used with a full-featured software package. Flatbeds range in price from less than $100.00 to more than $20,000.00 so, as you might surmise, there is a range of quality as well as price. At the upper end of the scale, these machines deliver files equal to the most-demanding publishing requirements, and do so with a minimum of fuss and bother. In the midrange, there are units that can meet the requirements of publishing when operated by a good scanner operator, although the *throughput,* or amount of scans generated per hour, will not be as high. Lower-end machines serve well as input devices suitable for Web publishing and e-mailing images to friends and family.

FLATBEDS

By their nature, flatbed designs are best suited for scanning reflective materials. Photographic prints, hand-drawn art, and preprinted pages can all be scanned successfully with a flatbed scanner. Scanning prints has a built-in limitation — the quality of the print to be scanned. We have all seen prints made at one-hour labs that are off color or lack detail in highlights or shadow areas. When attempting to get the best-quality reproduction, in most cases, a custom print should be ordered from a professional lab. Film can capture more data than paper can reproduce, so the services of a custom printer may be required to add detail to the highlights and shadows by the technique of burning and dodging to create a final image ready for scanning.

The cost of these prints must be added to the job, and might make a film scanner seem a good investment. Oversized reflective materials are easy to scan on the new large-bed machines, and stitching software has made it possible to scan very large originals in sections. Many flatbeds have an attachment to scan transparent images as well. Usually this takes the form of a light source built into the hinged lid of the scanner. Sometimes this adapter is sold as an accessory; sometimes the scanner comes with the transparency adapter as standard equipment. These transparency units have met with varying degrees of success. Often they work adequately when scanning larger transparent original film when little or no enlargement is required. Smaller transparencies, such as 35mm slides, often require higher resolution and better sharpness than most of these machines can offer. The several layers of glass in the optical path create issues related to flare and precise focus that become apparent when images scanned on these units are enlarged. Recently, manufacturers have addressed these issues with better transparency adapters that use the *sweet spot* (usually the center of the scanning array) and more advanced optical systems to raise the quality of scans from film originals.

Flatbed scanners are perfectly capable of producing useable images, yet can cost less then $200. For many applications, such inexpensive devices work quite well.

FILM SCANNERS

Film inherently has more detail and a greater range of tones than prints. For this reason, the best scans are made directly from the film itself. (Most professional scanning operators prefer to scan the negative and convert the file into a positive image after the capture is complete.) Special CCD-based film scanners have been developed for this purpose. CCD technology has been adapted to this use in order to build film scanners at a price point accessible to most image-makers. Companies such as Nikon, Canon, Minolta, Polaroid, Microtek, Kodak, and Imacon have all brought to market scanners designed to scan directly from film. Most of these scanners are designed for 35mm slides and negatives, but several of the companies have brought out units that can handle medium format and 4 × 5, as well. These units range in price from a few hundred dollars for lower-end, 35mm-only devices, to approximately $18,000 for the latest Imacon unit, billed as having drum-scanner quality and capable of handling film from 35mm up to 4 × 5 at resolutions up to 5000 dpi. Most film scanners can capture high bit-depth images, making them well-suited for photographers who have not made the jump to direct digital capture or who, for other reasons, have decided to shoot film on a significant number of their assignments.

> Film inherently has more detail and a greater range of tones than prints. For this reason, the best scans are made directly from the film itself. (Most professional scanning operators prefer to scan the negative and convert the file into a positive image after the capture is complete.)

Resolution

We have made reference to resolution several times; at first glance, it seems an easy enough concept to grasp. In truth, it seems to be one of the most misunderstood concepts in computer-based publishing. In older workflows, design and imaging-content providers did not need to know about or care about resolution. The photographer created the images, and the designer placed them on the page, after a highly trained scanner operator scanned them to the designer's specifications. The designer had to specify the size the image was to appear in the finished piece and any special cropping; that was all that the scanner operator needed to know to do the job. In today's workflow, often the photographer is doing the scanning or shooting digitally and is responsible for providing files ready to print. Sometimes the designer receives finished but not sized or converted RGB files, and must prepare them for use in the final design. Knowledge of the resolution requirements is crucial for performing at a high level.

RESOLUTION DEFINED

In digital terminology, *resolution* is defined as dots per inch (dpi). It might be more accurate to use the term *pixels per inch* (ppi) to avoid confusion, since printer dots are not the same as pixels. Scanners and digital cameras are usually specified as having so many pixels per inch (in the case of scanners) or a number of mega-pixels (in the case of cameras). Prepress requirements differ, depending on the type of publication and the paper on which it is to be printed. Many magazines are printed on glossy paper at a screen resolution of 150 lines per inch (lpi). This lpi refers to the halftone screen used to separate the full-color image into its cyan, magenta, yellow, and black (CMYK) components. Color printing on a press is done using only cyan, magenta, yellow, and black inks. These inks are laid down in a pattern of close-together dots, which, when viewed at a normal distance, appears to recreate a full-color image. The pattern can easily be seen with a low-powered magnifier when looking at any magazine page. (Many different line-screen frequencies are available to the designer, but in the following example, we'll use 150 because it is commonly used and makes the math easier to follow. Newspapers use lower screen frequencies and some high-quality publications use higher ones.)

HOW MUCH DO YOU NEED?

In the printing industry, a file resolution of 1.5-2 times the screen frequency is required for high-quality output. In a publication of 150 lpi, for example, this would mean 225-300 pixels per inch at the size the image will be used in the final printed piece. This makes it possible to calculate scanning resolution if we know three pieces of information: the screen frequency of the printed piece, the size at which the image will be reproduced, and the size of the original image. For example, if we want to reproduce an image at 5 × 7 inches on our page, and the original image was shot on 35mm film, the original needs to be enlarged by 500%. This is because the original image is 1 × 1.5 inches. A 500% enlargement gives us a 5 × 7.5 image, so we have to crop it just slightly to fit. Because in our example we have specified a line-screen frequency of 150 lpi, we need the final file to be at 300 ppi (a quality factor of 2). The formula for finding the scanning resolution is: (screen frequency × quality factor) × (enlargement factor) = scanning resolution or, in this case, 300 × 5 = 1500.

> (screen frequency × quality factor) × (enlargement factor) =
> scanning resolution
>
> 150 lpi × 2 (quality factor) = 300
> enlargement factor from 100% to 500% = 5
> 300 × 5 = 1500

Setting the scanner to scan at 1500 pixels per inch would provide a file of the correct resolution. Fortunately most scanning software includes a set of parameters where the operator need only enter the known factors and the software calculates the final scan.

For high-quality printing projects, resolution becomes critically important, to avoid pixelization, or a breakdown in the image. This is particularly true when an image is going to be enlarged.

A common problem crops up due to the fact that we use the terms "pixels per inch" and "dots per inch" so interchangeably. Printing devices are also rated in dots per inch, although the term has nothing to do with pixels per inch. As printing technology, especially ink jet, has evolved, the printers are able to make ever-smaller dot sizes; currently they are only several microns in size. It can take several of these microdots to recreate one pixel of file information. For this reason, we find that often we can print quite successfully from a file that seems at first glance to be too small. Currently files for ink-jet printing need not be larger than 240 ppi at the size they will be printed, and many image-makers report that files as small as 100 ppi print very well. Larger prints, designed for viewing at some distance, often look just fine from less-than-optimum file sizes.

Printing on light-sensitive materials via LED or laser light brings yet another dimension to the table. These printers are true continuous-tone devices and, as such, have no discernable dot pattern. Usually there is an optimum file resolution that works best with each of these printers. It is best to talk to the operator at the lab to get accurate information regarding the best way to prepare files for each machine.

Color Models

Another point of confusion for many of today's digital artists is what color model to use when creating their files. Scanners, digital cameras, film cameras, and monitors are RGB (red, green, and blue) devices. They create their images through the use of light or light-sensitive materials. Ink-based printing systems, such as printing presses and ink-jet printers, are CMYK devices, as they use these inks to create their images. Part of the confusion is caused when most ink-jet printers make better prints from RGB files than they do from CMYK files.

CMYK images contain four channels of information, while RGB images contain only three. You can see the three channels in this Photoshop screen capture.

The reason for this is that each CMYK device requires a slightly different set of conversion factors. The manufacturers of these printers have built the file conversion into the software that drives the printer, making them into what we call "RGB-savvy printers." When CMYK data is sent to these devices, it is converted back to RGB, and then reconverted to the printer's CMYK space, causing all sorts of strange things to happen to the color.

CIE-LAB, RGB, OR CMYK

In light of all this, we need to make some basic decisions about which color space to use for our projects. We have three main choices with several sub choices as well. The main choices are CIE-Lab, RGB, and CMYK. CIE-Lab is a scientifically determined color space that purports to encompass the entire visual spectrum or all colors a human can see. It was defined in the 30s when scientists realized that a way to quantify color was needed. It is the underlying color space in Photoshop and many other programs that can convert files from one space to another. The main problem with its use as a default color space is that it is so large. Because it covers so many colors that we cannot print, making meaningful corrections is a very delicate process that many experts feel is not justified by any increase in final quality. CMYK is not really one color space at all but a variety of spaces, each designed to work best with a specific device. Printers have found that

the best color results from following a set of guidelines that may be subtly different for each shop, or that when a more generic approach is taken, color must be tweaked during the proofing process to arrive at the best possible color. That seems to leave RGB as the best way to work, but it's not that

simple. RGB comes in different flavors, so choosing the one that works best for you requires some thought and a little history as well.

SOME HISTORY OF RGB

When it first became possible to make color separations on the desktop, the only system out there was the early versions of the Macintosh. These computers were almost universally equipped with 13″ Apple monitors. The native color space of those monitors became known as "Apple RGB" and is still offered as a choice when setting up the color preferences in Photoshop. Soon after the Macintosh began to be popular in publishing and printing, it became obvious that a 13″ screen was inadequate for the needs of a page-layout artist or an imaging specialist. The ColorMatch 21″ monitor was introduced along with a video card to drive it in 24-bit color. These were quite expensive, by today's standards, but they were effective and stable; even though the color might not look perfect on the monitor, it was stable enough to make decisions by. The standard established by these monitors is "ColorMatch RGB," and it is still widely used in print shops today. In 1998 Adobe, meeting the need for a larger RGB space to encompass the newer capture and printing devices coming on the scene, introduced "Adobe RGB 1998." Still later at the introduction of Photoshop 5, another RGB space was defined. This space was designed for use on the Web, and took into consideration the inexpensive monitors sold by the thousands as part of package computer systems. This smaller RGB space should not be used when preparing images for high-quality printing. It is known as "sRGB."

TIME TO CHOOSE

Generally the choice comes down to either ColorMatch or Adobe RGB, and the deciding factor for many is how much of their work is destined for press. Showing a client a screen in Adobe RGB has often resulted in dissatisfaction when the final printed piece cannot match the vivid colors encompassed by that color space. Even ColorMatch RGB exhibits a color shift when converted to CMYK, but not as dramatic as Adobe RGB. This is due to the fact that, in general, RGB displays more color than CMYK, and some of the colors change, especially the brighter blues and reds.

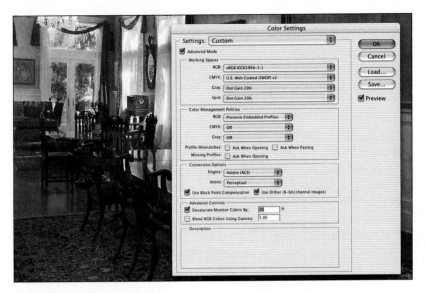

The newest versions of Photoshop provide incredibly detailed control over every aspect of color and its reproduction under a variety of different conditions.

Some photographers have become somewhat obsessive, attempting to define their own color spaces to include all the colors that their film can reproduce, in anticipation of a day when we will have devices that can print these colors. Choosing either Adobe or ColorMatch seems a more logical step for most of us. Spending the time working on your photographic skills or your software skills, in the long run, will help more in the creation of beautiful color prints.

> Remember, RGB retains considerably more color range than does CMYK. Conversion to CMYK from RGB also results in color shifts — particularly the bright reds and blues.

Plan Ahead

The best general statement we can make concerning your images is to plan for using the image as large as possible in the publication in which it is going to appear. If this is a magazine, figure that you're going to use the image at 8 × 10 inches or slightly larger. Then figure in the line-screen factor — let's say 150 lpi. Since you need twice as much resolution, that results in a 300 dpi scan at 8 × 10 inches. That way, you have more than you need if the image ends up being smaller. You can always throw away data — it's very hard to create it where it doesn't exist.

This might seem difficult to do, but is possible with a little forethought. Much personal work is meant to be printed for display (at least that is the hope), and so quality must be foremost in our minds. Thus digital cameras should be set to the highest quality they are

capable of, and scans should be both high resolution and high quality. Sometimes, though, we are just making snapshots that will never be anything more. JPEG is perfectly well suited for these situations, and you gain the advantage of being able to store many more images on your camera's card (or hard drive) than you can with other formats.

When you find yourself starting to make images to fulfill someone else's needs, however, you must ask some questions. Let's imagine for a moment that you have been hired to do some product shots for a catalog. During the course of your conversation with the client, you learn that a major trade show is just around the corner. When scanning the film, you scan at hi-res in RGB, anticipating possible use for the trade show, and knowing that you can always reduce the size of the file for the current job with little quality loss and give the designer a CMYK file for use in a product brochure or catalog. When the owner of the company asks if you can reproduce one of the best shots

as a wide-format ink-jet print for the show, you are able to meet the deadline because the RGB file is archived on your computer.

Bear in mind, however, that color is lost when you convert from RGB to CMYK. Converting images from CMYK back to RGB is never the best option, since the color you lose during the first conversion doesn't magically appear when you convert back. Keeping the original RGB image archived is the best way to avoid the problem.

> Sometimes, though, we are just making snapshots that will never be anything more. JPEG is perfectly well suited for these situations, and you gain the advantage of being able to store many more images on your camera's card (or hard drive) than you can with other formats.

Good lines of communication with your service provider can help to head off many problems. Knowledgeable prepress shops can provide guidelines for converting your files to CMYK, either in the form of ICC profiles or in a step-by-step approach to setting the color settings dialog box in Photoshop. Each shop may have its own idea of what makes a good CMYK file. This is because CMYK is a device-dependent color space, and there are slight differences in output from shop to shop. Asking advice before converting your files could save a round of proofing and subsequent correction, saving time as well as money. The service provider deals with how to get the best output from a wide variety of files on the equipment currently in use, and, because of that experience, is the best source of information.

SCANNING TO SIZE AND UP-SIZING DIGITAL IMAGES

Except when you need to plan ahead for a higher use, scans should be made to the size at which they will be used in the final printed piece. Scanning every image at high resolution creates file-storage problems,

and raises the possibility that someone might use the large files in the layout by mistake. This might not be too much of a problem when only a few images are involved, but can quickly become a nightmare when there are several hundred images to deal with, as in a catalog job. Keeping the job files manageable is an important consideration.

As stated previously, reducing the size of a scanned-image file or a digital-camera file can be done in relative safety. Some unsharp masking may need to be applied, but the file should print well when reduced. It is when trying to increase the resolution of a file that problems can arise. It is always best to scan for the largest-anticipated size. Digital-camera files are a predetermined size, and increasing the file size is sometimes necessary when large prints or double-page reproduction is called for. Fortunately the files produced by digital cameras are so clean and noise-free that some enlargement is possible. Several software developers have come to market with fractal-based products that can enlarge a good digital file with little degradation. Possibly the best known is Genuine Fractals, which does a great job of resizing digital-image files for large-format printing and large-page publishing needs. This plug-in is expensive but worth it, because it works. Using this software, it is not uncommon to see photographic-quality prints as large as 24 × 30 inches and even larger from 6 mega-pixel original camera files.

> Except when you need to plan ahead for alternative use, scans should be made to the size at which they will be used in the final printed piece. It is always best to scan for the largest-anticipated size.

FORMAT AND COMPRESSION CONSIDERATIONS

There are only a few formats to consider when preparing a job for print. Generally TIFF, EPS, and PDF are the formats currently in use when high-quality output is called for. When the image is photographic in nature, most print providers prefer TIFF files. Due to the new features in Photoshop that allow layered and transparent tiffs, the content creator must be aware of some new considerations. Most page-layout programs are not yet ready to accept layered or transparent tiffs, and therefore it is incumbent on the content provider to deliver a flattened TIFF with no extra channels or paths. Failing to check the files will result in unpredictable output that requires additional time and charges.

Files that include some text may be saved in Photoshop EPS format. This file format allows a composite file containing both vector and raster data. When properly output to a Postscript device, the vector data print at the highest resolution of the output device while the raster data output at their native resolution. When saving this type of composite document, be sure to check the Include Vector

Information box during the saving process. Files saved in this manner rasterize the data if opened in Adobe Photoshop, but print correctly when placed in a page-layout program and sent to an imagesetter.

Speak to your print provider to find out which file format fits best in the shop's workflow. Ask them how to prepare files that work best for them. There are many different ways to save EPS and PDF files, and even TIFF files have special considerations best left to the advice of the print provider.

Summary

We have explored the various ways that images become digital files. We touched on scanning technology, covering both PMT-based scanners and CCD-based machines. We looked at flat bed and film-based units, and discussed the merits of each. We discussed resolution, color models, and the necessity of planning ahead, whenever possible. We spent some time on resizing images, covering when and how to get the best results. Finally we discussed file formats, concentrating on those used in print production.

CHAPTER 11

Distribution

No matter how wonderful your images — their effectiveness, compelling nature, perfect lighting, and apparent mastery over depth of field, focal length, and shutter speed — if no one ever sees them, all of your work was for naught.

The bottom line is that somehow, once you've applied all that hard-earned knowledge, you're going to have to distribute your images to your audience. That audience might be as simple as a group of people forced (through subtle coercion) to watch a series of slides from your latest visit to the Ohio location of the World's Largest Ball of String, to the readers of a high-end fashion or sports magazine. Either way, whoever your audience might turn out to be, you have to select the method whereby you're going to get your photographs in front of them.

In today's world, your options are legion. There are newspapers, magazines, gallery shows, books, portfolios, stock houses, and more. Not to be forgotten, the Internet provides an excellent venue for getting your work in front of others. Many image-makers have taken advantage of this method of distribution by maintaining their own Web sites, or posting their images on sites set up to showcase more than one artist. News and information sites also need images and can be a source of income as well as point of distribution. On the other hand, you might be interested in just taking better pictures and sharing them among friends and family members, with no commercial intent whatsoever.

The basic point to keep in mind when considering distributing your images is where and how they're going to be seen. If you intend to take pictures only for a photo album for your own personal use, then your choices are quite simple. First, you have to use print film so that when your pictures are developed, they're returned to you in a format suited to albums. You can easily order multiple copies if you want to share the pictures with someone else.

If, on the other hand, you intend to use them for anything other than the family photo album, you're going to need digital images. We talked about several conversion options in the last chapter. Either way, keeping all your images in digital format presents several benefits.

The biggest benefit gained from having your images in digital format is the ability to cross-purpose them. *Cross purposing* is the process of using an image (or other creative asset, such as text or an illustration) for multiple purposes. It's something we've touched upon, but it's worth talking about again.

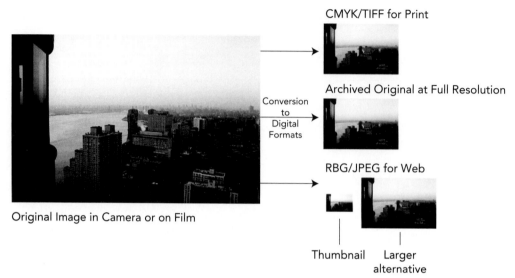

CMYK/TIFF for Print

Archived Original at Full Resolution

Conversion to Digital Formats

RBG/JPEG for Web

Original Image in Camera or on Film

Thumbnail Larger alternative

In the preceding graphic, you can see the original image — the one on the film or in the storage device within a digital camera. From there, a cross-purposing workflow would have three different stages. This assumes that in the case of a film-based image, it's either scanned by the photographer or at a processing site. This service is increasingly available at commercial processing companies.

First, the image is archived in its original, full-resolution version. That way, you can always use it to generate the various formats you might need for different purposes. Whether you need to put it on the Web, display it in a catalog, or generate a transparency, the original data, complete with a full range of colors, acts as the master from which the other versions are created.

If the image is to be printed using conventional methods, a CMYK version would be generated at the size at which it is to be reproduced.

Lastly, if the image is going on the Web, you would probably generate two versions — a *thumbnail* (a small version of the file) and a larger, higher-resolution version for use should the visitor wants to see a bigger version.

We'll start by exploring the issues for printing and then move on to digital or electronic distribution methods.

Printing

Now that you've captured that perfect image and need to create *hard-copy output* (a physical copy of the image), all you have to do is load it on your computer and press the Print command, right? Wrong. As is often the case, there are a good number of points that you must take into account before consistently excellent prints are going to come pouring off your output device.

Printed materials still represent the most common form of communications — whether you're talking about advertising, marketing, business communications, technical specifications, entertainment reading, instructional and training materials, and news. Although the Internet has certainly had a major impact on how information is distributed, so-called "ink-on-paper" remains the dominant medium. Despite forecasts that computers — and particularly the Internet — would eventually result in a paperless society, it seems that the opposite is true. There's plenty of printing being done at the big Internet companies. A large percentage of printed material requires photographs.

Although you don't have to learn everything there is to know about various printing technologies, it's a good idea to develop at least a general understanding of the different ways your pictures might eventually be printed.

There are three main types of printing technology to consider:

- **Conventional offset printing**. This is the kind of printing that's done on traditional mechanical presses — the kind you'll see if you visit a medium-to-large commercial printing company.
- **Ink-jet printing.** This type of printing uses colorants to image individual pixels on paper.
- **Photographic printing**. Photographic printing is the same as conventional printmaking, and involves using light-sensitive materials and chemical processing.

Each method has its good points and drawbacks. Trade-offs are made between cost and quality, automation and custom printing, and color range and longevity. How long your images are likely to last is something that's not taken into consideration by many people new to the field. For anyone who has been taking pictures for a long time, seeing what happens to old photographs is hard to forget. Even CDs have a lifespan, which, although hard to quantify, is nonetheless a factor. Hard figures concerning how long a CD will maintain the data you store on it are difficult to come by, but we wouldn't want to stake the farm on your CDs still being viable 20 or 30 years from now.

CONVENTIONAL OFFSET PRINTING

Most commercial printing is done using a technology known as "offset printing." Offset printing represents the most cost-effective method of producing thousands of copies of a publication — whether it's a magazine, a brochure, a catalog, an instruction manual, or a comic book. It's used for producing larger numbers of art posters and prints than can be economically manufactured using ink-jet or photographic printing devices.

There are pros and cons associated with offset printing. Among the major advantages to the process is economy of scale. The first printing (called a "print run") takes place; a charge is assessed for getting everything ready. This charge, called a "make-ready," includes the costs associated with services like converting all of your images to a proper format, creating the "master" items (called "plates") used on the presses to replicate the required number of copies, and other preparation charges. The inclusion of these make-ready charges adds to the per-unit cost for the first run, but isn't charged to subsequent reprints — provided, of course, that no changes are made to the originals. The end result of all of this is that the per-unit costs for printing on conventional offset presses is lower than any other means of production. In addition, the quality is high and widely accepted by the reading audience.

The primary disadvantage of conventional offset printing is the high cost of the make-ready, which makes the method unsuitable for small numbers of prints. A considerable amount of time, effort, and expense must be expended to prepare for a press run. This process (also called "prepress") requires skilled professionals.

Because of the costs associated with starting up the presses and putting ink onto the paper, a preprinting process known as "proofing" takes place. A *proof* is a reproduction that best represents what the print run is going to look like, within the current abilities of technology. Modern proofing systems can even output samples onto the paper or other materials (called "substrates") that is going to be used for the final run.

Until recently, all proofing was done using physical materials, that is the proof was a hard copy of what the run was to look like. Increasingly, color-accuracy technologies have gained increasing acceptance among the design community. This technology, usually called "color management technology," has resulted in designers often proofing colors directly on their monitors. (For more information on color management, see the Against the Clock book *Color Companion for the Digital Artist*.) Hard-copy proofing, however, is still the dominant process in place among the printing manufacturing communities. In most cases, designers are required to sign off on proofs before the presses begin their work to protect the printer from any liability arising from errors found in the final product.

INK-JET PRINTING

A second printing method rapidly becoming popular is ink-jet technology. Both in desktop models and in their larger cousins, known as "wide-format printers," these machines have revolutionized the printing of photographic images. The technology has progressed at an amazing rate for the past several years, and earlier concerns regarding color accuracy and stability are largely a thing of the past. Modern ink-jet printers like those from Epson and Canon produce prints that, to the naked eye, are indistinguishable from more conventional photographically produced images. Modern ink jets produce a print that lasts as long, under the same conditions, as prints made on photographic paper, and, according to some independent tests, may last even longer. This technology has brought the ability to produce photographic-quality enlargements onto the desktop of any image-maker so inclined. The initial equipment-price is quite low, with high-quality, letter-size printers starting well below $300.00, and printers that can produce a 13 × 19 enlargement coming in at about $700.00 on the street. Photographers in all genres and at all levels are embracing this technology, whether as a proofing medium before going to a large press run or as a final print.

An advantage to this process that is not, at first, readily apparent is the ability of many of these printers to print on specialty papers such as watercolor stock and canvas. Many photographers have taken advantage of this ability to add a dimension to their work that cannot be achieved with more conventional papers. Another advantage is that larger prints from small files can be made to look surprisingly good. Even though these printers advertise resolutions as high as 2880 or even higher, they need only a fraction of their advertised resolution to print well. In most cases 240 ppi at the size of the final print allows the printer to make a very high quality print. When especially large prints are required, 120 ppi is often quite successful, especially when the prints are viewed from an appropriate distance.

> Modern ink jets produce a print that lasts as long, under the same conditions, as prints made on photographic paper, and, according to some independent tests, may last even longer.

Drawbacks to this process include the fact that it is not fast, taking several minutes per print under the best of circumstances, and has a relatively high cost per print for ink and paper. These considerations don't come into play when producing a small number of custom prints as art or for a commercial client, but they can be stumbling blocks when more than a few prints are called for. Another problem is *color gamut*, or the range of colors that can be reproduced; early examples of this process showed a lack in some areas. The ink manufacturers have largely addressed this problem and continue to make progress in this area. Several printers now employ six or even seven

colors of ink. The addition of light black (formerly known as "gray"), light cyan, and light magenta have created smoother transitions between colors, adding to the great look of prints from these systems.

SILVER-BASED PRINTING

Not to be outdone by the digital revolution, conventional silver-based imaging products have been adapted to digital imaging as well. (Remember, silver-based imaging is the same process used in conventional film photographs.) In recent years, several manufacturers using differing technologies have brought out machines that can expose conventional, silver-based, light-sensitive papers. These must then be processed in chemicals, like any other photograph. Through the use of RGB lasers or high-quality CRTs, and in some cases LEDs, true photographic prints can be made from digital files. These printers offer a wealth of advantages to the labs that can afford the high initial cost. They offer the promise of much less waste due to the operator's ability to see a soft proof of the image on the monitor. With these machines, as with all digital printing, an image need be retouched just once, and then many prints of differing sizes can be made. Prints as large as 50 inches wide can be made by the largest of these units, with the length determined by the size of the file and the ability of the computer to feed data to the printer.

Photographic materials have been with us for quite awhile, and, as such, the cost per square inch is lowered by the vast amounts of this paper used worldwide. At this writing, prints from digital files in many areas cost no more than prints from negatives, and in the case of the newer minilabs, even when a print is ordered from a negative, the machine scans the negative and prints the image to the paper digitally.

Drawbacks to this system include the high initial cost of the printer, from $50,000 to $500,000, and the attendant problems of working with photographic chemicals. This pretty much confines these units to labs that serve either the professional market or the amateur photographer. Choice of substrate is limited, as well, to conventional photographic materials. On a positive note, photographic paper offers the widest color gamut currently available, as well as the ability to carry detail in highlight and shadow areas that would be lost in other printing methods.

Electronic Distribution

While conventional film-based cameras will remain a major factor in the hands of professional photographers, digital technology continues to make itself known at all levels of the field. This is true whether the images are being shot by one of the world's leading fashion photographers, or you're taking images at a neighborhood picnic. Even film images being shot on location at some point are being converted into digital data.

PROFESSIONAL PORTFOLIO SITES

Among professional photographers, the most popular form of electronic distribution is the portfolio site. A *portfolio site* presents the work of the photographer for potential clients to access online. If you are going to be in the business of selling your work, such a site can serve your purposes quite well — depending on a number of different factors.

> Among professional photographers, the most popular form of electronic distribution is the portfolio site.

First, just because you have a site doesn't mean that thousands of people will come and see it. Like anything, else, you've got to market yourself (and your site) if you expect results. You may be the best photographer in the world, but if you don't sell yourself and your services, your talent is going to go unrewarded — except, of course, for the warm and fuzzy feeling you get from looking at your own pictures.

Second, the design of the site has to be top quality. Remember, if you're selling existing photographs or are seeking custom assignments, the client is very likely to be a designer or an otherwise creatively endowed individual. True, sometimes you'll be doing work for people with minimal design sense, but most of the time your potential clients have an eye for what looks good and what doesn't. To make matters worse, designers are harsh critics of other peoples' work. Unless your site looks really good, and (perhaps more importantly) provides simple, intuitive navigation functionality, some visitors might not even spend the time to look at your material, much less reach into their pockets to pay for it.

There are certainly plenty of sites to visit if you're looking for good design — and plenty of great site designers out there who have already done work for people like you. At any rate, time spent

Dave Monroe's Moxie Studio's site makes use of an aperture ring as the primary navigation element. You can visit the site at moxiestudios.com. The design is simple, elegant, and very effective.

The thumbnails in the pop-up page on the right are used to access larger, easier-to-view versions of the images on this site from Skip Milos.

researching what other photographers have done on their Web sites is time well spent. You don't need to steal someone else's ideas, but you can certainly use their ideas as background material and inspiration for your own efforts.

As mentioned earlier, thumbnail versions of an image that provide link access to larger, higher-resolution pictures are very commonly employed on portfolio sites. The idea is to fit quite a few small thumbnails on a single page, and let the user click an image to see the bigger picture for any of interest.

Online catalogs are another place where thumbnails are quite useful, for the same reason. You can easily design a Web page that contains small, easy-to-see pictures that leave plenty of room for price, description, and other information, while providing a large image for potential buyers to view during the ordering process.

PERSONAL ONLINE IMAGE CATALOGS

What if you're not a professional photographer, and have no desire or need to spend the money necessary to launch a worldwide Internet presence for the sale and distribution of your images? Not to fret — there are plenty of ways to publish and distribute your great family and personal images without selling the family farm.

There are a variety of ways you can go online with your personal images, depending on the software you have available, and exactly which features or functions are necessary for you to achieve your goals.

A little later in this chapter, we discuss formats specifically for use on the Web, and some considerations to keep in mind, but the concept of publishing personal images on the Web is quite simple.

Left: This image, from the .mac service offered by Apple Computer, shows how easy it is to set up an online photo album for distribution of personal images. Learn more about this service by visiting apple.com.

Below: Another alternative method for posting personal digital photo albums online can be found at the Kodak Web site — kodak.com.

All of this assumes you have an Internet connection, naturally, so we don't need to go into the details of connecting to the Web. Once you have a connection, you can use a variety of different applications.

Following is an example from Apple's .mac service, a relatively inexpensive subscription service that offers a variety of different services, including space for archiving your images, and, if you need it, space to host a personal Web site. Among the options is an image-catalog system.

America Online offers image-album services, and even has a built-in "You have pictures" voice to remind others that your pictures have been posted for the entire world to see.

Kodak is another great choice for publishing your own personal photo albums online. The above-right image is from the Kodak Web site (kodak.com). You can create an account and, from there, easily upload images for other people to access from their own machines, or download images that others have posted to the site. Again, there are plenty of options available for distributing your images for personal use.

PREPARING IMAGES FOR THE WEB

Preparing images for use on the Web is considerably easier than getting your pictures ready for conventional printing techniques. First, you don't have to convert your images to CMYK, or worry about any of the dozens of things that can go wrong during such conversions (and other prepress techniques).

The most important consideration when you're publishing your photographs on the Web is how big they are. Referred to as the file's "weight," file size (measured in Kbytes) is the one sure way to turn off

potential viewers. If your images take more than a second or two to download, forget it. Download time is one of the reasons so many people make use of thumbnails when publishing their images on the Internet; the thumbnail is tiny (relatively speaking) and offers access to the slower downloading, larger version of the image.

The most common file format for publishing photographs on the Web, as we've already mentioned, is the JPEG. Remember, JPEG is a *lossy* compression method, which means that information is discarded during the compression process. This loss of image data can result in some pretty terrible results if overused. On the other hand, judicious use of the format can result in your images looking absolutely wonderful when viewed from your Internet site.

When you're saving a JPEG image, you have control over how much compression is applied to the image. The smaller you want the file, the more quality loss occurs. On the other hand, the less compression you apply, the slower the download process is. You face a balancing act when creating images for use on the Web.

In the following image, we're about to open a picture file that weighs in at a hefty 10 megabytes. The large, high-resolution picture of downtown Tampa, Florida was taken with a high-end Canon digital camera. At 10 megs, it's well suited for publishing in a glossy, four-color magazine. To download the image on a typical modem, however, users would have to wait around for more than two hours before they could see the picture.

At 10.2 megabytes, this picture of downtown Tampa, Florida would take more than two hours to download using a typical modem connection to the Internet. Even with a high-speed connection, such as cable or DSL, it would still take two minutes or more before the user saw anything.

Photoshop and Fireworks, the two most popular image-editing programs in use today, both offer methods of generating JPEG images for use on the Web. The programs are very well designed, and allow you to see different quality settings and download times on a single screen.

To better show the effects of different compression settings on the quality of the (Web) published image, we zoomed into a detail of one of the buildings in the picture. At the high-resolution print image, details were held far greater than this example shows. When you're putting your images on the Web, however, such zoom detail doesn't do

anything but slow down the system. After all, you can't zoom into a Web page, and the size of the image in its place within the design is the size that the viewer is going to see.

In the upper-left corner is a detail of the original image; it's 10.2-megabyte size shows in the lower-left corner of the image. The next image at the upper right shows how a low-quality JPEG file is going to display. You can see considerable degradation and stray pixels (called "artifacts") showing around the edges of the windows. Note the download time is 78 seconds.

On the lower left is a medium-quality JPEG image that comes in at 371k and takes 133 seconds to download. On the lower right is the same image, using a maximum quality setting for the JPEG format, which takes an astounding 1200 seconds to download.

After downsizing the image to a more manageable 3 × 4 inches (instead of the 10+ inch image we started with, originally, we were able to create a JPEG image, using medium quality settings, that came in at only 52k and downloaded in a mere 1.2 seconds.

Summary

Taking great pictures is only one component in the path to becoming a successful photographer. This holds true whether your ultimate aim is to pursue a career in the field, or you're merely seeking to take more effective and good-looking images. From simple newsletters to award-winning Web sites, a majority of professional communications relies on visual images which started their existence inside someone's camera, or more accurately, in his or her mind's eye. Once you've taken that perfect image, however, it needs to be distributed in one or more forms. In this chapter you've learned some of the nuts and bolts for preparing your digital images for viewing by a potential audience. You've learned the basics of getting an image ready for print and the Web, and how to ensure that the colors you captured are the same when seen by your audience.

GALLERY

The images presented in the Gallery represent a wide selection of techniques, tips, and concepts that were presented throughout the *Photography Companion for the Digital Artist*. Each image is the result of an actual assignment; they reflect the reality of commercial and professional photography.

Take some time to look through the Gallery as you go through the book's sections and chapters. These images support the text, providing you with visual reinforcement of critical concepts and ideas. The collection includes both candid and formal portraits, day- and nightscapes, examples of composition utilizing the rule of thirds presented in the composition chapter, as well as the effects of film speed, lighting, and lens selection. You'll also have the opportunity to see the combination of photography and software in the section of montages and artwork.

FILM SPEED

The differences resulting from film speed and resolution of a published image aren't always apparent to the untrained eye, but become critically important to the experienced photographer.

These two examples, which present the model's image at two different resolutions, underscore the difference between two different film speeds and the impact that it has on the final results printed in a color publication.

LOCATIONS

As these images demonstrate, shooting effective and compelling location images isn't limited to sunrise and sunset, nor do they absolutely require the use of wide-angle lenses. All four of these images fall into the broad category of shooting places, yet they are as different from each other as they would be from a picture of a person involved in a sporting event. The rules of composition, however, are constant, and can be seen in all four pictures.

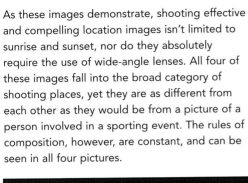

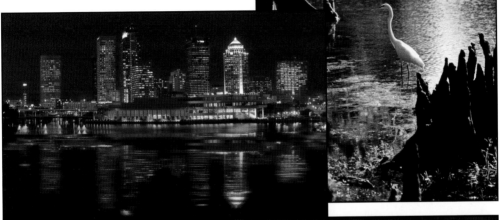

COMPOSITION

Composition is often considered an elusive aspect of a picture. This is particularly true of people who have never been formally trained in the art and science of photography. The rule of thirds — a fundamental building block of professional photography — is evident in these three images. Despite the fact that the three subjects are completely unrelated and fall into separate photographic categories, the positioning of their key components follow the same basic theory of composition, and their quality shows it.

PEOPLE

An argument can be made that the most diffi-
cult of all picture-taking assignments are the
ones that require you to take pictures of other
people. While good people pictures are often
more difficult to capture than they might appear
to be, there are some basic rules that will
improve your own results. These pictures were
taken with the full knowledge and cooperation
of the subjects. This category of imagery is
known as "controlled photography."

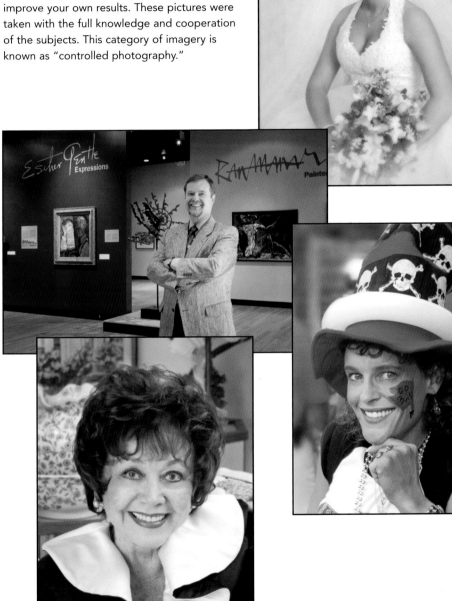

PEOPLE

These are images from the second category of people pictures — candid photography. *Candid pictures* are those taken either without subjects knowing that they're being photographed, or involved in some activity that makes them appear to be unaware of the process.

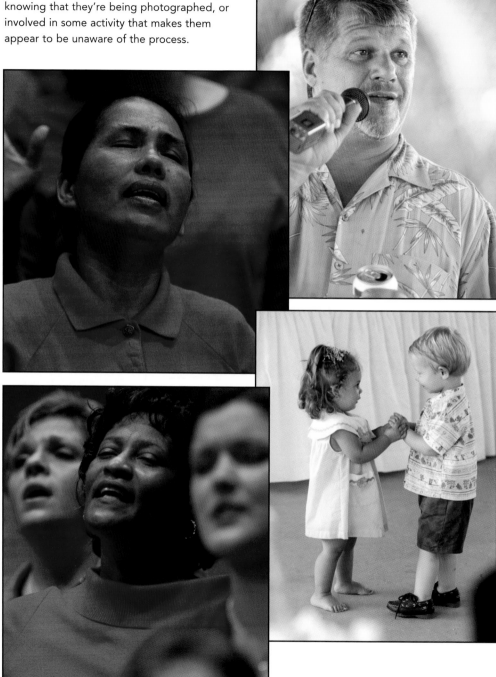

PRODUCTS

Product photography is one of the staples of the professional photographer, and may very well be one of the primary reasons you need to take better pictures. Good product photography requires a specialized application of composition, lighting, and other factors not necessarily evident in other fields of image-making. These images present several different approaches to taking pictures of objects.

ARTWORK AND ELECTRONIC MONTAGE

Although this book is more focused on taking original photographs than on the use of software to enhance those images, such enhancement is certainly a subject worth mentioning. Each of these images went through a series of processes using Adobe Photoshop. In each case, the digital manipulation of the original photograph resulted in the appearance of more traditional physical media, such as watercolors, pastels, charcoal, and oils. Among the techniques used were filters and careful adjustments to tonal values. In all cases, however, proper exposure, composition, and lighting were in place before the images were used as a primary component in the artwork.

Glossary

35mm camera

Film cameras using 35mm film. They range from simple point-and-shoot cameras to high-end professional models. The most common is the SLR. See also *35mm film*, *SLR* or *single-lens reflex camera*, and *camera*.

35mm film

The most common film format, this film has sprockets along the edge and uses a 2 × 3 aspect ratio.

Additive color

Color produced by mixing three hues of light — red, green, and blue (the three additive primary colors). See also *primary* and *subtractive color(s)*.

Analog or film photograph

An image made on light-sensitive film that must be processed chemically before it can be viewed.

Angle of view

The perspective or area seen by a lens or viewfinder.

Aperture

The lens opening through which light passes.

Artificial light

Light from sources other than nature — a lamp or electronic flash. Light the photographer has set up to illuminate a scene.

ASA

A film speed rating similar to an ISO rating.

Aspect ratio

The mathematical relationship of one dimension to another.

Automatic flash

A flash unit that measures light reflected from the subject and stops the flash when the exposure is correct.

Automatic focus

A feature enabling the camera to adjust its lens to focus on a specific area.

Available or existing light

The light that already exists where a photograph is being made.

Back lighting

Light coming from behind the subject toward the camera.

Bank

A group of floodlights placed close together.

Bit

The smallest unit of information usable by a computer.

Bit depth

The number of bits used to represent each pixel in an image, determining its color and tonal range.

Bounce light

Light that is reflected off another source onto the subject.

Bracket

Making additional exposures beyond the one likely to be the most correct. The additional exposures are greater and less than the preferred exposure. Bracketing compensates for error and offers a selection of options after processing.

Brightness

The measurable volume of light reflected by an object. The object's apparent lightness.

Bulb

A shutter setting at which the shutter remains open as long as the shutter release is held down.

Burst rate

The time a camera requires to be ready to make the next exposure.

Butterfly lighting

Portrait lighting in which the main source of light is placed high and directly in front of the face.

Byte

A unit of digital data containing eight bits.

Camera

A picture-taking device. Typically consisting of a light-tight box, a film holder, a shutter, and a lens. See also *35mm camera, circuit camera, medium format or roll-film camera, prosumer camera, reflex camera, rigid camera, SLR or single-lens reflex camera, tethered camera, twin-lens reflex camera*, and *view camera*.

Camera back

A device that hooks onto the back of a standard camera to convert it to a digital system.

Candid photography

Images made when the subjects are unaware (or apparently unaware) of being photographed Opposite of controlled photography.

Capture

The part of the camera that records what you see when you look through the viewfinder and press the shutter button. The capture component is the chemical component of the film camera; in the digital camera, electronic components read the incoming light and color information, and store the data inside the camera's memory. Also, take a picture ("capture an image").

Catch lights

Highlights or bright spots in an image that result from light bouncing off reflectors onto the subject. See also *highlights*.

CCD

Charge-coupled device. A light-sensitive device built into digital cameras and scanners. See also *CMOS*.

Circuit camera

Old cameras designed to photograph extremely large groups of people posed on grandstands in a horseshoe configuration. Driven by a clockwork mechanism that moved the entire camera in a semicircle.

Close-up

A larger-than-normal image of the subject or part of the subject.

Close-up lens

See *macro lens*.

CMOS

Complementary metal oxide semiconductor. A light-sensitive device, built into digital cameras and scanners. An alternative to CCD sensors. More cost effective to manufacture and use less heat than CCDs. See also *CCD*.

CMYK

The four colors used in printing on a press to create "full-color" images: cyan, magenta, yellow, and black. Laid down in a tight dot pattern, they fool the eye into seeing apparent full color.

Color balance

A film's or a CCD's response to the colors of a scene. Color films are balanced for use with specific light sources. Also, the (alterable) reproduction of colors in a color print.

Color cast

A trace of one hue in all the hues in an image.

Color gamut

The range of colors that can be formed in one color reproduction system (such as RGB or CMYK).

Color gradation

The smooth transition between different shades of colors in an image.

Color temperature

A numerical description of the color of light measured in degrees Kelvin (°K). Film is color balanced to a specific Kelvin temperature.

Complementary colors

Color harmony resulting from using two colors from opposite sides of the color wheel.

Continuous tone

An image smoothly gradating tones from black through gray to white.

Continuous light source

Also known as hot lights. Lights that are on continuously (unlike flashes).

Contrast

The difference in darkness or density between one tone and another.

Controlled photography

Images made when the subjects are aware of and cooperating with the photographer. Opposite of candid photography. Also known as formal photography.

Crash points

The intersections of the vertical and horizontal imaginary lines used in the rule of thirds. Items at these intersections take on more visual impact. See also *rule of thirds*.

Credit line

A line of type giving the photographer's name adjacent to or along the photograph when printed.

Cross purposing

Using an image or other creative asset for multiple purposes.

Daylight film

Color film that is balanced to produce accurate color when the light source has a color temperature of about 5500°K, such as midday sunlight or an electronic flash. See also *film*.

Dedicated flash

An electronic flash unit that automatically sets the correct shutter speed for use with the flash and triggers a light in the viewfinder when the flash is charged and ready to fire.

Density

The degree of opacity of an image on paper or film, caused by the amount of silver present in various areas of film or paper after exposure or development.

Depth of field

The area between the nearest and farthest points from the camera that is acceptably sharp in an image. The term refers to how shallow or deep this area of focus is within the image.

Depth of focus

The small range of focusing area that will produce an acceptable sharp image when a lens is not focused acceptably.

Diffuse highlights

The areas of a subject that receive the most light from a given source. Opposite of specular highlights.

Digital imaging

A method of image-editing in which a picture is recorded as digital information that can be manipulated by a computer.

Digital zoom

Digital cameras achieve a zoom effect by cropping into the live area of the image sensor to achieve a tighter look. Fewer pixels are used to form the image, reducing the quality of the image. See also *zoom lens*.

dpi

Dots per inch — a measure of the resolution of a digital image; also of a digital printer or scanner. The number of dots or points that can be printed or displayed by the device. See also *ppi* and *resolution*.

Electronic flash

Commonly referred to as strobe units. They are available in many forms — built-in, hand-held, shoe-mounted or mounted on the camera, and large portable or heavy-duty studio forms. These units make light by exciting a normally inert gas like xenon, sealed in a vacuum tube, with high voltage until it suddenly becomes a conductor, producing a bright spark contained in the tube. They can produce a great amount of light and are reusable. See also *flash, manual flash, strobe units*.

Emulsion

A light-sensitive coating applied to photographic films or papers. It consists of silver halide crystals and other chemicals suspended in gelatin.

Exposure

Letting light strike a light-sensitive paper or film. Also, the intensity of light multiplied by the length of time it strikes the light-sensitive material.

Fast

A film or paper that is very sensitive to light; a lens that opens a very wide aperture; a short shutter speed. Opposite of slow.

Fill light

A source of illumination that lightens (opens) shadows cast by the main light and thereby reduces the contrast in a photograph.

Film

The material used in a conventional camera to record a photographic image. A light-sensitive emulsion coated on a flexible acetate or plastic base. See also *daylight film, instant film, roll film*, and *transparency film*.

Film back

A device that allows changing film types in the middle of a roll. Also called a film magazine.

Film grain

The effect created when the size of the light-sensitive particles on film becomes large enough to be visible. As film speed is increased, so is film grain.

Film speed

Film's relative sensitivity to light. Film speed ratings increase as the sensitivity of the film increases. Rating systems include ISO (most common in the USA and Great Britain), DIN (common in Europe), and others.

Fisheye lens

A lens with an extremely wide angle of view (up to 180°) and considerable distortion (straight lines at the edge of a scene appear to curve around the center of an image). See also *wide-angle lens*.

Flash

A light source, such as a flashbulb or electronic flash, that emits a brief but bright burst of light. See also *electronic flash*.

Fixed lens

A noninterchangeable lens that is permanently attached to the camera body and designed as part of the camera.

Focal length

The distance from the lens to the focal plane when the lens is focused on infinity. The longer the focal length, the greater the magnification of the image.

f-stop

The common term for the aperture setting of a lens.

Galley

The raw output of a typesetter, typically as single columns of type on long sheets of paper.

Gobo

Light modifiers designed to remove or exclude light from portions of a scene. Devices that go between the light and what needs to be protected from it. Often used to keep light from shining directly into the camera lens.

Grayscale

A means of rendering a digital image in black, white, and gray tones only.

Grip equipment

Items used to modify light, fix lights in place, and set the camera in position. Named for the grip, the role of the individual in the movie industry who puts together this equipment.

Halftone

A reproduction of continuous-tone artwork or a photograph with tone value and detail represented by a pattern of equally spaced dots of various sizes. When printed, the dots (close together in dark areas, farther apart in light areas) merge to give the illusion of continuous tone. An image that can be reproduced on the same printing press with ordinary type.

Highlights

The brightest areas in an image. See also *catch lights*.

Histogram

A graphic representation of the tones in an image. A visual frequency distribution bar graph used in photo editing and adjustment programs.

Image stabilization

A technology that enables the photographer to shoot pictures using long lenses at relatively slow shutter speeds while holding the camera by hand.

Incandescent light

Lights that use a hot wire in a vacuum to produce illumination. They are inexpensive but dim with age. Ordinary light bulbs.

Instant film

A film that contains the chemicals needed to develop an image automatically without darkroom development.

Interchangeable lens

A lens that can be removed from the camera and replaced with another lens, usually of a different focal length.

Inverse square law

Light diminishes in intensity according to the distance from the light source to the subject.

ISO

A numerical rating describing the sensitivity to light of film or of a digital camera's CCD. The ISO rating doubles as the sensitivity to light doubles.

JPEG

A file-compression system, often offering several levels of compression, commonly used to put photographic images on the Web. A lossy compression system, losing some data each time the image is compressed. See also *RAW* and *TIFF*.

Key light

The main light on a subject. See *main light*.

Leading line

A line within a naturally occurring shape or in the photograph that leads the eye into the main subject.

Lens

A piece or several pieces of optical glass shaped to focus an image of a subject. See also *fisheye lens*, *fixed lens*, *interchangeable lens*, *long lens*, *macro lens*, *normal lens*, *telephoto lens*, *wide-angle lens*, and *zoom lens*.

Lens speed

This measurement indicates how much light the lens is capable of gathering. See also *speed*.

Long lens

A lens with a focal length longer than the diagonal measurement of the film used. The angle of view is narrower at a given distance than the angle that the human eye sees.

LUTs

Look-up tables that store the known characteristics of common films. They reverse the tones and colors as well as remove the mask so are helpful in obtaining good scans from negative film.

Macro lens

A lens designed for taking close-up pictures.

Main light

Also called the key light, the principal source of light, usually in a studio setup. It casts the primary shadows and defines the texture and volume of the subject.

Make-ready

The charge assessed for preparing a job for printing. It includes costs such as those associated with converting images to the proper format, creating plates, and other prep charges.

Manual exposure

A nonautomatic method for operating the camera; the photographer sets the shutter speed and the aperture.

Manual flash

A nonautomatic means for operating the flash; the photographer controls the exposure by adjusting the size of the camera aperture. See also *flash* and *electronic flash*.

Mask

The overall orange color that color negative film takes on when processed. It is part of the color print system, used to control contrast, and is slightly different from manufacturer to manufacturer.

Medium format or roll-film camera

The workhorse of the photographic industry. It uses film without sprocket holes on plastic spools sandwiched with lightproof paper. Between 35mm and large-format cameras.

Megabyte (MB)

1,000,000 bytes. Used to describe the size of a computer file.

Megapixel

Resolution is expressed in this form. Each megapixel contains one million pixels.

Negative

The effect created when film is processed and the tones of a scene are reversed, so bright areas are dark and dark areas are light. When color negative film is processed, the colors are reversed.

Normal lens

A lens whose focus length is about the same as the diagonal measurement of the film with which it is used. The angle of view is about the same as what the human eye sees.

Open shadows

The shadow areas of the image are bright and balanced.

Open up

To increase the size of a lens aperture. Opposite of stop down.

Overexposure

To give more than normal exposure to film or paper.

Perspective

The apparent size and length of objects within an image.

Photoflood

An incandescent bulb in a dish reflector. It produces very bright light but has a relatively short life.

Photographic paper

Light-sensitive paper on which photographs are printed.

Pixel

Short for picture element, a part of a dot made by a scanner or other digital device. Images are composed of many individual pixels, each having a specific color or tone. Also, a point on computer monitor.

PMT

Photo-multiplier tube. One technology for scanning images. PMT-based drum scanners use one image sensor. The hardcopy is attached to the drum and passed before the image.

Polarizing filter

A filter that reduces reflection from nonmetallic surfaces by blocking light waves that are vibrating at selected angles to the filter.

Portfolio site

A Web site that presents the work of the photographer for potential clients to access online.

Posing

Placing the subject in a specific position in relation to the lights and camera lens.

ppi

Pixels per inch — a measurement of the resolution of a computer monitor, digital camera, or digital image. See also *dpi* and *resolution*.

Primary colors

Basic colors from which all other colors can be mixed. See also *subtractive* and *additive color*.

Print

A photographic image, usually a positive image on paper. Also, to produce such an image from a negative by contact or projection printing.

Proof

A test print made to evaluate color balance and accuracy, density, contrast, registration, and more.

Prosumer camera

A step above the point-and-shoot category of digital cameras are these high-end cameras. These are sophisticated image-making machines with high-resolution imaging chips and high-quality lenses.

Pull

To develop film for less time than normal, compensating for overexposure. See also *push*.

Push

To develop film longer than normal, to compensate for underexposure. See also *pull*.

RAM

Random access memory. RAM chips act as temporary data storage in a computer or other device to allow rapid data access and processing.

RAW

Files in this format represent all of the data collected by the imaging chip at the time of exposure. This format has been adopted by most camera manufacturers. See also *JPEG* and *TIFF*.

Reduction

A print that is smaller than the size of the negative. Also, a process that decreases the amount of dark silver in a developed image. Negatives are usually reduced to increase density. Prints are reduced in certain specific parts to brighten highlights.

Reflector

A device that adds (redirects) light to shadow areas. A reflective surface, such as a piece of white board or fabric, or more reflective silver or gold metallic materials when more light is needed. A reflective surface, often bowl- or dish-shaped, placed behind the lamp to direct more light toward the subject.

Reflex camera

A camera with a built-in mirror in the optical path that reflects the scene being photographed onto a viewing screen. See also *SLR or single-lens reflex camera* and *twin-lens reflex camera*.

Resolution

Generally, a measure describing what a printer can print, a scanner can scan, or a computer monitor can display. Also, the fineness of detail in a digital image, typically represented by the number of pixels per inch (ppi) in a displayed image or the number of dots (dpi) in a printed digital image. Also, the amount of data available to represent detail in a given area. See also *dpi* and *ppi*.

Retouching

A process by which artists make changes to a physical negative or print using dies and tiny brushes to remove blemishes and repair damage. Also performed electronically to digital images. Often used to smooth skin texture, eliminate wrinkles, and generally portray an idealized image of a client or product.

RGB

Red, green, and blue, the colors of light used by a computer monitor. When combined, they can create a color image. The colors of most digital artwork. Scanners, digital cameras, film cameras and monitors are RGB devices. See also *CMYK*.

Rigid camera

One on which the lens is not adjustable in relation to the film plane. See also *view camera* (an adjustable camera).

Roll film

Film that comes in a roll, protected from light by a length of paper wound around the film. Loosely applies to any film packaged in a roll rather than flat sheets.

Rule of thirds

Any frame can be divided into thirds, vertically and horizontally. Items at the points where those lines cross become more important visually. See also *crash points*.

Scrim

Light modifier placed between the light source and the subject, usually to alter the quality of the light. It also reduces the light's intensity.

Sharp

An image or section of an image that shows crisp, precise texture and detail. Opposite of blurred or soft.

Shooting for the process

Taking photographs intended for alteration or combination during processing.

Shutter

A mechanism that opens and closes to admit light into a camera for a measured length of time.

Shutter speed

The amount of time that film is exposed to light.

Shutter-release cable

A flexible cable with a plunger at one end. The cable screws into the shutter button and let's you snap a picture without touching (or moving) the camera.

Sitter

A model.

Slave sensor

A device that fires the flash when triggered by the flash of another unit attached directly to the camera.

SLR or single-lens reflex camera

The mirror in the optical path of this camera first reflects the image to a viewing screen and then flips up out of the way to allow the light to reach the film. The most common type of professional 35mm camera. See also *reflex camera* and *twin-lens reflex camera*.

Slow

A film or paper that is not very sensitive to light, so requiring a relatively large amount of light (long exposure or large f/stop aperture) to record the image; a lens whose widest aperture is relatively small; a long shutter speed. Opposite of fast.

Smart media

A type of intelligent data-card device.

Specular highlights

Reflections of light sources in shiny areas of the subject. Opposite of diffuse highlights.

Specularity

The quality of light when it is hard and sharply defined. Opposite of diffuse.

Speed

Film's or paper's relative sensitivity to light. Also, the relative ability of a lens to admit more light by opening to a wider aperture. Speed is determined by dividing the length of the lens by the maximum diameter of the aperture.

Spotlight

An electric light that contains a small bright lamp, a reflector, and typically a lens that concentrates the light. The spotlight produces a narrow beam or bright light.

Stock photography

Photographs that already exist and are available (at a price) for use by others. Often accessed through stock houses or through the original photographers directly.

Strobe units

Common term for electronic flash units. More accurately strobe refers to a flash that fires repeatedly. See also *flash* and *electronic flash*.

Stylist

An individual who dresses the photographic set, plans the appropriate props, and adds the special touches that enhance an image or mood.

Subtractive color

Producing colors by mixing dyes containing differing proportions of cyan, magenta, and yellow (the subtractive primary colors). See also *additive* and *primary color(s)*.

Sweet light

The hours around sunrise and preceding sunset. Valued because the ratio of light from the sun and from the dome of the sky are more balanced with each other.

Telephoto effect

Using a long focal length very far from all parts of a scene to create a change in perspective. Objects appear closer together than they really are.

Telephoto lens

Any lens of very long focal length and short back focus; one constructed with an effective focal length longer than its actual size. It produces an image of the subject larger than a normal or wide-angle lens would.

Tethered camera

A camera that is hard-wired to the host computer.

Thumbnail

A smaller version of an image. On a Web site, clicking the thumbnail typically brings up the larger size of the same image.

TIFF

Tagged image file format. A graphics file format that can handle color depths from 1-bit (black and white) to 32-bit photographic images. Used for files that will be printed but not displayed on the Web. See also *RAW* and *JPEG*.

Transparency

A positive image produced on transparent film and viewed by transmitted light.

Transparency film

Most commonly used for slides, it is also available in all sizes and formats up to 8 × 10 and beyond. Transparency film, which produces a positive image on a transparent base, is the preferred choice of most commercial photographers since it delivers a high degree of color accuracy, saturation, and sharpness. See also *film*.

Tripod

A three-legged support for a camera, usually with adjustable height and a moveable head.

Twin-lens reflex camera

A camera in which two lenses are mounted above one another. The photographer views through one lens and takes the picture through the other, which opens into the film chamber. See also *reflex camera* and *SLR or single-lens reflex camera*.

Underexpose

Give less than normal exposure to film or paper.

Vanishing point

The point of convergence created when lines in an image seem to converge. The eye is led to this convergence. Useful for composition.

View camera

A camera that can change the relationship of the lens plane and the film plane, allowing correction of perspective and control over depth of field. The front and back of the camera can be set at various angles to change focus and perspective. See also *rigid camera*.

Viewfinder

A small window on a camera through which the subject is seen and framed.

Warm

Colors containing red, orange, or yellow so giving the impression of heat or warmth.

Watt-seconds

Common usage for the amount of light produced by an electronic flash unit. More properly, watt-seconds refer to the amount of potential energy stored in the capacitors inside the power head of the flash.

White balance

A color adjustment that compensates for off-color light and still permits the rendering of white objects as white. Also, the intensity of red, green, and blue in a light source. White-balance control on a digital camera compensates for light sources that deviate from the standard daylight balance.

Wide-angle distortion

A changed perspective caused by using a wide-angle lens very close to a subject. Objects appear stretched out or farther apart than they are.

Wide-angle lens

Also known as a fisheye lens, at it smallest it creates images that look like they were taken through the lens of a fish's eye. It is well-suited for taking wide vistas as well as interior shots of homes and businesses. It has a lesser focal length and produces a smaller image of a subject than a normal or telephoto lens. See also *fisheye lens*.

Zoom lens

A lens that can be adjusted to a range of focal lengths along a continuum. See also *digital zoom*.

Index

193

INDEX